50 GEMS

Monmouthshire

TIM BUTTERS

AMBERLEY

To Sharon, Sonny and Alice. Travelling companions who helped me see the old and familiar in a brand-new light.

First published 2020

Amberley Publishing
The Hill, Stroud
Gloucestershire, GL5 4EP

www.amberley-books.com

Copyright © Tim Butters, 2020

Map contains Ordnance Survey data © Crown copyright and database right [2020]

The right of Tim Butters to be identified as the Author
of this work has been asserted in accordance with the
Copyrights, Designs and Patents Act 1988.

British Library Cataloguing in Publication Data.
A catalogue record for this book is available from the British Library.

ISBN 978 1 4456 9625 6 (paperback)
ISBN 978 1 4456 9626 3 (ebook)

Typesetting by Aura Technology and Software Services, India.
Printed in Great Britain.

Contents

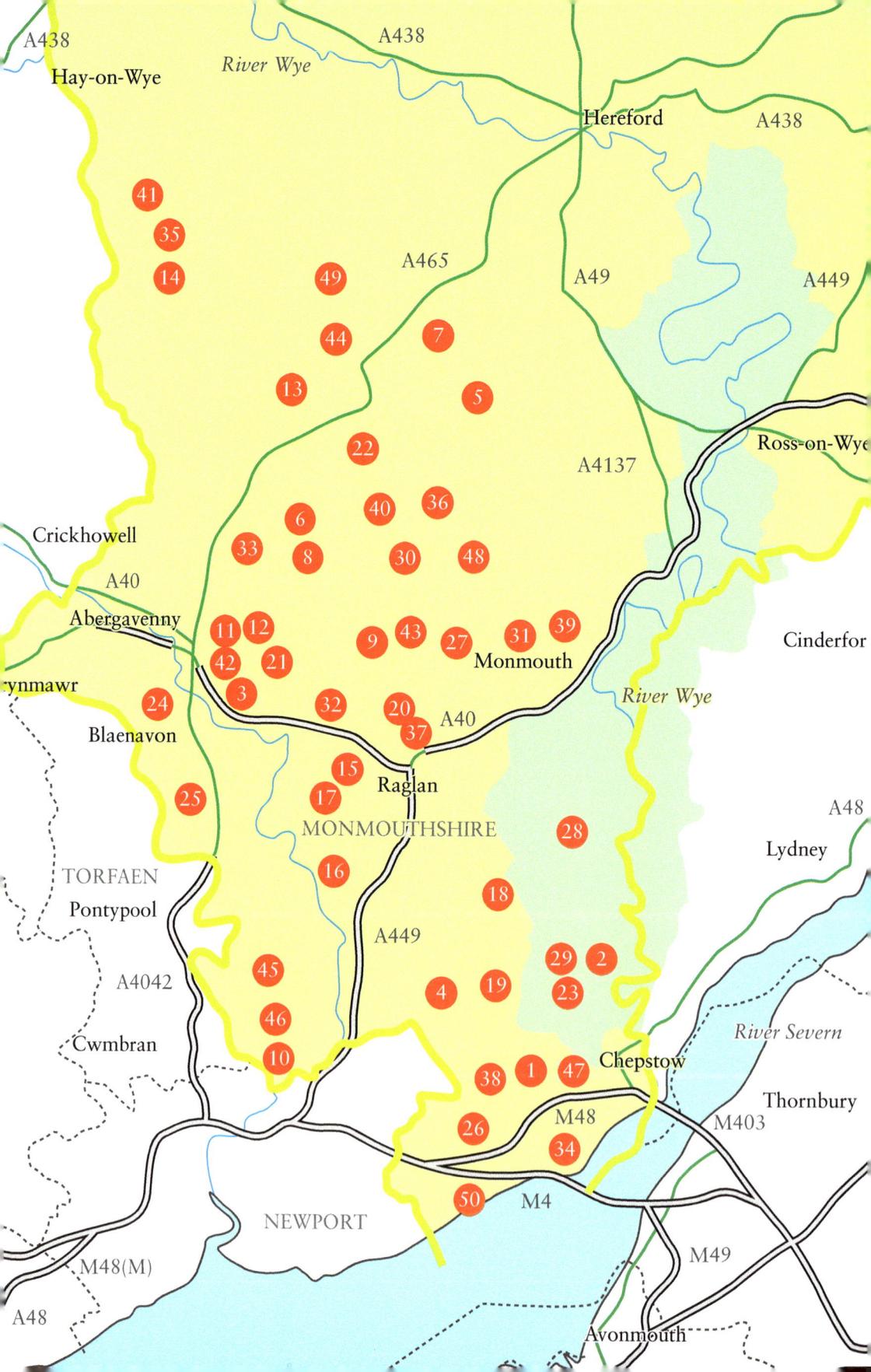

A438 Hay-on-Wye A438 River Wye Hereford A438

A465 A49 A449

41
35
14
49
A4137 Ross-on-Wye
44
7
13
5
22
Crickhowell
40 36
6
33 8 30 48
A40
Abergavenny
11 12 9 43 27 31 39
42 21 Monmouth
3 River Wye
24 32 20 A40 Cinderfor
Blaenavon 37
ynmawr 15
25 17 Raglan A48
MONMOUTHSHIRE 28 Lydney
16
TORFAEN 18
Pontypool A449
A4042 29 2
45 4 19 23
46 River Severn
Cwmbran 10 Chepstow
38 1 47 Thornbury
26 M48 M403
34
50 M4
NEWPORT M49
M48(M)
A48 Avonmouth

Introduction

Hands down, no questions asked and a money-back guarantee, the best way to get a real feel for history is by visiting the places where it happened. Books only ever tell half the story. It's the character of the landscape, the secrets that lie buried in stone and events both great and small that help to paint the subtler shades and supply the more nuanced tones of any story.

Not that this is a book about stories. It's a book about places. Fifty of them to be precise, but they all have a tale to tell and something unique to convey to anyone who crosses their path.

Monmouthshire is a special place: a county upon an island full of special places.

The fifty gems included in the book may not be everyone's cup of diamonds, but personally I believe every one of them sparkles in its own unique way. Of course, words and pictures can never fully do justice to the places that make a certain geographical area special. They can only offer the reader a little appetiser of why they are worth visiting.

And that's the sole purpose of this book. It's a guide and entry point for anyone wishing to explore this fair county further. It's also my own little ode to Monmouthshire, a place that captivated me with its enchanting spell many moons ago. As you'll also find out, it's a place like no other.

1. Dewstow Gardens and Grottoes – A Sunken Delight

As all grottoes should be, Dewstow is off the beaten track and something of a hidden gem. In fact, this particular jewel has laid buried and forgotten under thousands of tonnes of soil for over fifty years.

Now this labyrinth of gardens, tunnels, ponds, sunken ferneries, rills and waterfalls has finally been unearthed, visitors are spellbound by its intricate aesthetic, and also the captivating story behind this secluded spot of Caerwent.

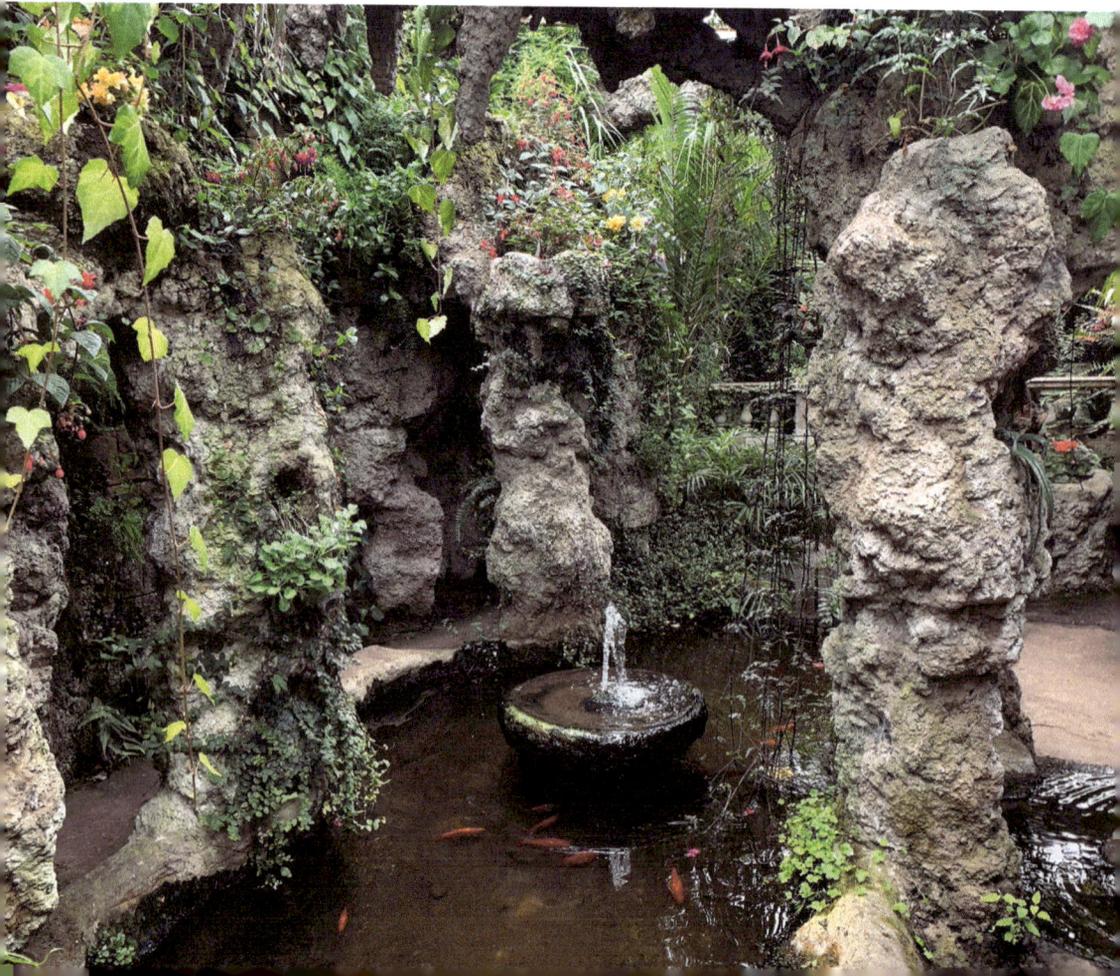

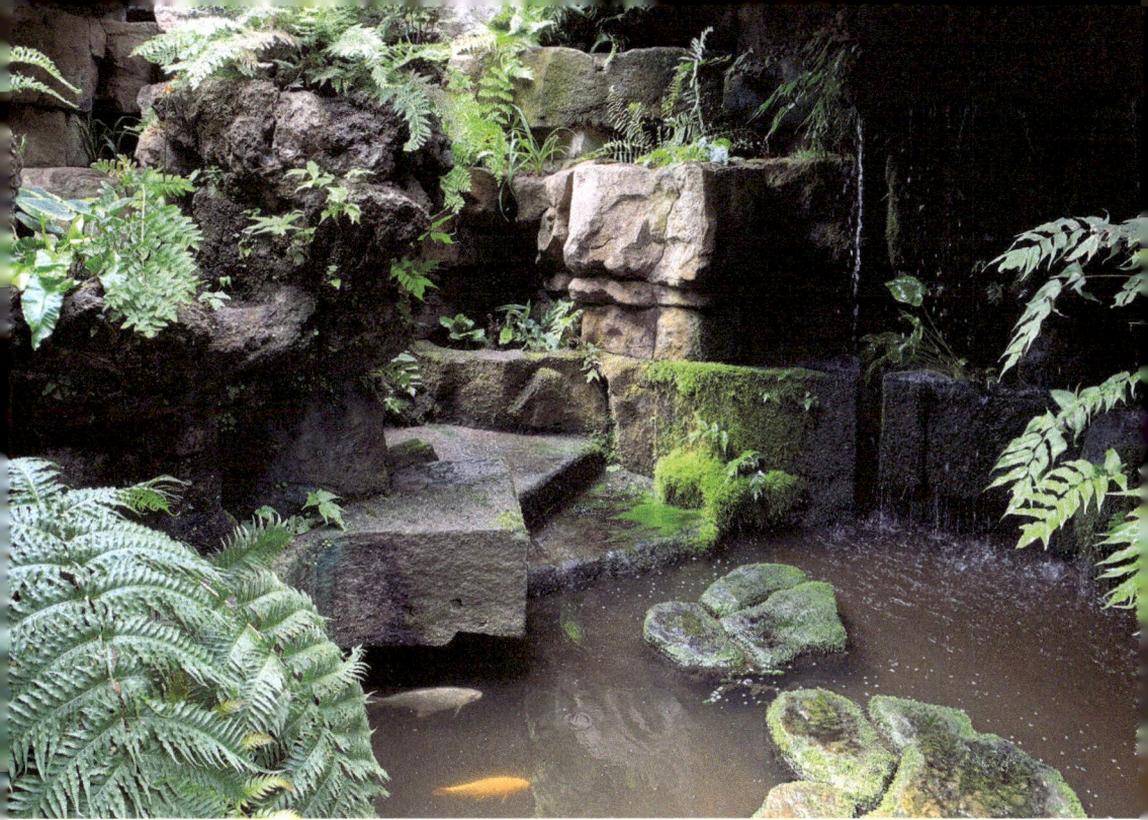

Above and opposite: Behold! An enchanting kingdom.

The story begins in the 1890s when Victorian recluse and squire of the manor Henry Oakley commissioned James Pulman and Son to dig under his prized coquet lawns and create the sort of underground world you'd expect to find fairies playing pan pipes in. It took nearly twenty-five years to realise his dream, but it was well worth it.

This realm of otherworldly caverns and passages was eerily lit by concealed shafts of light, which entered via strategically placed grilles cut into the lawn above.

Squire Oakley was a wealthy bachelor and it's still a mystery as to why he transformed the grounds of his Welsh villa, with its fine views over the Severn Estuary, into a place you'd expect a legendary wizard such as Gandalf to live.

Oakley resided in his beloved fairy-tale kingdom until his death in 1940, but during his lifetime no visitors were ever invited to his magical grottoes. Oakley had no heirs to leave his estate to, and during the hell and hopelessness of the Second World War when the nation needed food to feed its empty stomach, no one had any time for such foppish and fancy grottoes. Oakley's secret kingdom was filled with soil and turned over to pasture. Hidden from both eye and memory the gardens and grottoes were abandoned and forgotten, presumably forever.

And then in 2000 local farmer John Harris purchased Oakley's old house and estate for his family to live. One day while tidying up the gardens he uncovered some mysterious steps that led beneath the earth. Intrigued, he carried on digging and what he found was simply incredible – the enchanting sprawl of the grottoes was waiting patiently to be discovered by a new generation.

After six years of excavation, Oakley's passion was once again resorted to its former glory, and now finally for the first time in its history, Dewstow Gardens and Grottoes is open to the public to walk among its sunken delight, its crafted rock, its mysterious pools and its melody of water falling on well-worn stone.

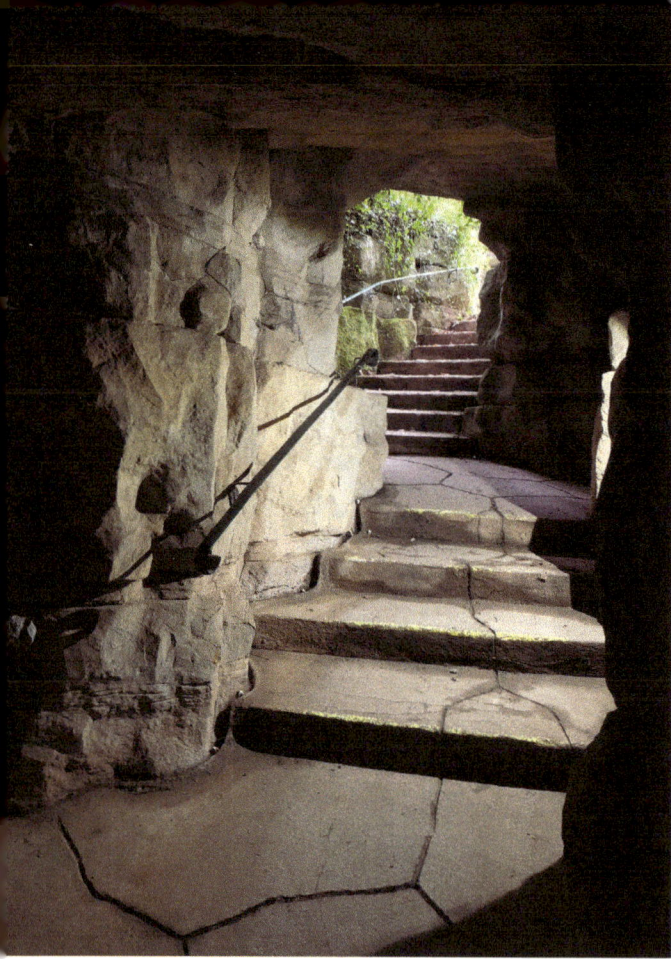

Left: Steps leading to another world.

Below: A garden of delights.

2. Tintern Abbey – A Gothic Masterpiece

In July 1798, William Wordsworth visited Tintern Abbey. It wasn't the first time the poet had set his gaze upon this Gothic masterpiece. The bard had previously visited as a troubled and melancholy young man, but on this occasion his spirits were soaring, his vision clear and his mind uncaged. So much so that he immortalised both the structure and the surrounding area in his famous verse 'Lines Composed A Few Miles Above Tintern Abbey'.

To Wordsworth's poetic eye, 'The still, sad music of humanity' had neither power to 'chasten nor subdue' when a soul was in the presence of 'a presence that disturbs me with the joy of elevated thoughts, a sense sublime'.

Of course the 'Lover of the meadows and woods, and mountains and of all that we behold from this green earth,' was talking about the beauty of the Wye Valley in general, but nestled among all that sublime splendour Tintern Abbey plays a significant role.

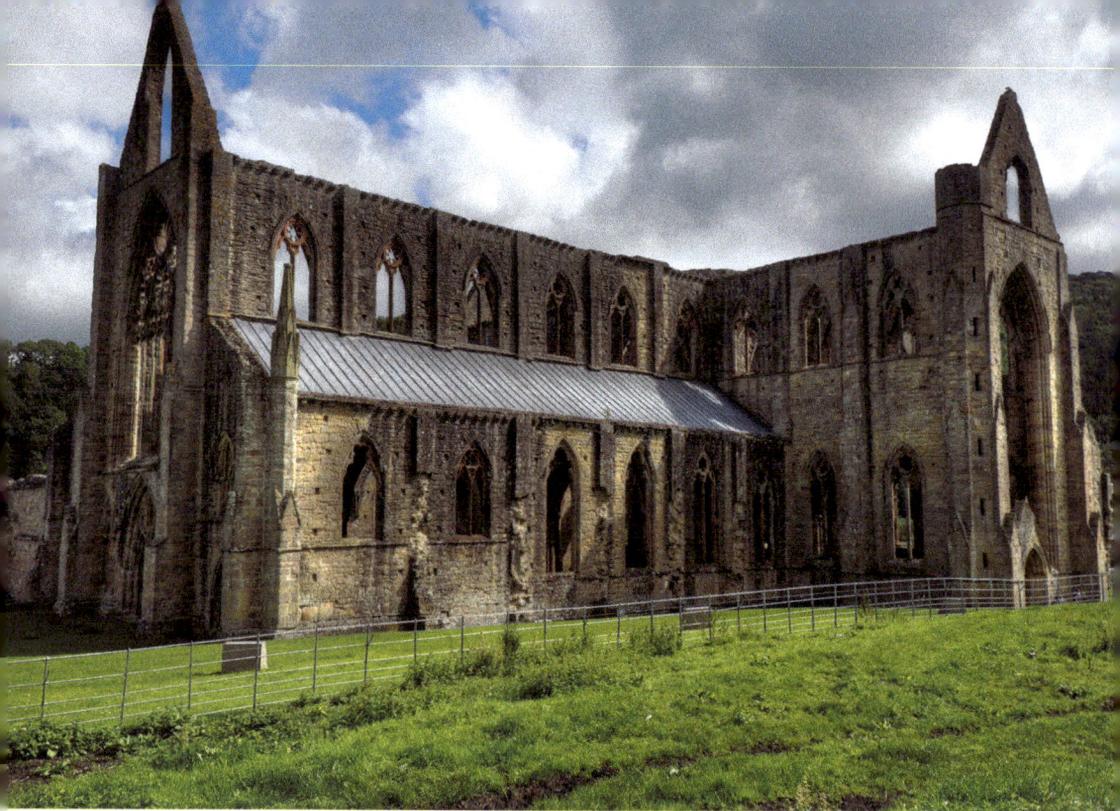

The sublime set in stone. (Photo by Steve Slater, CC BY 2.0)

As anyone who has visited these romantic ruins will testify, it's roofless majesty still strikes a chord in exactly the same key that would have resounded with Wordsworth and other artists such as J. M. W. Turner all those moons ago.

The towering walls and arches possess a sublime magic that can quicken the dullest heart with a rare glimpse of all that is elusive and infinite.

Its setting on the banks of the 'sylvan Wye' and beneath 'steep and lofty cliffs' conspire to paint a definite picture and create a certain mood.

Location is everything, and when the white-robed Cistercian monks established a timber-made home here back in 1131 under reformed robber Abbot Henry, who was renowned for breaking down in tears at the altar, they must have appreciated the views.

Courtesy of the patronage and purse of the Marcher lords, the modest timber dwelling soon became a mighty stone structure, and from the late thirteenth century Tintern Abbey garnered a reputation as one of the masterpieces of British Gothic architecture.

Not renowned as being a man with a refined sense of beauty, Henry VIII condemned the abbey to ruin during the English Reformation. Left rotten and forgotten for year after year, interest in the ivy-covered abbey was finally revived during the eighteenth century where it came to symbolise the romantic mood of the times. Curious travellers flocked to the ruins in vast numbers and it became a huge tourist attraction.

It's been over 500 years since Tintern Abbey's fall from grace, but it still stands to inspire and remind visiting souls from all over the world what humanity can achieve in the service of the divine.

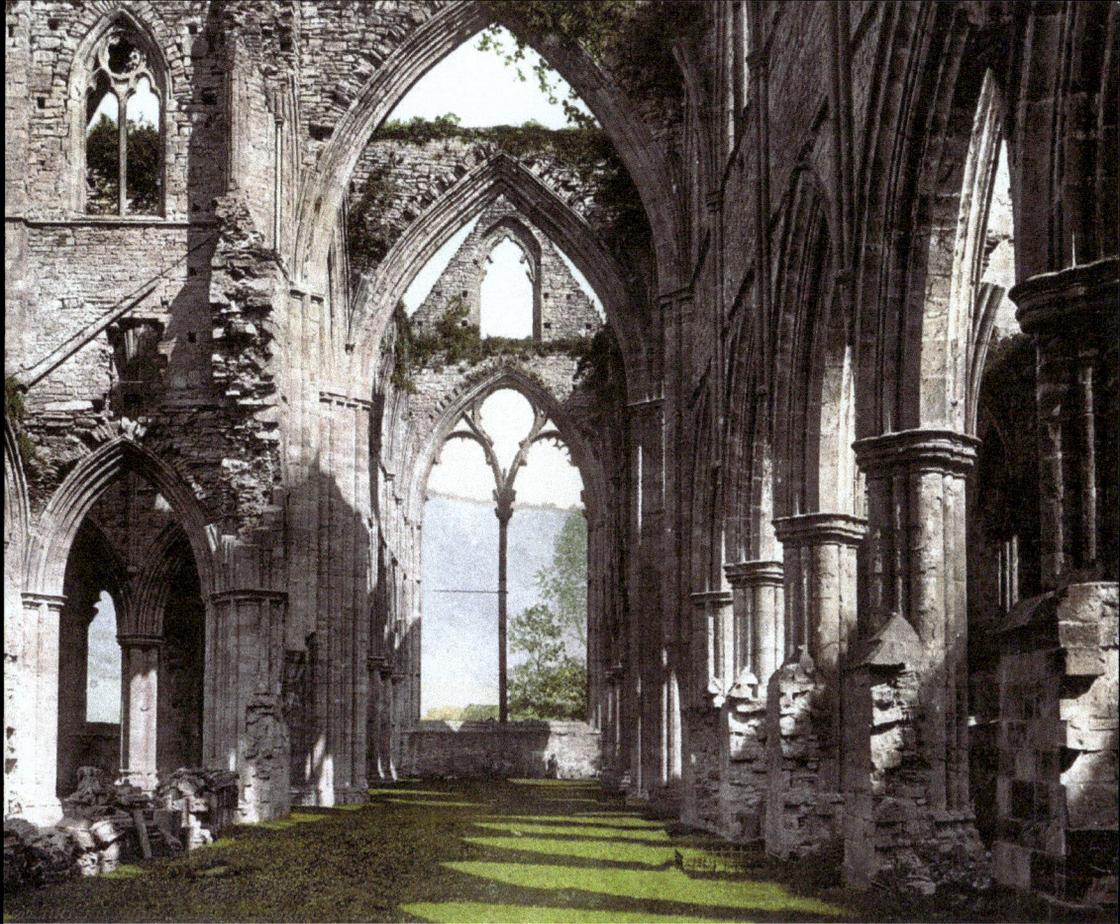

Above: Tintern Abbey.

Right: A room with a view.

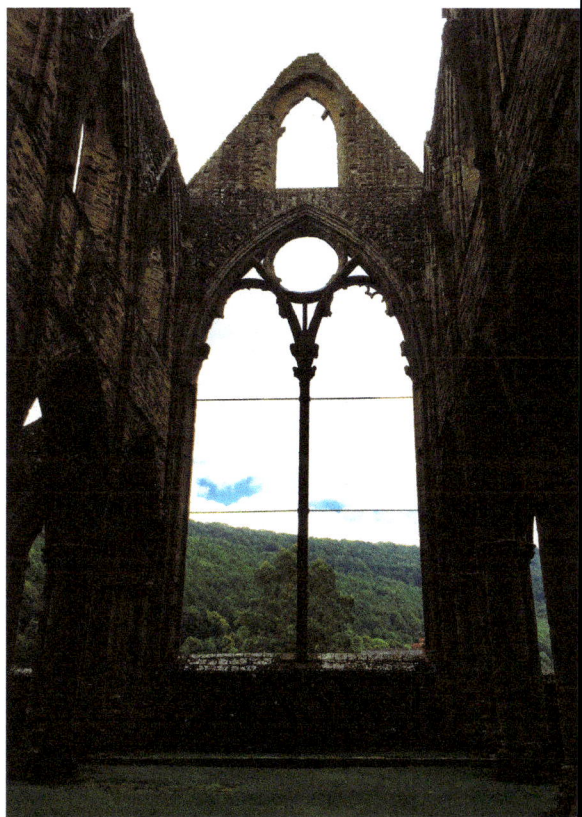

3. Hill's Tramroad – A Walk Through Time

On a fine autumn day when the distant sun is pale, the smoke-scented air is crisp and the low-lying mist weaves its weird magic on high hilltop and down beckoning vale, a walk on Hill's Tramroad from Blaenavon to Llanfoist serves as a gentle reminder of how the formidable patience and calm assurance of mother nature conquers all.

For those unfamiliar with this area of untamed splendour, it was once a sight of the heaviest of industry and backbreaking toil. The turf was torn, tracks were laid, and carts carrying iron rattled along pulled by horse and man to Llanfoist Wharf, where Blaenavon's hugely profitable export would be shipped via Newport Docks to far-flung corners of the globe.

Named after Blaenavon iron master Thomas Hill, the Tramroad saw schools, pubs, chapels and entire communities spring up like strange flowers along its weaving and winding route.

Heading into the past.

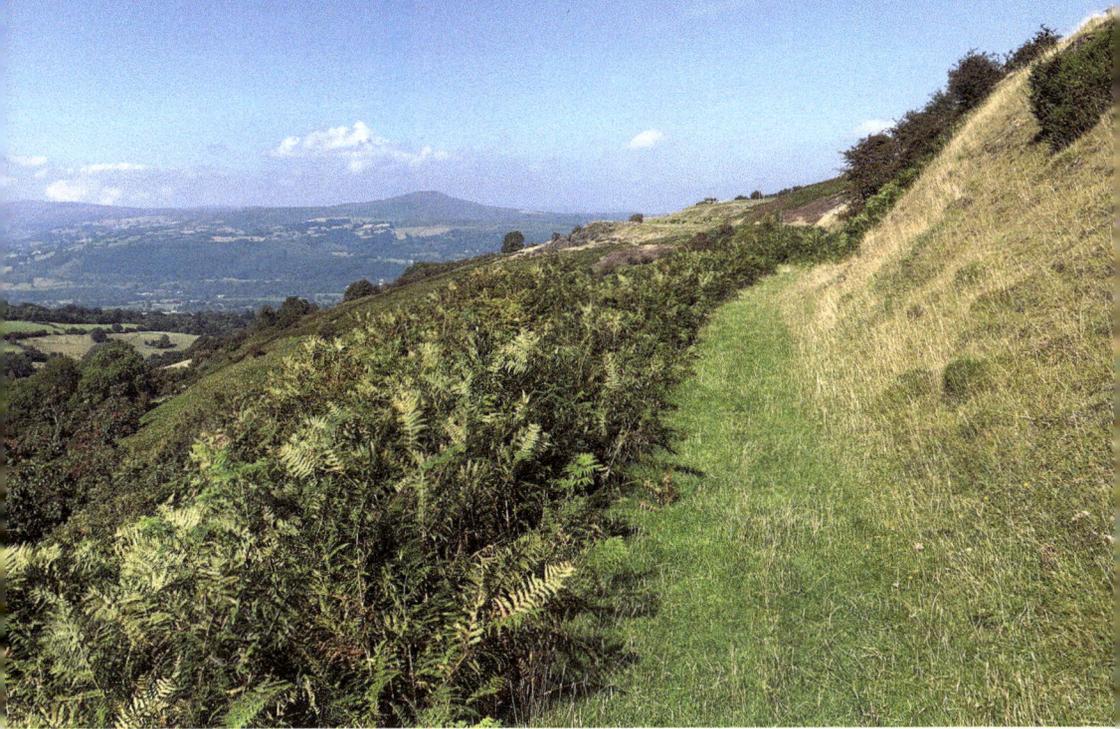

The villages of Pwll Du and Garnddyrys are no longer there, but the remains of the forges, quarries and houses where people who, to quote Alexander Cordell, 'Lived their lives on the edge of a golden valley,' are still visible to anyone willing to take a ramble through the past and along this remarkable industrial highway.

A journey upon Hill's Tramroad is a path that once walked is never forgotten. As you head from Torfaen in the direction of the now sadly defunct Lamb and Fox Inn, which at one time was one of the highest pubs in Wales, and towards the lost village of Pwll Du it's difficult not to feel transported back to another time and place.

In its heyday, Pwll Du, which means 'black pit,' stood defiant and isolated on an exposed hillside, 1,500 feet above sea level. The community of roughly 300 people consisted of hard-working miners and their families. The residents mainly lived in two rows of terraces. One was called Upper Rank and the other Lower Rank. They were often nicknamed 'Short Row' and 'Long Row'.

Pwll Du had chapels, a shop, a bakehouse, a washhouse and two pubs – the Lamb Inn and the Prince of Wales – which was unusual because it stood right on the border of Monmouthshire and Breconshire and had a bar in each county.

At 1.5 miles the Pwll Du Tunnel was the longest underground network on any British horse-drawn tramroad. Trams were hauled from the Blaenavon Ironworks through this tunnel en route to the Garnddyrys Forge where the pig iron would be converted into bars, rails and plates.

The tunnel's entrance has long since been blocked up with masonry and, like the rest of Pwll Du, lies for the most part buried and forgotten.

The village was declared a slum in 1960 and demolished. The residents were reluctantly shipped to new council houses in Govilon.

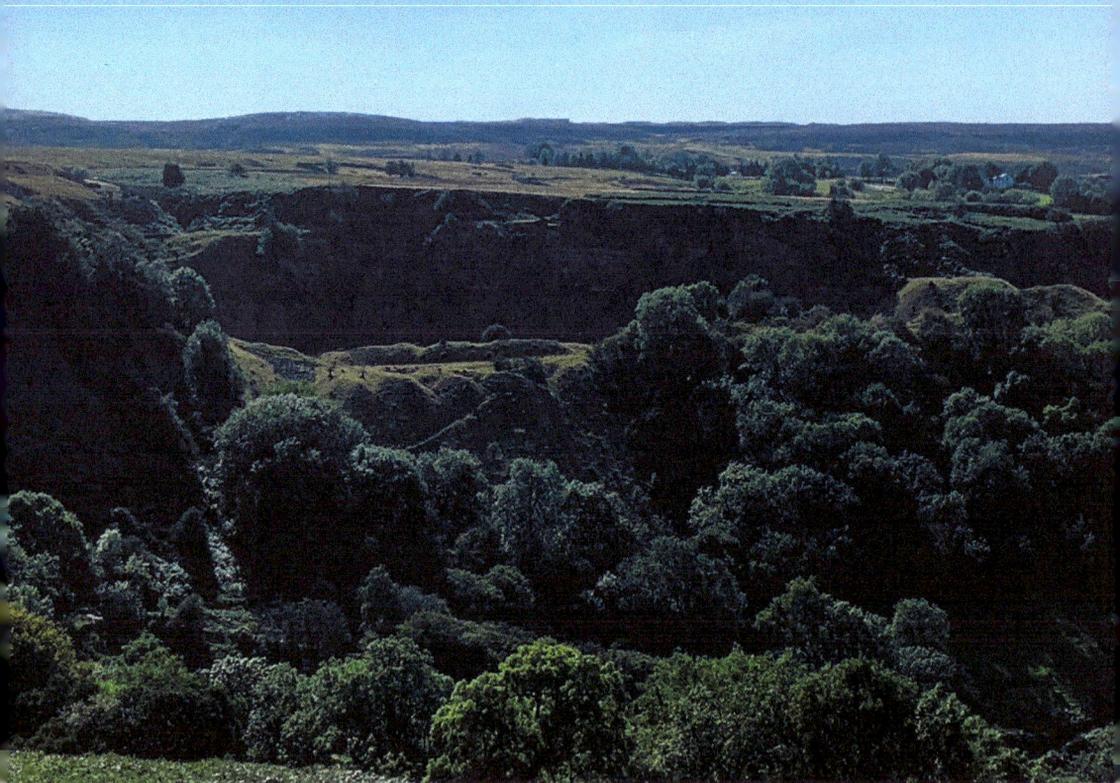

Into the valley.

Today when the lonely wind whistles through the bracken and heather and a soul can see nothing but sky and county in all directions, it's difficult to imagine this area being anything other than a still and restful place of birdsong, but the scattered stones and whispered memories of a lost village beg to differ.

Keep following the path of Hill's Tramroad and you'll eventually come across the ancient route from Blaenavon to Govilon known as Rhiw Ifor (Ifor's Track), before the tramroad leads you to the remains of Garnddrys Forge and the village that grew up around it. It was Garnddrys that inspired Alexander Cordell to write *Rape of the Fair County*.

Like Pwll Du, the houses and pubs of Garnddyrys are no more but their isolated remains, in particular, the village school where children learned to read and write before starting work, often as early as six or seven years of age, are a poignant reminder of what once was.

From Garnddyrys you can follow the tram road across the Blaenavon Road and along the front of the Blorenge to the 'Big Drop,' which will take you on the steep incline towards Llanfoist Wharf and journey's end.

Once again, when you walk through the leafy shade and towering trees that surround the last leg of Hill's Tramroad it's difficult to imagine how heavy industry had previously transformed this area, as the stone sleepers are the last remaining scar that hint at this wooded area's past

A brief walk through the murk and damp of the tunnel that passes beneath the canal, accompanied by the ever-present gurgling of the Devil's Gully on the right,

will lead to a brief hike up the steps towards the Monmouthshire and Brecon Canal, which offers a fine view of the mountains and the contrasting sweep of modern civilization. All in all the perfect place for a rambler and a gambler to take a breather on a nearby bench before deciding where to head next.

4. Wentwood Forest – A Leafy Mystery

There is something eternally enchanting about a walk in the woods. As children stories of fairy tale forests fueled our imagination, and as adults we are naturally drawn to the densely tree-populated areas of the world in search of solitude, solace and the restorative power that being in an ancient place free of noise pollution and the maddening influence of the crowd brings. The Japanese have a word for it, *shinrin-yoku*, which translates literally as 'forest-bathing'.

When you walk through the trees, the sound of birdsong, the intoxicating scents of foliage and bark, the dappled sunlight and the dark and mysterious corners of any woodland all conspire to appeal to something ancient and undernourished in our bones, which delights at the chance to walk once again in the green-spirited heartlands.

A blanket of bluebells. (Photo by Richard Wyson)

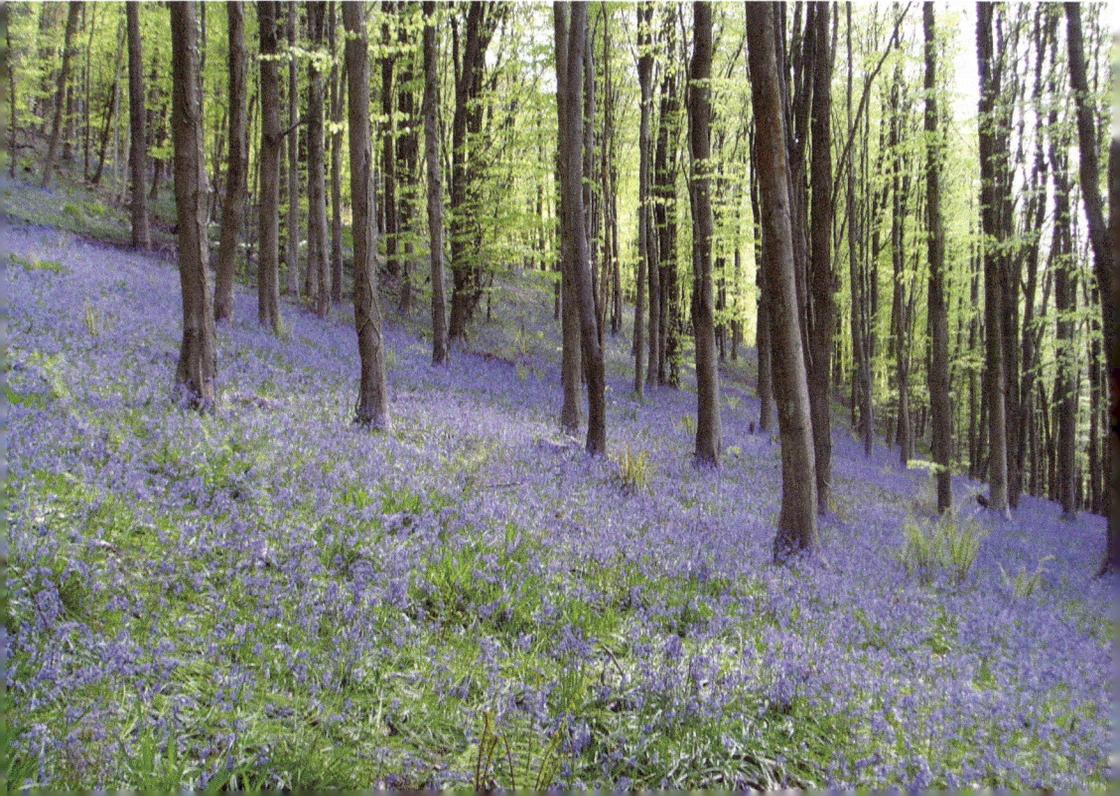

Monmouthshire is spoilt for choice when it comes to trees, but the ancient and hilly woodland, which was once the hunting ground for the lords and ladies of Chepstow Castle, is a grand place to start if you want an intoxicating taste of a wild Welsh forest.

Wentwood Forest is the largest ancient woodland in Wales. It once covered a much larger area between Monmouthshire's two great rivers, the Usk and the Wye, and it split the old kingdom of Gwent in two. People either lived in Gwent Uwchcoed or Gwent Iscoed, which translates as 'above and below the wood'.

In 2005 its thousand-year-plus history was in danger of falling foul of the woodcutter's axe as commercial forestry turned its beady eyes to the abundant species of trees that grow there. Yet thanks to a fundraising campaign to raise £1.5 million the Woodland Trust was able to buy Wentwood and preserve it for future generations.

During the First and Second World Wars, many of the forest's native trees were felled to build support for trenches. In their place fast-growing conifers were planted for commercial purposes. The downside of this was the dense shading and soil disturbance from the conifers was detrimental to the native plant life, wildlife habitats and native species of trees.

Since the Woodland Trust has taken over the management there has been a selective culling of conifers to allow native species of trees such as oak, beech and hazel to flourish again. Much to the collective delight of dormice, bats, song thrushes, bullfinches, wood warblers, willow tits, cuckoos, tree pipits, goshawks and badgers, to name but a few of the creatures that call Wentwood their home.

A stroll beneath the deciduous tree canopy of Wentwood in the spring is a frolic through the bluebells and other spring flowers that have abundantly littered the tracks and pathways of this kingdom of trees for generations. And as you walk in the footstep of countless souls who have passed this way before you don't be surprised to find an unexpected spring in your hitherto weary step.

The elusive nature of Wentwood Forest can ignite a despondent mind, inspire a sullen soul, and summon the most reluctant spirit to finally step off the stress-inducing and tyrannical treadmill of dull routine, and dance with rare delight through the leafy mysteries of mother nature's sacred places.

5. Skenfrith Castle – A Vanishing Act

In 1587 Thomas Churchyard wrote a little ditty called 'The Worthiness of Wales: A Poem'. In it he celebrates what have become known in Monmouthshire as 'The Three Castles'.

In the words of Churchyard, 'Three castles fayre, are in a goodly ground, Grosmont is one, on hill it builded was; Skenfreth the next, in valley it is found, The soyle about, for pleasure there doth passe. Whit Castle is, the third of worthie fame. The countery there, doth beare Whit Castle's name. A stately seate, a lofite princely place, whose beautie gives, the simple soyle some grace.'

Standing on the banks of the Monnow, Skenfrith Castle is also known as the vanished castle because so much of it has been lost to history and memory.

A brooding bastion.

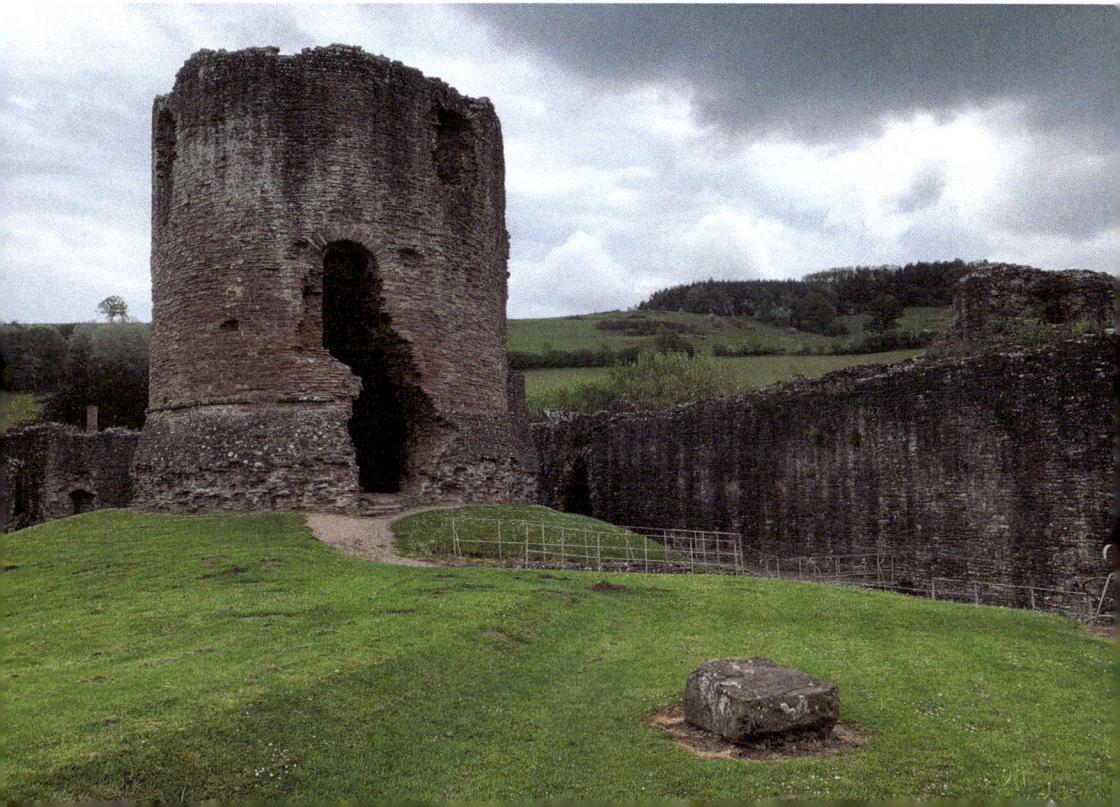

Yet its location in sleepy Skenfrith, it's close proximity to the languid Monnow and its abundance of rolling lawns to kick a ball on or relax with a liquid lunch makes it a charming spot to spend a Sunday afternoon.

In Welsh the castle is known as Ynysgynwraidd, which translates as 'isle' or 'water meadow' of Cynwraidd, which was the name of a Welsh chieftain living here in the sixth century.

The beginnings of the castle were established by those passionate fortress-building colonials, the Normans, not long after William the Conqueror's invasion in 1066. Its original purpose was probably to protect the route from Wales to Hereford.

In the wake of a significant Welsh revolt in 1135, King Stephen grouped Skenfrith, Grosmont and White Castle together under the banner of the Three Castles, and the three musketeers continued to repel Welsh attackers for centuries.

Skenfrith's most notable feature is its round keep, and although it's now hard to visualise, there used to be a moat here similar to the one still in existence at White Castle.

On the same grounds as the castle you'll find Skenfrith Church, which is dedicated to the Irish saint Bridget. It's one of the oldest churches still in use in the county, and in addition to its notable wooden belfry, inside you'll also see the tomb of the Morgan family and a glass case containing a fifteenth-century embroidered cope portraying the ascension of the Virgin Mary.

Despite being defined in part by that which is absent, Skenfrith Castle, with its imposing keep and mighty walls of thick stone, stands as an unmistakable symbol of the true nature of castles – alien, oppressive and an unmistakable declaration of war.

The church of an Irish saint.

6. White Castle – A Storybook Fortress

If you happened to pay a visit to the lazy lawns and elegant decay of White Castle between 1942 and 1945 you might have seen a tall and aloof-looking gentleman with a slightly distant look in his eyes, painting and sketching the swans that used to frequent the moat.

As in the way some people do, his general demeanor and slightly superior swagger would suggest that there is someone who considers himself a cut above, a man marked out from the common breed, either by personal distinction or high office. That impression would deepen significantly when taking into account the nonchalant but nevertheless watchful pair of men in close proximity to the painter of swans. For they were high-ranking military personal and the man at the easel was their prisoner. By night he was kept under lock and key at nearby Maindiff Court and by day he was allowed to roam the picturesque and surrounding area pretty much at will.

The curious-looking gentleman with the intense eyes, peculiar gait, foreign tongue and brooding brows was well known among many of the locals – they called him the

A storybook castle.

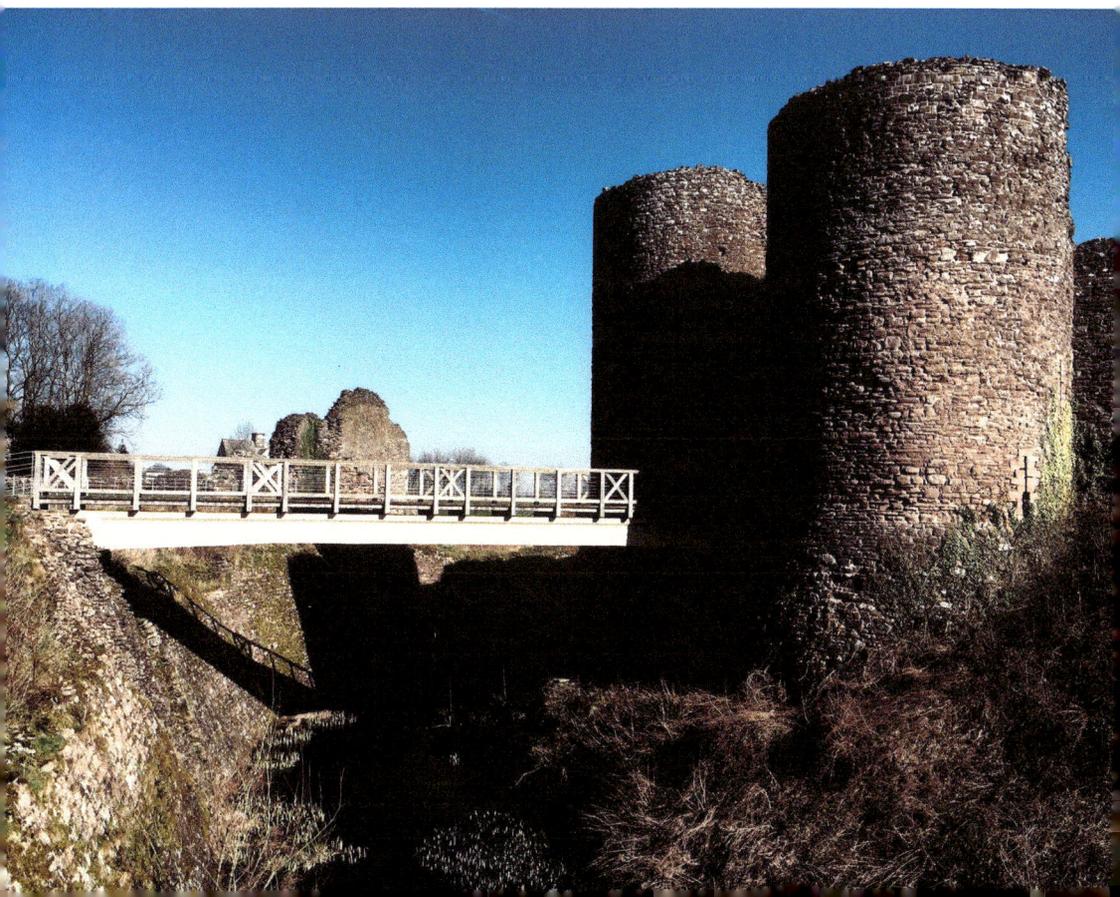

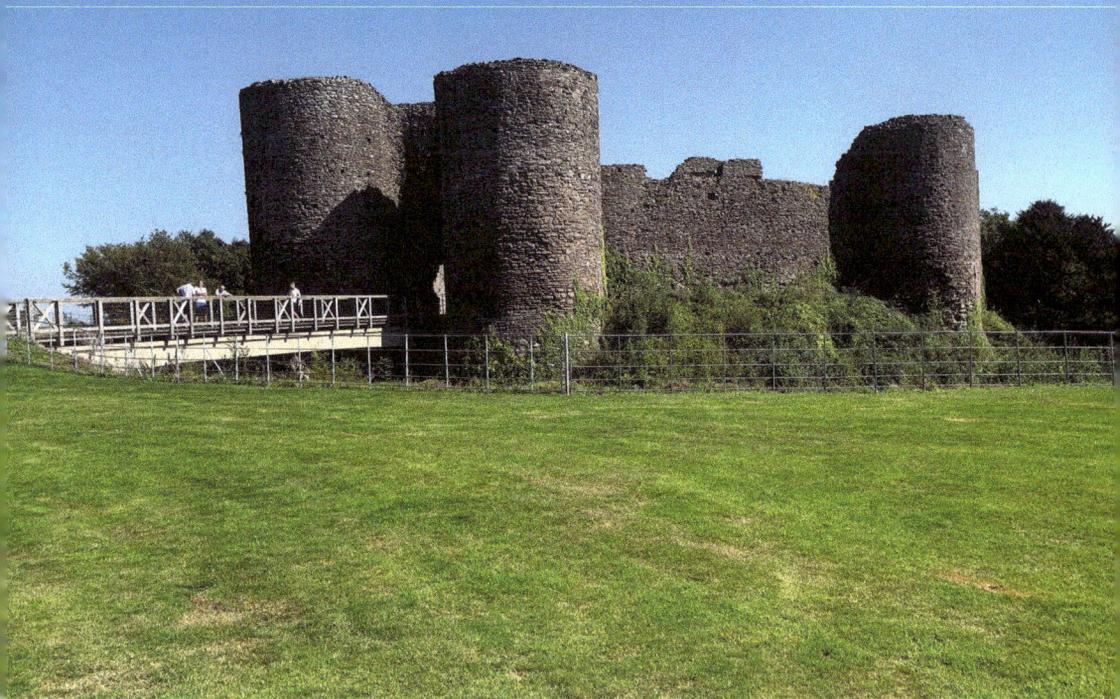

Abergavenny Kaiser. His real name was Rudolph Hess and he was once the deputy führer of Nazi Germany.

Over the centuries and down the decades Hess has just been one of many millions of visitors enraptured by the curious charm of White Castle.

To the modern eye, it might look like a storybook castle, but this bastion of stone and history on a ridge high above the Monnow Valley was originally a formidable fortress and born out of a festering fear and hatred for the natives.

One look at the imposing and circular flanking towers standing in lonely majesty, its no-messing twin-towered gatehouse and its wide water-filled moat will leave you in no doubt that White Castle was once a place of great military and strategic importance.

Today it's a great place to have a kick about, a spot of cricket or even a picnic, but way back when, and we're talking beyond the reach of recorded history, the site of White Castle was thought to be the home of local chief Gwyn ap Gwaethfod.

However, when the Normans invaded, Gwyn's primitive fortress of wood was seen as being on an extremely strategic site, which the French boys wanted for themselves, and so they took it.

Originally named Llantilio Castle after the neighboring village of Llantilio Crossenny, White Castle was so called because of the distinctive white plaster that once covered its walls.

Sometime in the early thirteenth century King John gave Hubert de Burgh control of the Three Castles, which also include Grosmont and Skenfrith, to aid them in their continued subjugation of the Welsh.

The feudalism and oppression carried on for many a moon, until one fine day the sun rose in skies beneath which the castles were in ruins; the land was at peace and the banner of the dragon flew high and free in the breeze once more.

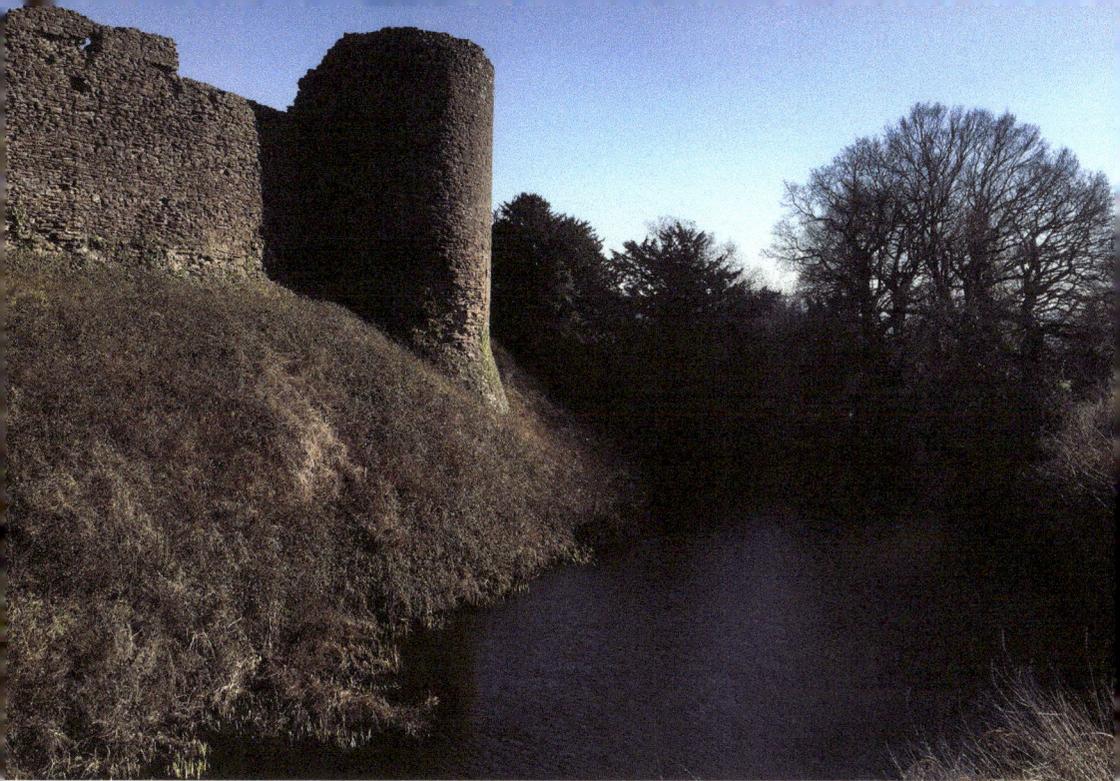

7. Grosmont Castle – The Site That Time Forgot

Like the village that surrounds and seemingly protects it like a village green preservation society, Grosmont Castle has a sleepy ambience of idle leisure and blissful purposefulness, which can make a soul feel that worrying about the mundane is about as productive as shouting at clouds.

The tall octagonal chimney whose fine gabled and coronetted top is still visible adds to the impression that once upon a time a mob of artistic types resided here who would spend their days reciting poetry, drinking fine wine and playing chess.

Of course first impressions can be misleading. Grosmont Castle was a thing of war not beauty, and when Owain Glyndŵr and his forces attacked in the early fifteenth century there must have been some handy types on hand with the future King Henry because they certainly managed to send the Welsh troops packing.

Soon after, however, the castle was abandoned and the forces of neglect moved in and set up camp, as moss took the place of oil paintings, the empty heavens replaced artfully crafted ceilings, and a murder of crows stood in for fair maidens.

Today, though, it's a fine place to meander and let your imagination run riot. It's also a perfect castle to circumvent and offers a circular walk that is by no means

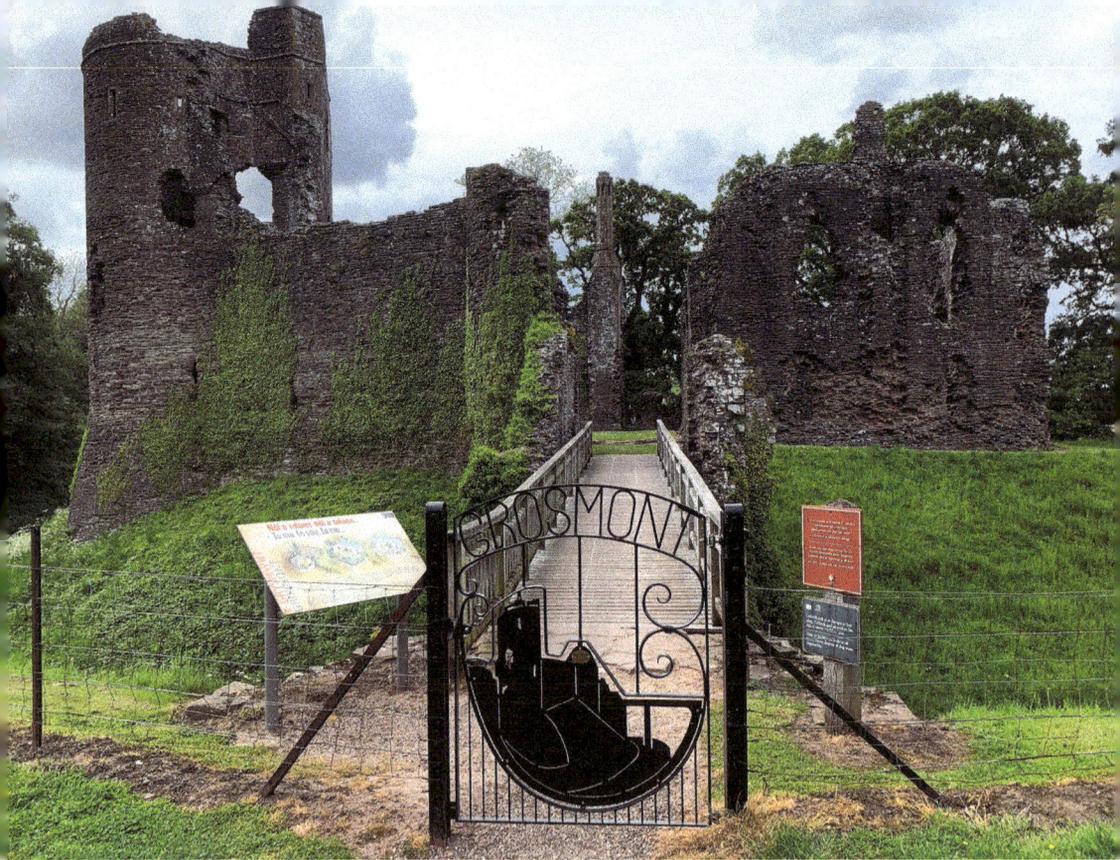

Above: An enchanting ruin.

Below: An elegant masterpiece.

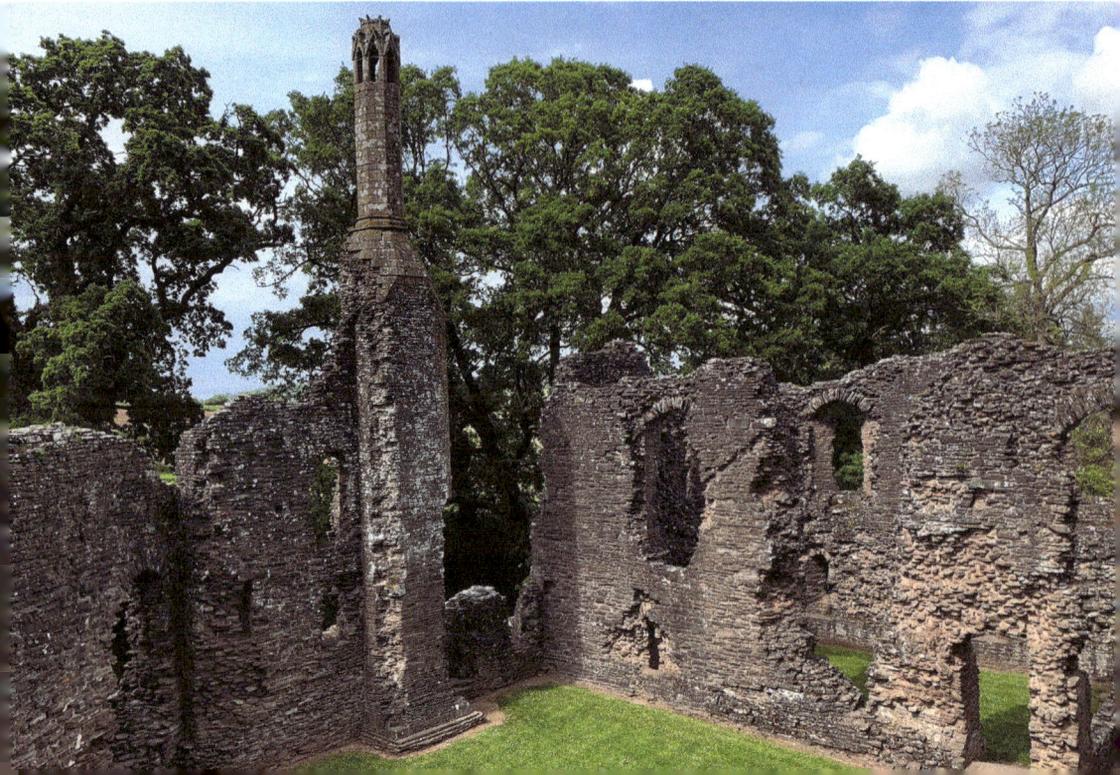

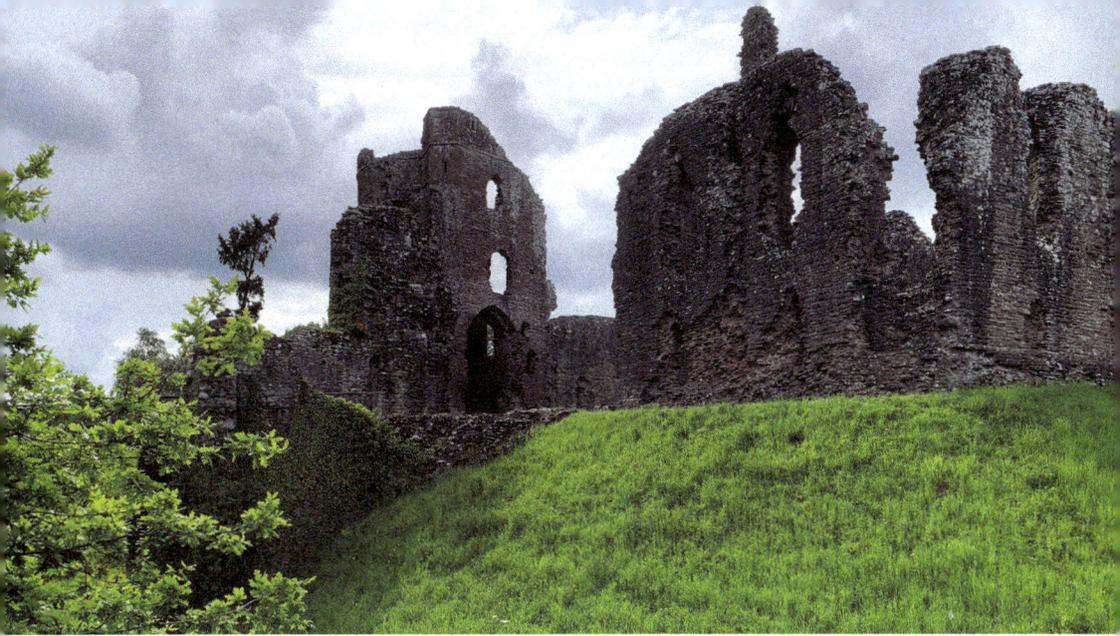

A dry moat.

strenuous and is somewhat delightful – a unifying factor all walks in close proximity to historic sites appear to share.

And if you're thinking of visiting on a day when the skies are black and the downpour is damnable then you could do worse, because on rare occasions when the wild Welsh rain falls for days on end without respite or reprieve, the moat around the castle once again fills with water and grants a rare glimpse into the past – and a nigh-on perfect photo opportunity – of what this defensive measure must have looked like when fully operational.

As we come to the end of this brief tour of the Three Castles, more sure-footed and energetic readers will probably be interested in the Three Castles circular walk. It comes highly recommended and offers ramblers and gamblers the chance to visit Skenfrith, Grosmont and White Castle in the space of a day. It links in with both the Offa's Dyke Path and the Monnow Valley Walk and affords commanding views of the Welsh Marches, the Black Mountains and the Forest of Dean. It's an inspiring and clearly marked hike, and as you pass through wood and down vale you'll have the opportunity to explore many other engaging sites not featured in this book due to limitations of space.

8. The Sugar Loaf – The Lonely Mountain

As is only fitting for the most iconic peak of the Black Mountains, the Sugar Loaf, or to give it its far more impressive Welsh title, Mynydd Pen-y-fal, sits in regal repose 2 miles north-west of Abergavenny.

This volcano-like mountain dominates the skyline of the surrounding countryside for as far as the eye can see. Rumour has it that when a young J. R. R. Tolkien visited

Buckland Hall in nearby Bwlch it was the distant view of the Sugar Loaf's conical summit that inspired a key part of *The Hobbit*.

Erebor, the Lonely Mountain where the dragon Smaug guards his hoard is said to be based largely on the Sugar Loaf and nearby Crickhowell is said to be the inspiration for the village of 'Crickhollow'.

There's no doubt that Tolkien knew both Monmouthshire and Powys well, and when it came to writing *The Lord of the Rings* many suggest the author based his apocalyptic and grim vision of Mordor on the fire and brimstone sky that lit up the skies of South Wales during the industrial heyday of the early twentieth century.

In fact Mynydd Pen-y-fal is just 4 metres short of being classified as a mountain, but it's a fancy, fine and frolicking fact that the Loaf is perfect for loafing on during a midsummer's day when the skies are blue, the temperatures are soaring and a strong south-westerly wind buffets around the summit to keep you chilled. When the elements conspire in such a fashion only a fool would ignore the opportunity to enjoy a glass of wine and the panoramic views before the leisurely descent down this languorous mount.

As you descend from the heavens, along the well-trodden paths leading from the peak, try and visualise how they must have once looked in the early days of the twentieth century when they were carriageways with a cavalcade of around ninety horses two abreast, drawing carriages of people too lazy or inebriated to walk who wished to take in the mountain air.

The most famous visitor to this mighty Monmouthshire mount was Buffalo Bill Cody. The Wild West wanderer visited Abergavenny with his travelling show in 1907 and was so taken with the Sugar Loaf he just had to climb it. Which he did, and nearly the whole population of Abergavenny accompanied him.

Perhaps one of the most fascinating tales about the mighty Loaf is the lost village found on its slopes in 1999. Thick woodland had obscured this hidden Atlantis for nigh on a century. It was discovered during a survey of archaeological sites and experts were at a loss to explain its sudden disappearance and subsequent reappearance.

The lonely mountain in the bleak midwinter. (Photo by Tony Kelly)

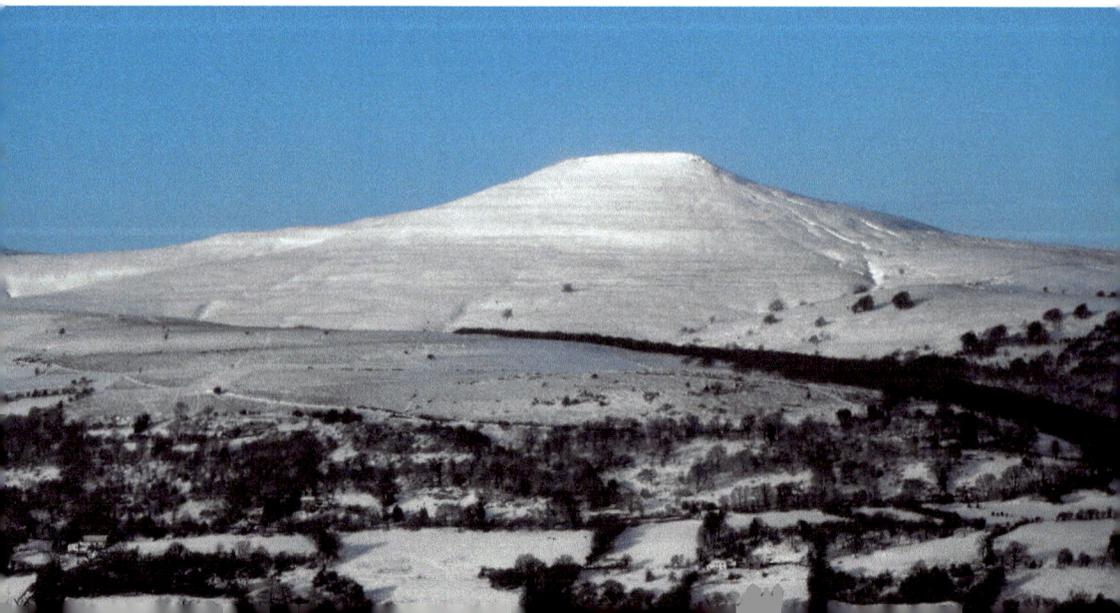

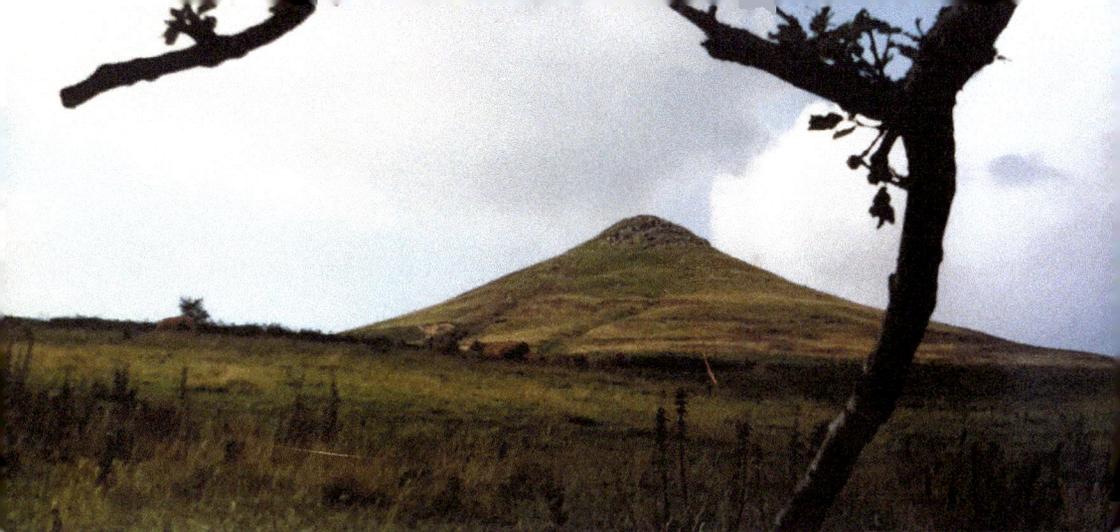

It's believed the settlement of around twenty-five ruined dwellings has its origins at the end of the seventeenth century. Some suggest a rich landowner bestowed the land upon a group of like-minded people who wanted to form a new community away from the hoi polloi. Whatever the truth, the village didn't last; by the beginning of the twentieth century the site was deserted. Why? We'll probably never know. Perhaps they simply didn't have a head for heights.

9. Monnow Bridge – An Enduring Icon

There's an ancient superstition that said if you say goodbye to a friend on a bridge you'll never see them again. It was also believed for time out of mind that running water has magical properties, and vampires, witches and demons cannot follow a soul fleeing over a bridge.

Admittedly, these old folk tales are not something a soul gives much thought to when making their way across an industrial nightmare of steel and cable such as the Severn Suspension Bridge, but if you ever cross Monmouth's Monnow Bridge in the pale moonlight you may find your mind wandering in the autumn twilight between what is real and what is supernatural. And with good reason. The Monnow Bridge and gate spans the passage of centuries between the medieval world and the modern. In fact, it is the last of its kind and the sole remaining fortified medieval river bridge in Britain.

The present stone structure was built in the 1200s to enable a passage over the majestic Monnow, but excavation work in the late 1980s revealed remains of a wooden bridge thought to have been erected in the 1170s.

In 1297, on the orders of King Edward, the heavily fortified gatehouse, which gives the bridge its distinctive appearance, was built.

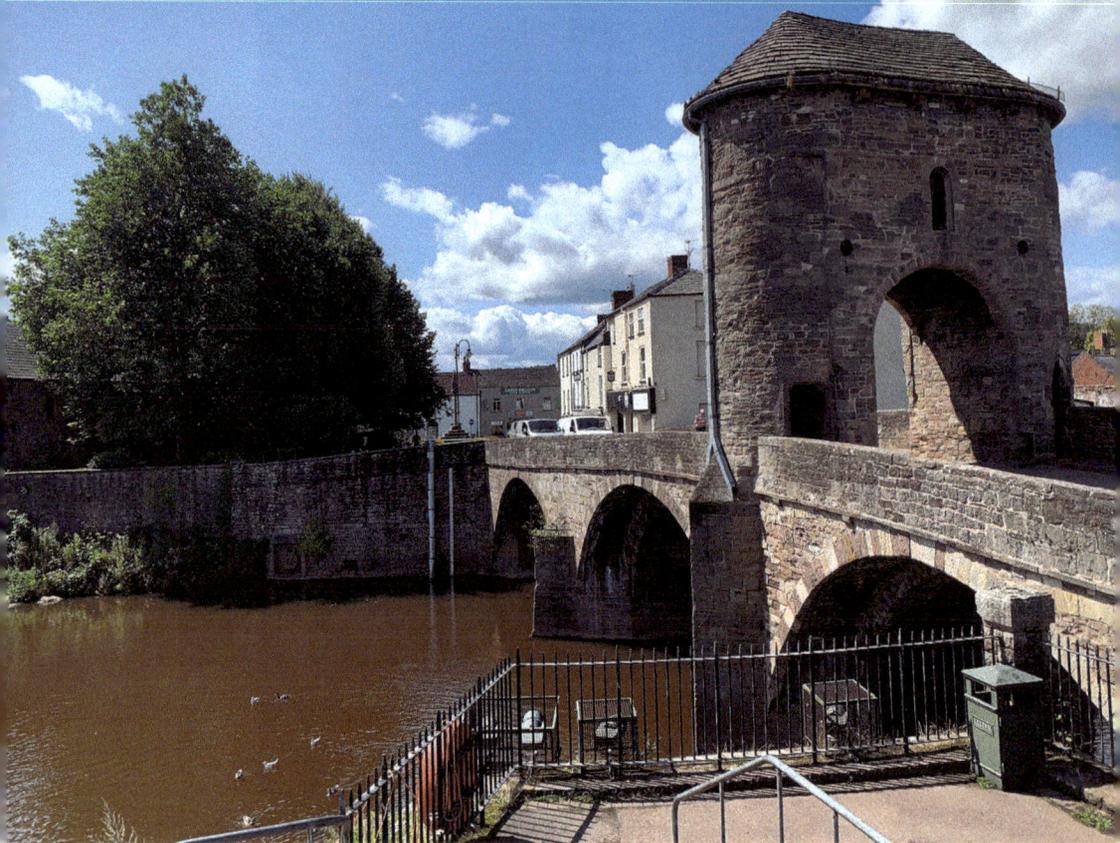

A bridge over peaceful water.

Like most of the Norman aristocracy, Henry of Lancaster was paranoid about Welsh revolt and rebellion and so he petitioned his uncle, the king, for a murage grant to transform this strategic crossing into the town of Monmouth into a bombastic bastion of troops, tyranny, terror and, in time-honoured tradition, tolls!

For years soldiers stood to attention in the guardhouse overlooking the bridge to keep rogue undesirables at bay. Meanwhile, money collectors stood below to collect the coins of the realm and let the harmless waifs, strays and wandering cash cows in. In 1705 the battlements were given an extension and converted into a dwelling that doubled up as occasional gaol and militia guardroom. During the Newport Rising of 1839 the powers that be decided to place a garrison at the gatehouse in case any Chartists fancied taking Monmouth by force. Between 1819 and 1858 the bridge was widened to ease the traffic flow of the old horse and cart, and pedestrian walkways were also added.

Today the Monnow Bridge has been completely pedestrianised, leaving visitors completely free to marvel at the River Monnow while idling on the bridge, or at the bridge, when lounging on the banks of the Monnow. Either way you'll not have to worry about the infernal menace of the motorised hordes as you chill and get your fill of a little slice of yesteryear.

Monmouth is not New York and does not boast a Manhattan skyline, but if it did the Monnow Bridge would take pride of place, such is its iconic stature in the town that gives the county of Monmouthshire its name.

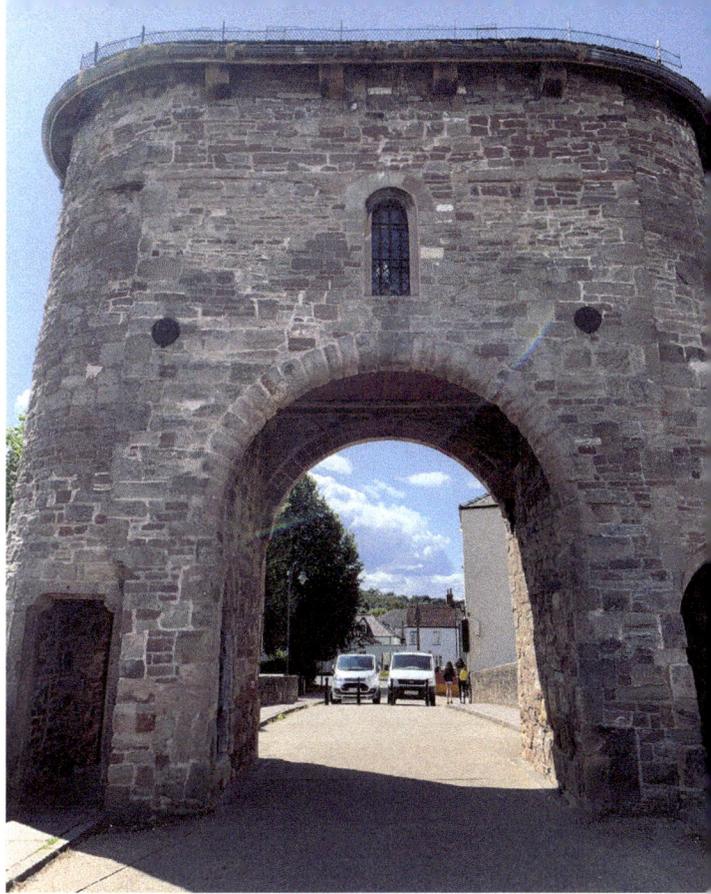

An ancient archway.

10. Llandegfedd Reservoir – Monmouthshire's Atlantis

Monmouthshire is a county that has been blessed in abundance by Mother Nature's artistic hand. Its rolling hills, sleepy meadows, winding rivers and fairy-tale woodlands are a balm for any soul seeking to escape the dredge, drudgery and concrete of modern life. Yet if there is one thing it lacks it's a coastline to call its own. The landlocked county has no breathtaking sweep of golden sands or incoming tides to wash away the stress and duress of existence, but what it does have is Llandegfedd Reservoir.

And if a dip in the deep blue is not on the menu, this patch of watery expanse is a sound substitute. If you like wide open spaces and watersports then Llandegfedd will quite literally float your boat. On any given day you'll find a host of windsurfers, powerboaters, paddleboarders, canoeists and kayaks making a splash on this 434 acres of water, and all vessels can be hired from the on-site Watersports Centre.

Its dreamy depths are also brimming with rainbow and brown trout for those who like to cast their line and lay back in idle repose on a bank or in a boat. The site

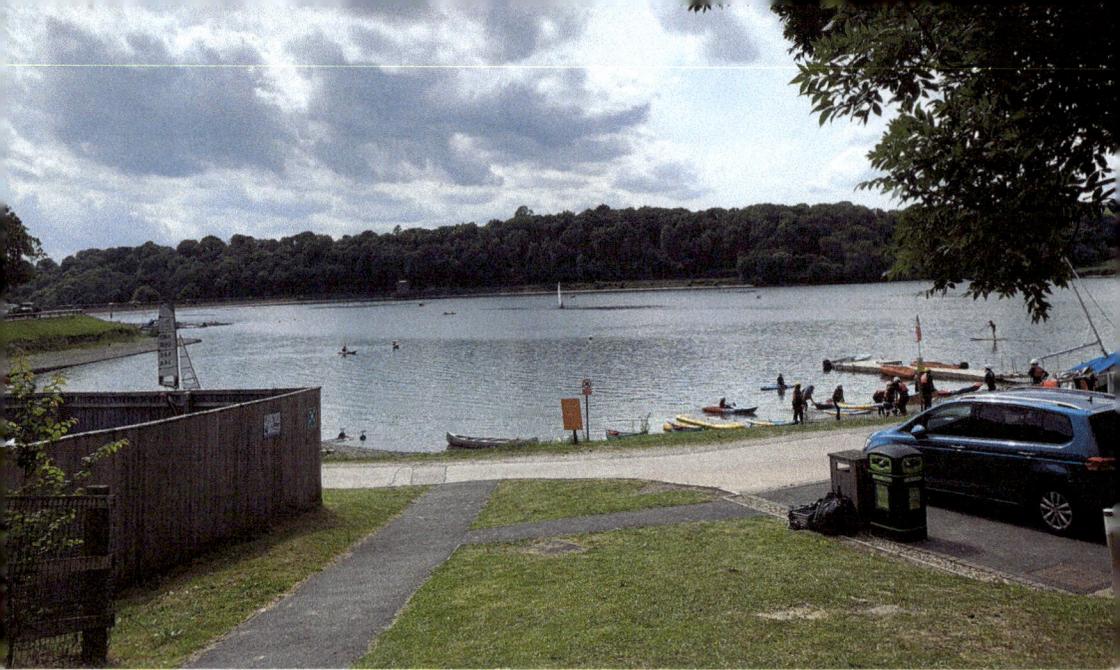

around the reservoir is designated as a Site of Special Scientific Interest and is a great place for watching a diverse and abundant collection of our feathered friends.

The boundaries for both Monmouthshire and Torfaen run through the area, and according to local myth the reservoir was created by flooding an old village that once stood on the site. Which in many ways would make it the Atlantis of Monmouthshire.

11. Monmouthshire and Brecon Canal – A Man-made Marvel

For well over 200 years the Monmouthshire and Brecon Canal has cast its spell on all those who have walked, jogged or cycled on its towpath, or boated sedately and serenely on its 35 miles of watery wonder.

As you travel through the bridges, locks and tunnels of the affectionally named 'Mon and Brec', its languid and leisurely atmosphere will cool even the hottest of hotheads. Its length and breadth are untouched by crass commercialism and the stress-inducing pace of modern life. As it makes its soft, slow and serpentine way through some of the most sublime scenery and views Monmouthshire has to offer you'll unwind quicker than a time-travelling clock. It's ironic that a man-made waterway tailor-made to meet the savage demands of the Industrial Revolution has since been transformed into a place of perfect peace and idle pleasure.

It was originally built in the late eighteeth century under the supervision of engineer Thomas Dadford as two separate canals: the Brecknock and Abergavenny Canal, and

A dog wonders where all the water in the canal's gone?

the Monmouthshire Canal. The two canals were eventually linked and today it runs from the Pontymoile Basin until the journey's end at Brecon's Dadford's Bridge.

The Great Western Railway eventually put pay to the canal's usefulness, and to the hard-nosed industrialists and iron-masters it became a mere afterthought to their ruthless brand of capitalism.

Yet over the years a lot of TLC and restoration have turned this former road of utility into a path to paradise. And today when you journey upon its long stretches of sweeping solitude and blessed silence, broken by the occasional birdsong and hail of a fellow traveller, it's hard to imagine the vast amount of coal iron and limestone that were once ferried up this industrial corridor.

The Mon and Brec is littered with sites of particular interest such as the Ashford Tunnel, Lanfoist Wharf, Goytre Wharf and bridges with such memorable names as Solomon's, Crown, Skew and Humphreys. It also passes through some of Monmouthshire's most enduring villages and a part of it lies within the Blaenavon World Heritage Site. All in all, it's well worth a cruise, a stroll or even a leisurely ride at any time of the year.

12. The Punchbowl – A Happy Hollow

The Blorenge mountain is home to many a rare delight, but perhaps the most delightful of all is the still and silent hollow of water and wonder that was carved into its north-east flank during the last Ice Age – known as the Punchbowl.

No matter by which manner you approach, be it the steep and stony descent flanked by the weird and striking contours of ancient beech trees or the gentle meander along the track, which cuts beneath the sheer face of the Blorenge like a sorcerer's serpent, the first time you lay eyes on this high and lonely haven of tranquility it will take your breath away.

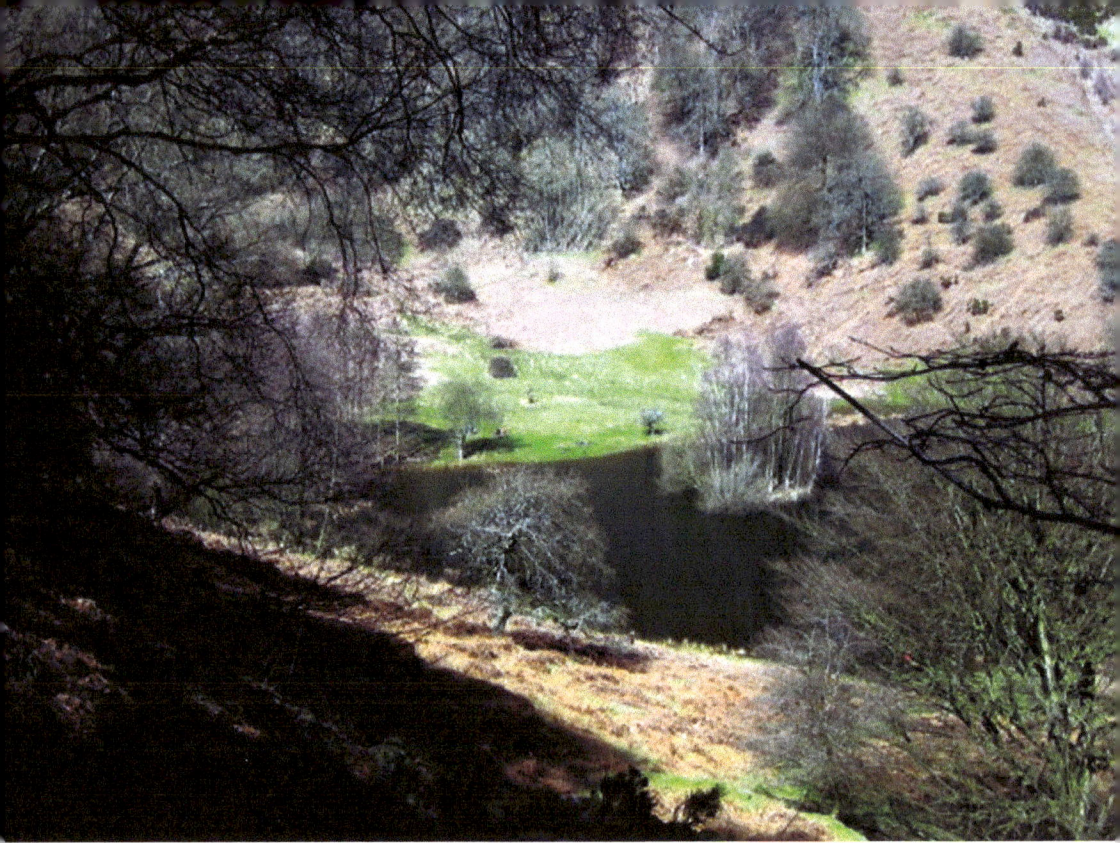

Above and below: A hidden place of magic and mystery.

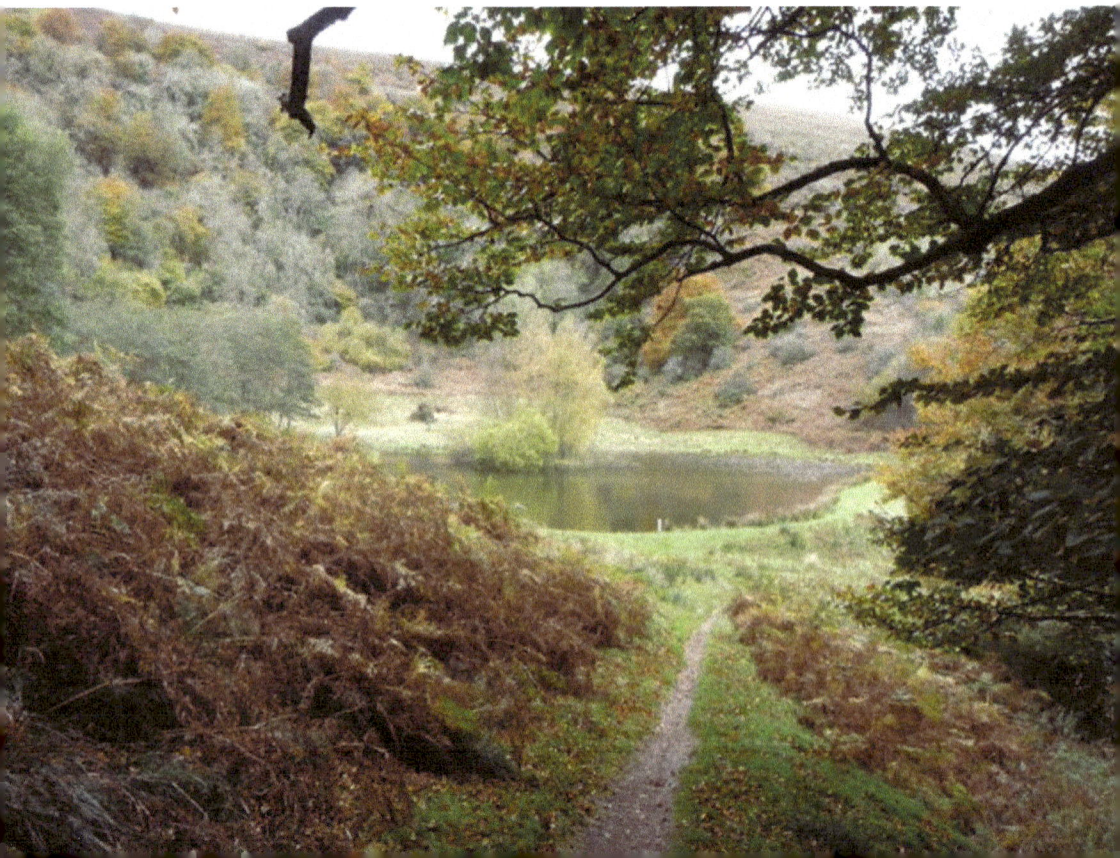

Few places in Monmouthshire are infused with the otherworldly atmosphere of the Punchbowl. It doesn't just feel old, it feels timeless in the way only certain things that cannot be governed by numbers, logic and our restless ambition to catch infinity in a bottle do.

In the Punchbowl's elusive environs you half expect to see a lady's hand rise from the water bearing the legendary swore Excalibur, or perhaps catch a rare glimpse of the elusive fey folk dancing like angels in sunbeams of red and gold.

The Punchbowl forms a natural amphitheatre. Its heavenly pool of tranquility acts as the focal point, and it is surrounded by an audience of towering trees that gang together on the steep wooded hillside in mute contemplation of the dramas that have unfolded on the shimmering surface below. One of these dramas being the highs, lows and brute savagery of illegal bare-knuckle boxing.

The Punchbowl was formerly a popular venue for a gentleman who wanted to slug it out for a purse, and it is one of history's little quirks that this sanctuary of silence got its name from a legacy of violence

In 1889 Nantyglo's David Rees and Brynmawr's William Williams went toe to toe and eyeball to eyeball in a bruising and bloody forty-two rounds, which lasted an hour and forty-two minutes. The prize? £10.

Yet in the half-light of dusk and dawn, when the shouts and shrieks of the mob are but a discordant chord in an otherwise sublime melody, a contemplative soul alone in the Punchbowl's perfect peace and restful quiet can feel as if the mysteries of the universe are but a heartbeat away. To quote Shakespeare, 'There are more things in heaven and earth, Horatio, Than are dreamt of in your philosophy.'

13. St Martin's Church – The Leaning Tower of Monmouthshire

The phrase 'crooked church' seems almost like blasphemy, but it certainly applies to St Martin's.

Standing in the shadow of the Skirrid, which is said to have caused the landslide that the church was built upon, St Martin's is unique in that no inch of it is square or at right angles with any other part.

Like Canterbury and Lichfield, it is an 'Agony Design'. Inside its strange and twisted interior, you'll notice the altar end was built at an angle from the main body to represent the broken body of the crucified Christ. The angle has been accentuated by further subsidence so both the west and east end have now begun to lean.

Nestled in the village of Cwmyoy, which translates as the 'valley of the yoke', St Martin's and its leaning tower must be a candidate for the strangest-looking church in Wales, if not the world.

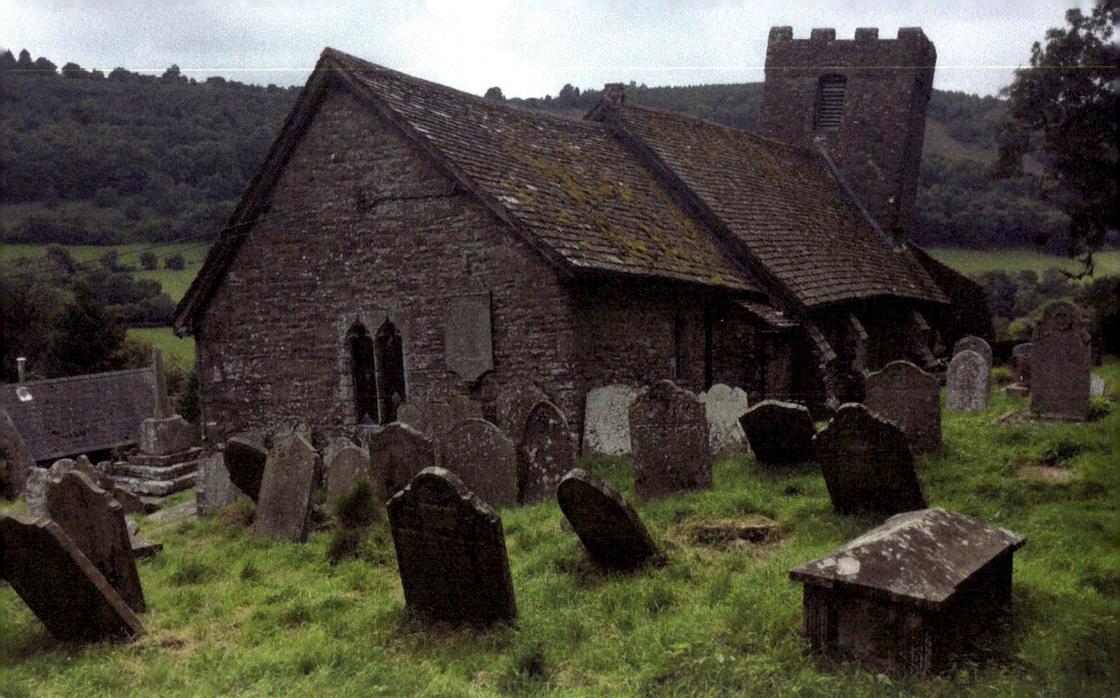

Previous vicars at the church have commented that their first sensation upon entering it was one of disorientation, as they lurch across the altar-like green-gilled sailors struggling to find their feet.

Built in the Middle Ages, the church is rich in history and visitors to St Martin's often return year after year and marvel at the fact that it is still standing. Yet like the faith it bears testament to, it may be weathered by the storms and bent out of shape by the ebbing and flowing of time, but its crooked stones and tower still stand and keep a lonely vigil for the sweet promise of the divine redemption and resurrection to come.

14. Church of St David – A Place for Pilgrims

If you're planning a trip to Llanthony Priory then make sure you stop to have a gander at the Church of St David, which is a stone's throw away from the main buildings.

Built on the earlier site of the monastic cell of St David, this ancient and holy site has been a magnet for pilgrims across the centuries.

One of the Romans' most enduring legacies to ancient Britain was their Christianity. Long after they left many Celts continued to worship Christ. When the pagan Saxons pushed the Celts back into Wales and to the north, it is said that the solitary and hermit-like figure of St David lived on this site in a cell and enjoyed a life of quiet contemplation and silent prayer.

The current church is thought to have been built by William de Lacy and consecrated in 1108. Since its Victorian restoration in 1893, it has remained largely

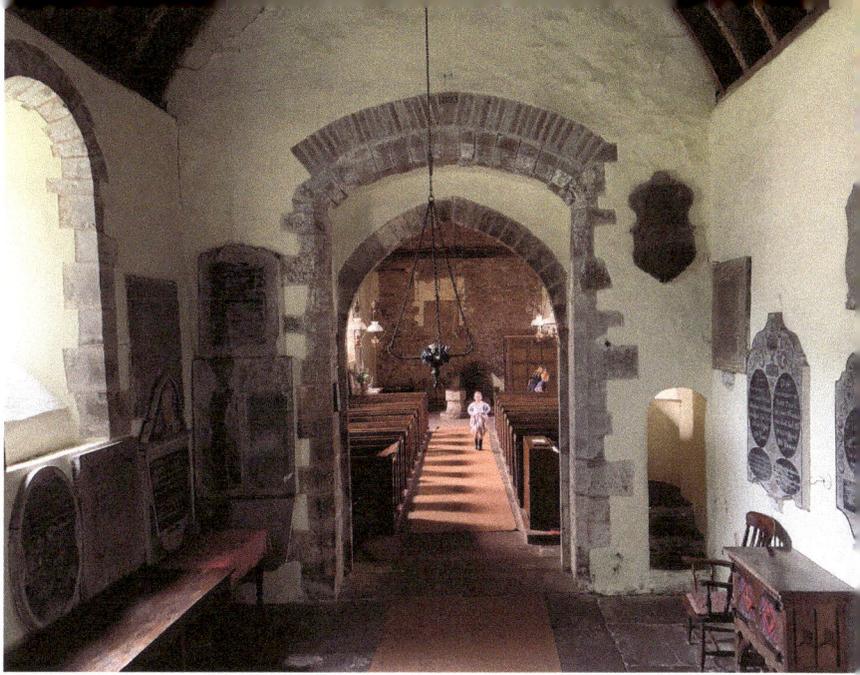

unchanged. On a midsummer's day, its historic and intriguing interior is the perfect
place to escape the crowds who flock to Llantnony Priory. On such occasions it
serves as a blessed sanctuary where a soul can find some sweet relief in its shelter of
cold stone and calming atmosphere of reflection.

15. Raglan Castle – A Silhouette in Stone

Led Zeppelin fans may recognise Raglan Castle from the concert movie *The Song
Remains the Same*. It features in the scene where Robert Plant, in full Arthurian
regalia, battles a foe before throwing them in a moat.

It's not hard to see why the legendary rockers were attracted to what in essence
is a grand fortress-palace. With its breathtaking symmetry and appearance of regal
grandeur, this bastion of stone looks like a set piece off *Lord of the Rings*. Except
Raglan Castle, which was designed to both impress and intimidate, has a very real,
rich and colourful history that could rival any Tolkien saga.

The site was probably established as a motte-and-bailey castle in the late eleventh
century when the Normans conquered Gwent, but the glorious building that
dominates the surrounding countryside was initiated by the 'blue knight of Gwent' –
Sir William ap Thomas.

The castle's famous moated Great Tower was a real labour of love for Thomas,
but after his death in 1445 his son William Herbert picked up the reins and really
went to town on a building project that was both lavish and ambitious.

The veteran of the French wars, who made his fortune importing Gascony
wine and played a pivotal role in defeating Lancastrian forces during the

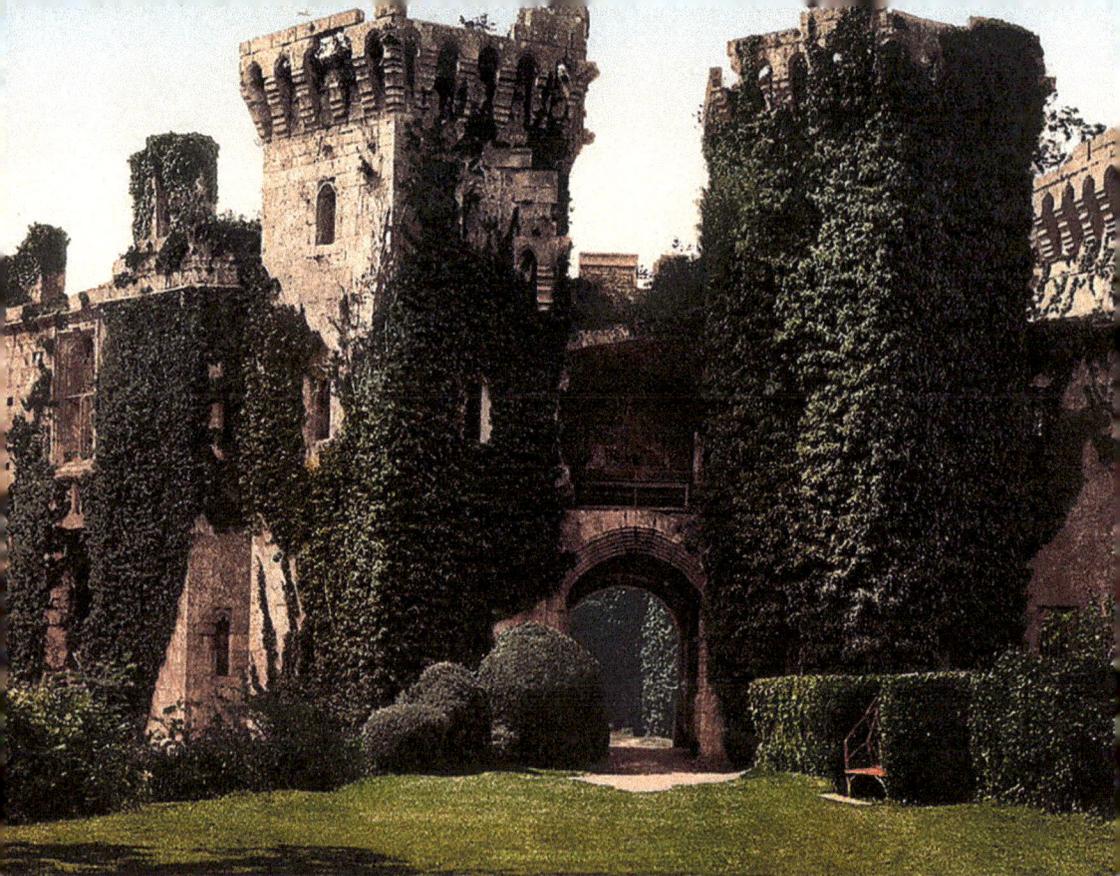

The power and the glory.

Wars of the Roses, was considered the most powerful Welshman of his era. Obviously Herbert wanted a residence to reflect this and, as you can still see today, Raglan Castle certainly ticks all the boxes.

On Sir William's watch the Fountain Court, Pitched Stone Court and the remarkable machicolated gatehouse were built, and the castle earned the praise of poet Dafydd Llwyd who celebrated its 'hundred rooms filled with festive fare, its hundred chimneys for men of high degree'.

Edward IV even sent the future Henry VII to Raglan to be brought up under the tutelage of his firm favourite, Sir William. Unfortunately for Sir William his ultimate vision for Raglan went unrealised when he suffered defeat at the Battle of Edgecote in 1469 and was brutally beheaded. His body was buried in the grounds of Tintern Abbey and the story of Raglan Castle turned a page when it passed into the hands of the Somersets, earls of Worcester.

In their velvet-gloved care it was transformed into an exquisite Elizabethan country house surrounded by luxurious and landscaped Renaissance gardens with long walled terraces and a lake.

Such was the Somersets' appetite for expensive opulence, the moat walk was once adorned with statues of Roman emperors; however, statues fall in the same way as empires, and all that remains today is empty spaces where sculptured marble once delighted the lords and ladies of the manor .

As for the Somersets, all their fancy finery and frolics were brought to an abrupt end in 1642 when Civil War broke out and the 5th Earl of Worcester declared for the Royalist cause.

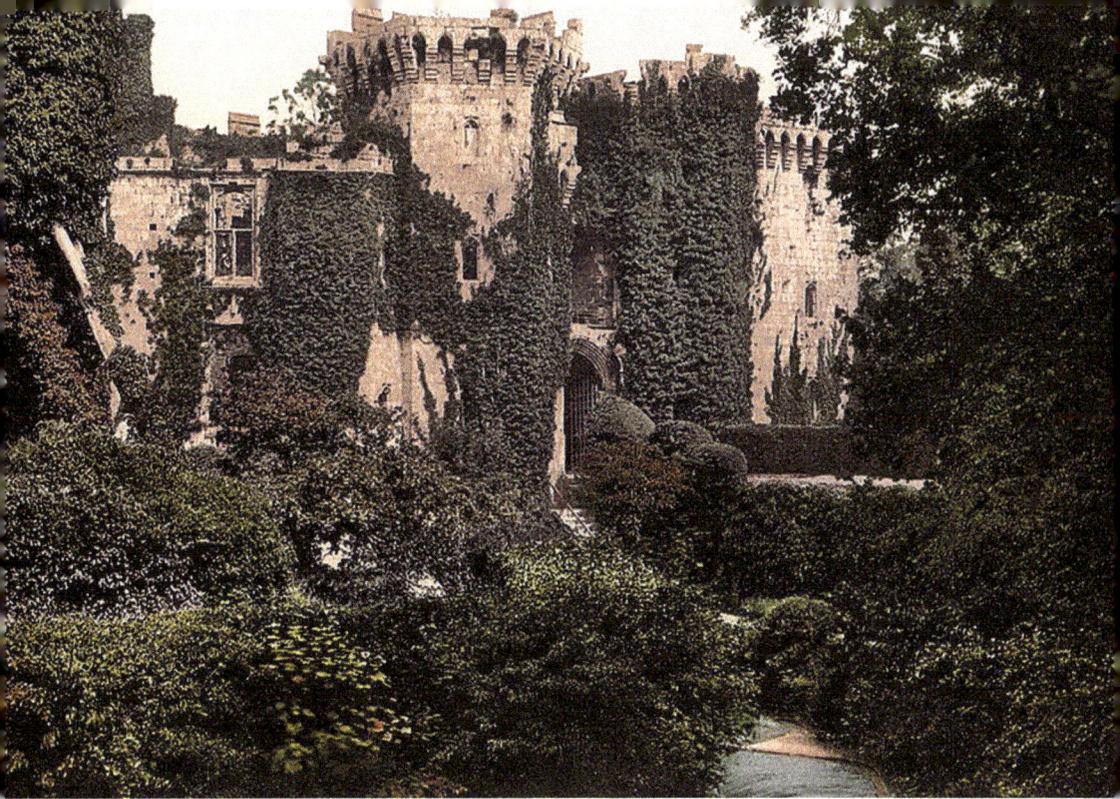

Above: Raglan Castle.

Below: A birds-eye view.

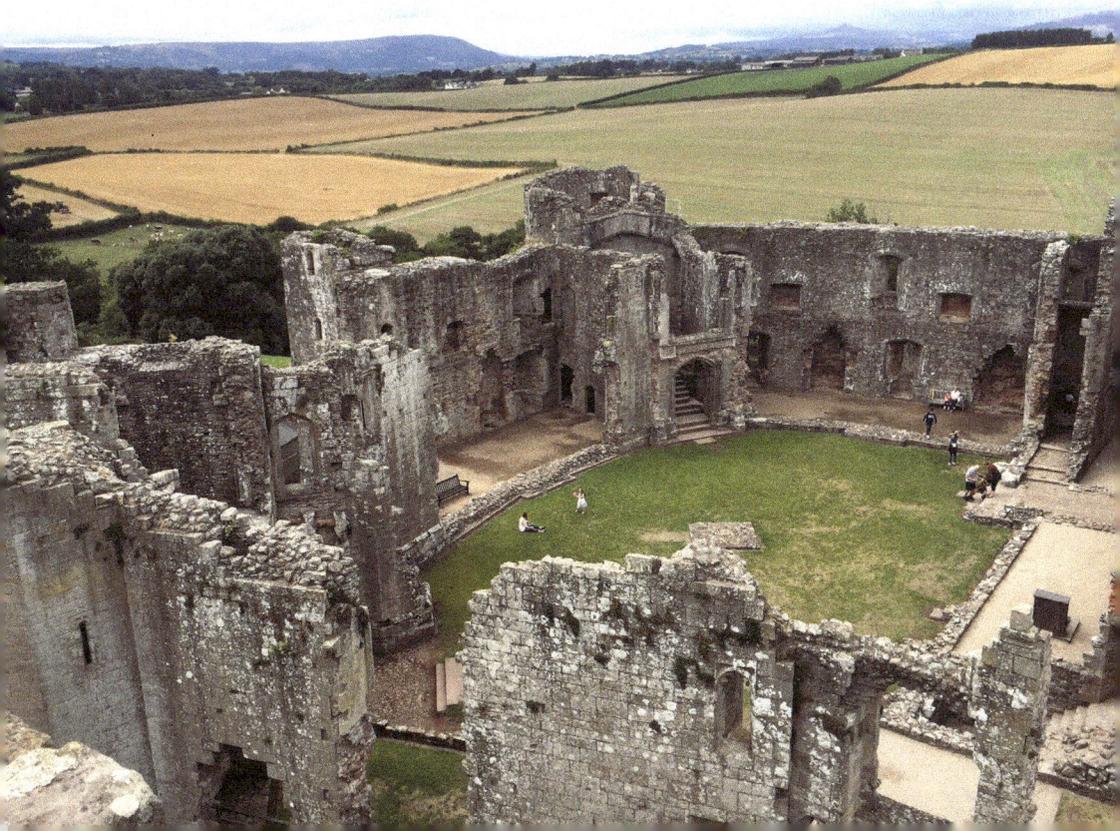

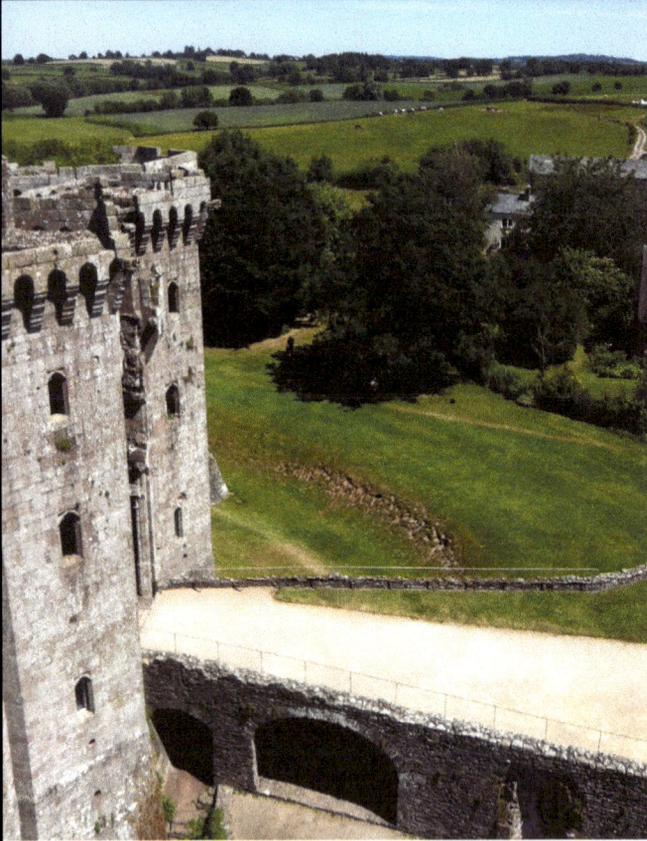

Left: Guarded and great.

Below: A puzzling picture from within the castle's walls.

Four years later the castle couldn't survive ten weeks of siege by Sir Thomas Fairfax and his Parliamentarian troops. As Cromwell's Roundheads moved in, so too did a harsh, unforgiving and utilitarian mindset. A campaign of deliberate destruction began and much that had been so lovingly created over centuries was destroyed in a matter of days. Fortunately, much of what once was still remains, and visitors to this special spot can walk in the footsteps of history and get a real feel for the drama and days of a bygone age.

16. The River Usk – A Kingdom of Fishes

The River Usk, or as it's know in Welsh, Afon Wysg, flows through a large stretch of Monmouthshire like a thing of shimmering beauty, before it ends up in Newport and discharges itself into the Severn Estuary. And like most things that end up in that old port town, it always looks slightly soiled and a little the worse for wear after leaving leafy Monmouthshire for industrial Newport.

The Usk is a Site of Special Scientific Interest, home to a diverse range of flora and fauna. Take a jaunt alongside its banks or a paddle in its delightful depths, and among the flotsam and jetsam strewn casually around by modern society, you'll have a good chance of bumping into otters, kingfishers, herons, red kites, twait shads, lamprey, common roaches and, of course, Atlantic salmon.

The broad and majestic Afon Wysg.

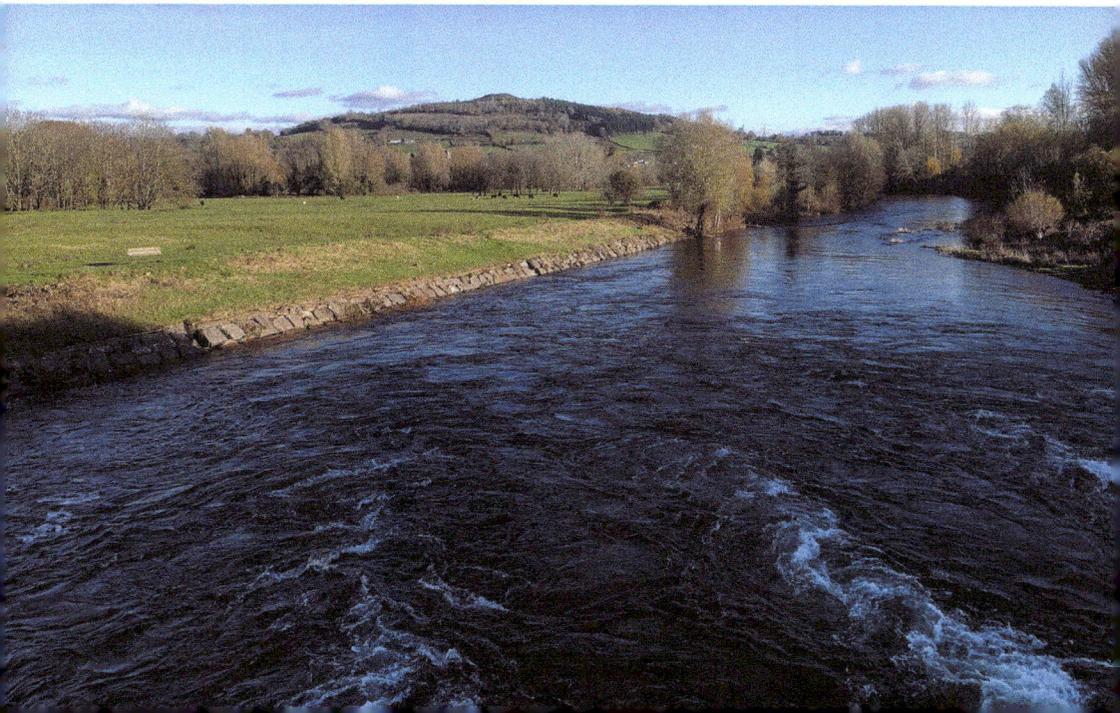

In the Common Brittonic tongue, the Usk translates as 'abounding in fish'. And, of course, among the fly-fishing community, the Usk has long been famed for the quality and quantity of its salmon.

Rivers are majestic things. They are in a state of perpetual motion but are a source of great calm and stillness. Like time itself, a river never stands still, and in such waters as the Usk a soul can find solace in a thing of beauty that flows down the years and through the centuries like a world without end and a gift without equal.

17. Goytre Wharf – An Industrial Beauty Spot

If history really floats your boat then when not combine your two passions and take a trip to Goytre Wharf.

On a fine autumn morning with the mist rising off the water and the November nakedness of the surrounding trees casting striking silhouettes in the pale sunlight, there's something intoxicating about this little patch where water meets woodland.

Since its restoration in the 2000s Goytre Wharf has proved a popular Monmouthshire destination. There's day boat-hire facility, a café, a picnic area, fishing spots and forest trails to roam in.

There's also a lot of history here. Goytre Wharf is also home to some of the best-preserved limekilns in the world, and these stone structures to industrial strength, ambition and tenacity remain an intriguing reminder of how the Mon and Brec Canal's purpose has changed over the last 200 years from torrid toil to languid leisure.

A day's boating awaits.

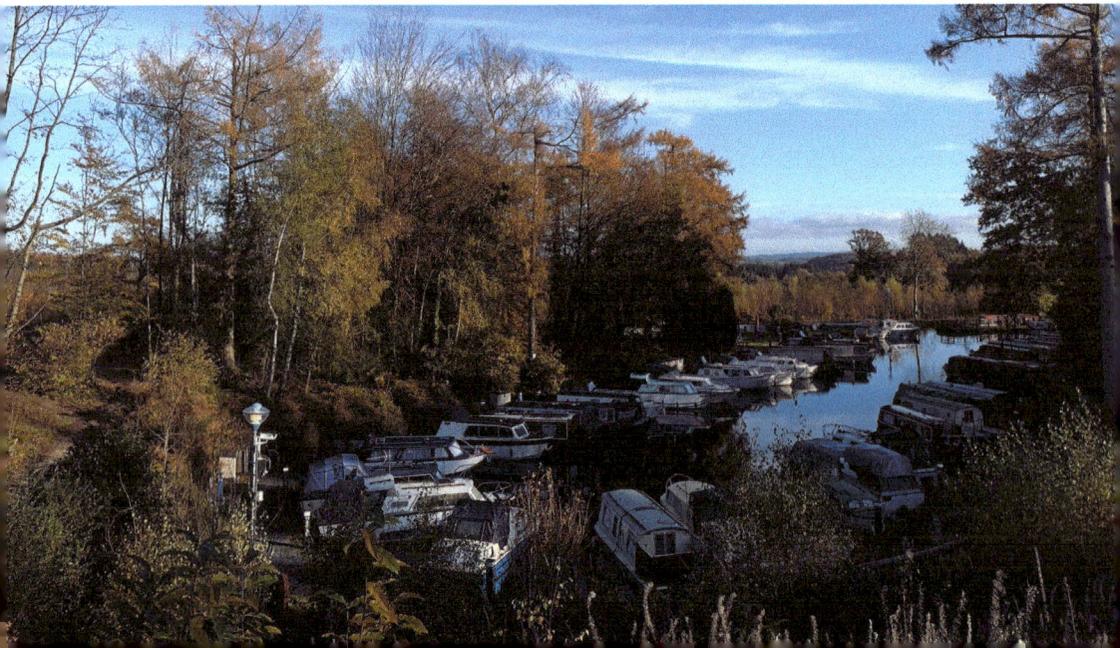

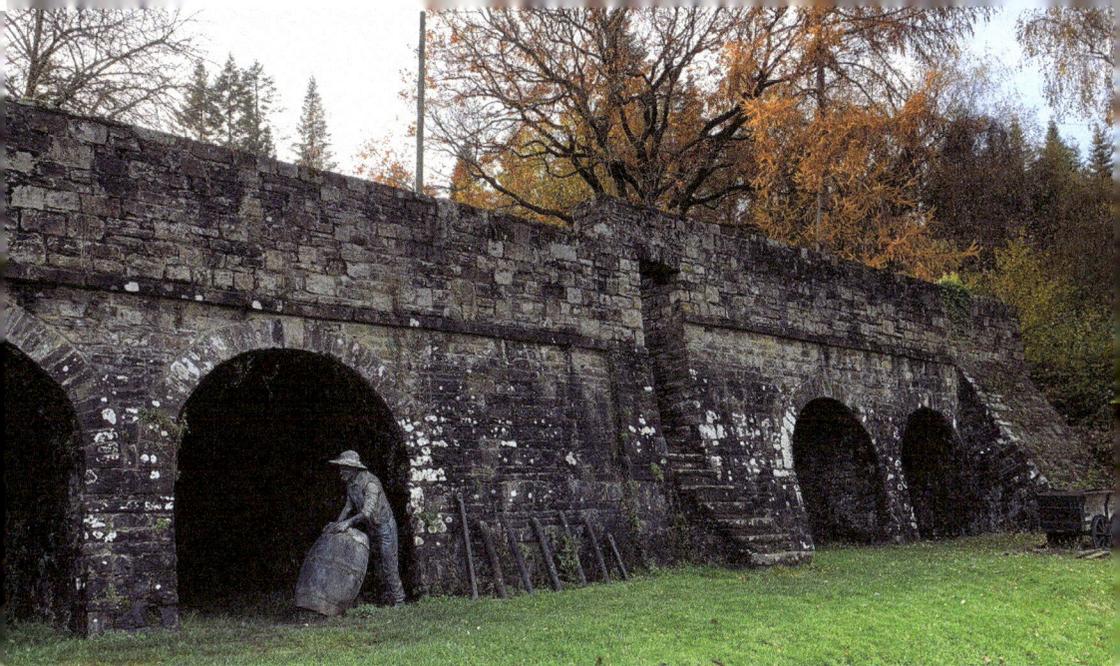

The industrial past.

18. Harold's Stones – A Giant's Legacy

From out of the murk and mist of the centuries, prehistoric mysteries such as Stonehenge and many lesser-known British standing stones and circles have reached out and awakened in many a curious spirit that has stood in their presence something of the timeless allure of the unknown.

Where did these megalithic monuments originate, for what purpose did they serve, why were they situated in such specific locations and why were they revered so much by our ancestors? These are just a few of the questions that an individual is faced with when confronted by these towering testaments to a forgotten age.

Maybe it's something in the blood, but even in modern times we still share a strange desire to mark both occasions and characters who have managed to catch the fickle eye of history with the erection of standing stones. Two cases in point would be the Aneurin Bevan memorial stones in Tredegar, and the Gorsedd stones in Abergavenny's Swan Meadows.

The Monmouthshire village of Trellech takes its name (tri = three, llech = flat stone) from what has become known as Harold's Stones. There three towering stones stand in a field just off the Monmouth to Chepstow road and just south of Trellech village. Legend has it that they were first erected by the last Saxon king – Harold – to celebrate his 1063 victory over the Britons. Of course, this is absolute hogwash. The stones stood many centuries before Harold was born, just like they have stood in centuries following his slow and agonizing death at the Battle of Hastings from a Norman arrow in the eye.

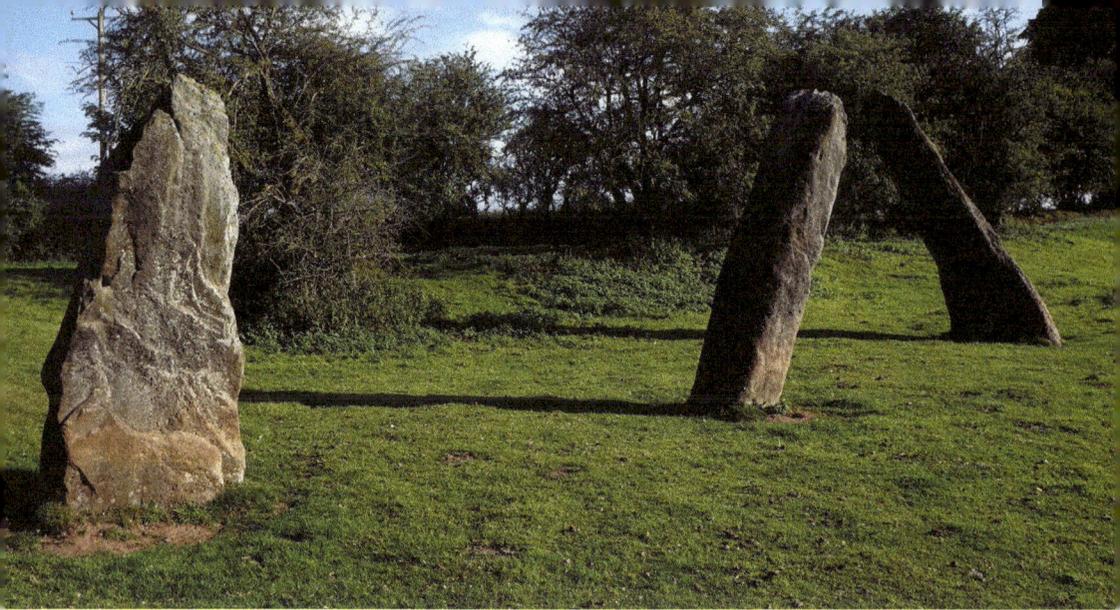

So from whence do these stones come? No one knows for sure, but there is a legend that they mark the spot where three Celtic chieftains fell when battling Roman forces led by, you guessed it, a man called Harold who was the scourge of the Gwent tribes.

Another popular legend suggests they were thrown by the mythical giant Jack O' Kent from the top of the Skirrid Fawr while he was dueling with the Devil.

Intriguingly, there was once a fourth stone, and some have speculated the three stones could be the remains of a much larger circle.

A sundial featuring a likeness of the stones was carved in 1689. It is now kept under lock and key at Trellech's St Nicholas Church. The sundial also has the Latin inscriptions 'MAIOR SAXIS' (greater because of the stones) and 'HIC FUIT VICTOR HARALDUS' (here Harold was victorious).

We'll never know the true significance, meaning and purpose of the stones, but when you stand in the presence of the ancient world and walk in the footsteps of giants, Rudyard Kipling's 'six honest serving-men' are rendered somewhat obsolete. The what, why, when, how, where and who has no business here. Just to know such things as Harold's Stones still exist in an era governed by reason and not rhyme, is more than enough.

19. Chepstow Racecourse – Horses for Courses

Punters have been hedging their bets and experiencing the high highs of winning and low lows of losing at Chepstow Racecourse since 1925. It's a perfect place to watch the thrills and spills of the 'Sport of Kings' and have a flutter on the gee-gees as they pound around the track.

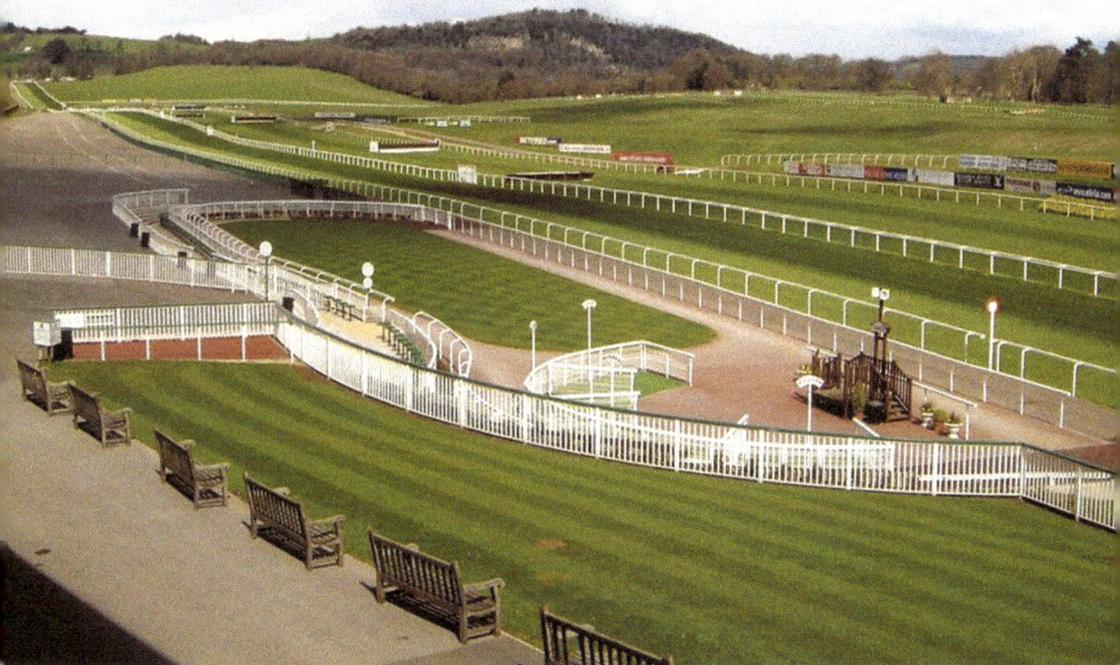

As home to Wales's most prestigious race meeting, the Coral Welsh Grand National Chepstow is a popular place to have a day out if you're looking for something slightly sporty to do in Monmouthshire.

Its 400 acres of parkland is home to thirty-two annual meets and includes both flat and jump racing. The track itself is an oval circuit just shy of 2 miles.

Chepstow Racecourse is one of only three in Wales – the other two being at Bangor-on-Dee and Ffos Las. During the upheaval of the Second World War Chepstow Racecourse briefly became RAF Chepstow and provided accommodation for bombers and a grass runway. Today it is once again a home for horses to churn the turf, and for visitors looking to experience a day at the races.

20. The Savoy Theatre – The Great Entertainer

What better way to end a day at the races than with a night at the theatre? And if you want to experience the glitz and glamor of an old-fashioned stage with plenty of character, history and atmosphere, then look no further than Monmouth's Savoy Theatre.

It's Wales's oldest theatrical site, don't you know. And the Grade II listed building's velvet and intimate interior is just the ticket for a touch of the old let's dress up and play pretend.

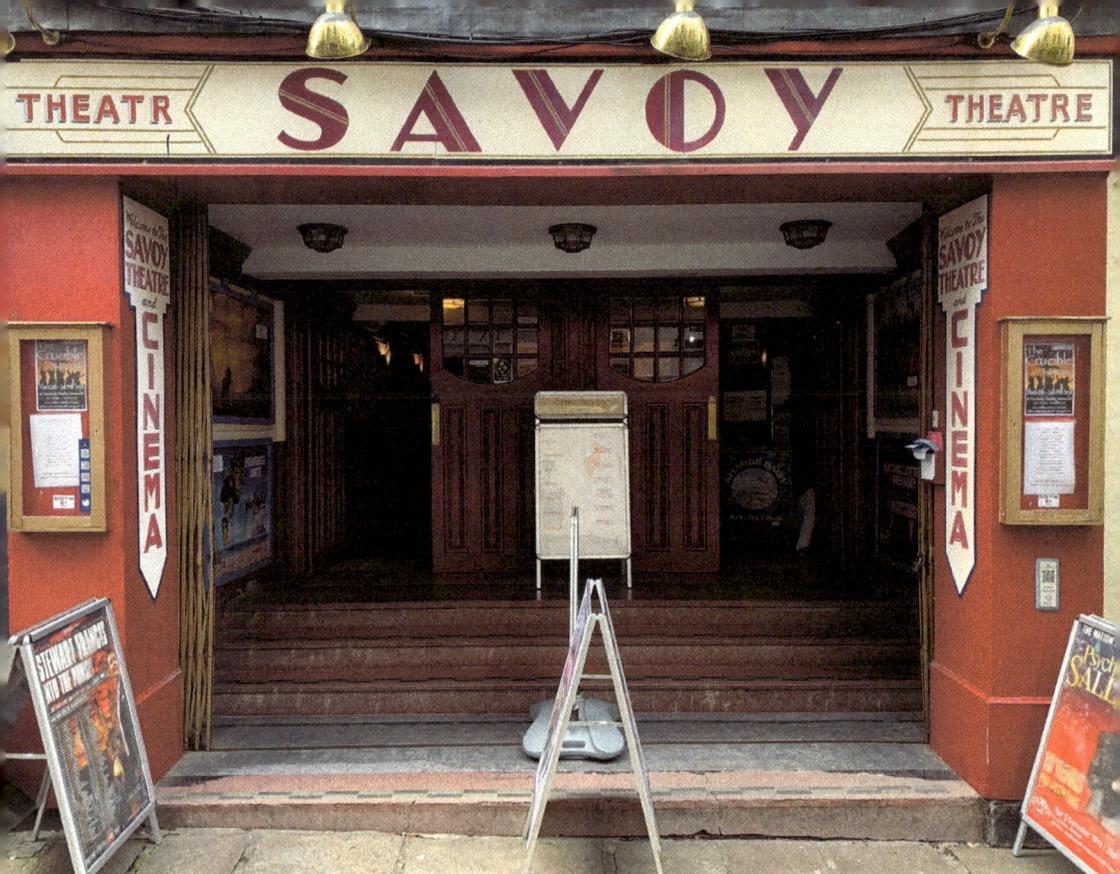

A night at the theatre.

Granted an entertainment license in 1832, the Savoy, which originally went by the catchy title of the Assembly Rooms before adopting the moniker the Theatre Royal has been putting on shows and keeping the masses amused in one shape or other beyond living memory.

A pub called the Bell Inn originally stood on this spot, and the Savoy was also briefly a roller-skating rink before it had a facelift and change of use in 1910 and reopened as Monmouth's first cinema – the Living Picture Palace and Rinkeries. A name that, I'm sure you'll agree, beats 'Vue' hands down.

The Savoy was named at various times the Palace, the Scala and the Regent, and in 1928 it changed its name to the The New Picture House' and showed the first talkies in the town.

It closed as a cinema in the late 1960s and reopened as bingo house before the two fat ladies and legs eleven also went the way of the dodo, and it closed its doors again in 1983. Since the 1990s the Savoy has operated as both a cinema and a theatre, and you can see a mixed programme of both mediums on any given week.

If you visit the old place look carefully at the black mark next to one of the chandeliers on the ceiling. Local legend said that it was made by a woman falling through the ceiling.

Even before you flee the madness of the street and set foot in its dimly lit and welcoming lobby leading towards the elaborate gilded plasterwork, glass chandeliers and mysterious red curtains beyond, one look at the exterior of the Savoy will convince you that they just don't make venues like this anymore.

21. The Blorenge – An Iron Mountain

Presence is that most elusive and undeniable quantity. You've either got it or you haven't. And the Blorenge has got it in a big way. The mountain stands imperial with the villages of Llanfoist and Govilon at its feet. It possesses a brooding and magnetic quality that captures the eye and spirit and implores the curious soul to climb its 1,841 feet and explore its myriad charms.

If there's one hill that appears to watch over the nearby town of Abergavenny like a sentient and kindly guardian, it's the Blorenge. Shaped like the throne of some giant king who's long gone wandering, the Blorenge carries many a scar from the Industrial Revolution, but the tram roads have now become popular walkways for those who want to experience the might and majesty of this grand old eminence.

The Blorenge bestows upon all those who walk in its shadow a comforting sense of tranquil wonder. To walk up the near-vertical face of this imperial mount is an arduous task, but well worth it. Large swathes of Monmouthshire stretch out beneath its fierce elevation like a toy town and, with lungs full of burn and legs full of lead, the open-minded hillwalker is left with new and startling perspectives on the transitory nature of history and the eternal fortitude of nature.

The Blorenge brooding in the background.

The striking symmetry of the Blorenge was born during the Ice Age, and a walk on its fair flanks will reveal among other things the site of a Second World War bunker; the grave of Sir Harry Llewellyn's famous Olympic-winning horse, Foxhunter; and on a fine day you'll find many a multicoloured paraglider throwing themselves off the top of the Blorenge in sheer unbounded joy.

Interestingly, Blorenge is the only word in the English language to rhyme with orange, and the mountain's name is thought to be derived from the Welsh word for pimple – 'plor'.

The breathtaking beauty of the mountain also inspired Cecil Frances Humphreys Alexander to write her world-famous hymn 'All Things Bright and Beautiful' when she was staying in Govilon. The fourth verse, 'The purple-headed mountain, the river running by', is a direct reference to the Blorenge and the nearby River Usk.

Leaving the Blorenge to re-enter civilization, a soul is always filled with a strange sense of loss for something elusive, which was briefly reawakened in the modern mind on those euphoric and ancient heights.

The Blorenge is a fine mountain to experience in any season, but perhaps it is most spectacular when its technicolour reds and golds are shrouded in autumnal mists and the fresh bite of the turning air and twilight's glow conspire to paint its glory on the most apt canvas.

22. Hen Gwrt Moated Site – A Vanished Manor

Somethings are defined by their absence, and the Hen Gwrt Moated site is definitely one of them. On a site where there was once a medieval manor, all that now remains is a square-sided moat. Yet this little patch of land is still well worth a visit as a stark reminder of how empty fields and secluded spots often have a telling tale to tell.

The story of Hen Gwrt in Llantilio Crossenny begins in the thirteenth century. The parish was once divvied up between the kings and the bishops of Llandaff. The holy men ruled the roost from their timber-framed thirteenth-century manor house of Hen Gwrt, which translates as 'Old Court'. The moat appeared in the fourteenth century and the site subsequently fell into the hands of the Herberts of Raglan Castle who reconstructed it as stone hunting lodge centered within one of their deer parks.

The surrender and slighting of Raglan Castle during the English Civil War spelled the end of Hen Gwrt and it was completely destroyed.

There is a story that Hen Gwrt was also the home of Owain Glyndŵr's legendary opponent Dafydd Gam. Yet there is no tangible evidence to support this.

Still, to visit Hen Gwrt today and cross the little footbridge, which leads to that long-abandoned island flanked on all sides by an ancient moat, is to stand and wonder how different the world of today will be thousands of years from now, and how in the end both deeds and substance and flesh and fact are often little more than the stuff over which the grass grows.

23. Chepstow Bridge – Bridging the Gap

Chepstow Bridge, sometimes known as the Old Wye Bridge, is a charming little construction. It opened on 24 July 1816 and, as is only fitting for the world's largest iron arch road bridge from the first fifty years (1780–1830) of iron and steel construction, it has stood the test of time and remains in fine fettle.

Built by engineer John Urpeth Rastrick, who was inspired by the work of Thomas Telford, this ancient Grade I listed landmark replaced a ten-arch wooden bridge that had stood for centuries.

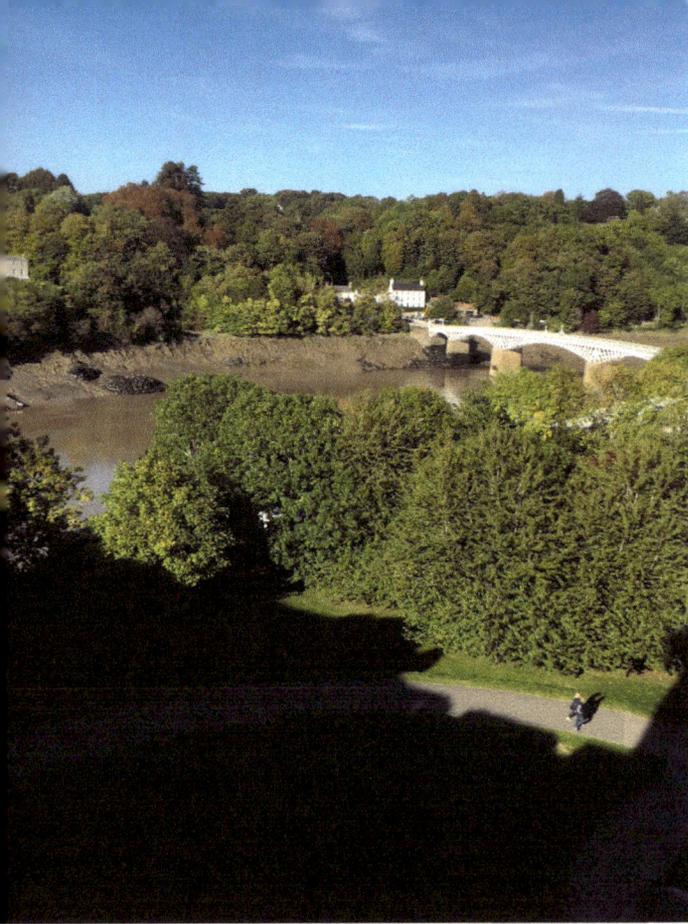

It was once a vital passage from Wales to the West Country, until the first Severn Bridge was hung suspended and took pride of place in 1966. Out of the five-arch road bridges built before 1830, only Chepstow has survived. For over 200 years this structure has bridged the gap between two lands and two communities – Monmouthshire and Gloucestershire.

To stand in the middle of the bridge with the tides of the Wye bubbling furiously beneath your feet is to stand in a gap between two counties and two countries. And it's always a novel idea to walk its span and regale others with the time you walked from Wales to England and back in a matter of minutes.

24. Clydach Gorge – A Fey Place

In the years before Clydach Gorge was raped and ravaged by the industrialists, many believe a certain young man who would go on to change the world was so seduced and enraptured by its natural beauty and mystical otherness, he decided to immortalise it and its peculiar inhabitants in verse. The man was William Shakespeare and the play was *A Midsummer Night's Dream*.

Visitors to the gorge today cannot help but notice its ironworks, limeworks, quarries, railroads, tramroads and great bridges. They linger in the sprawling landscape like relics of some brutal alien civilization. Their mute abandonment serves as a stark reminder of how all endeavour, innovation and industry will all one day be rendered obsolete by nature and time. Like in Shakespeare's day, it is now the waterfalls, caves, ancient woodland and the unspoiled and untamed sense of that which is hidden and unknown that brings people to the gorge.

In the English tongue they call them the 'Fair Folk', but in the Land of our Fathers they are known as the Tylwyth Teg. The Tylwyth Teg live underground or in water and in Wales. Their number is said to be great, especially in the area of the Clydach Gorge where Devil's Bridge, Puck's Valley and Shakespeare's Cave await the intrepid adventurers wishing to immerse themselves in this curious and atmospheric area far removed from the tyranny of time.

A soul alone in the Gorge, among its cascading waterfalls, towering trees and eerie silence, can well imagine how the young bard took inspiration from such a setting. Could the Puck of *A Midsummer Night's Dream* be based upon the shapeshifting 'Pwca', who was said to terrorise those unwary and unwise enough to cross their path when walking in the Gorge? Were things revealed to Shakespeare's eye in this

A Shakespearian-sized influence?

Above: Unspoilt and untamed.

Below: Carrying the scars of another age.

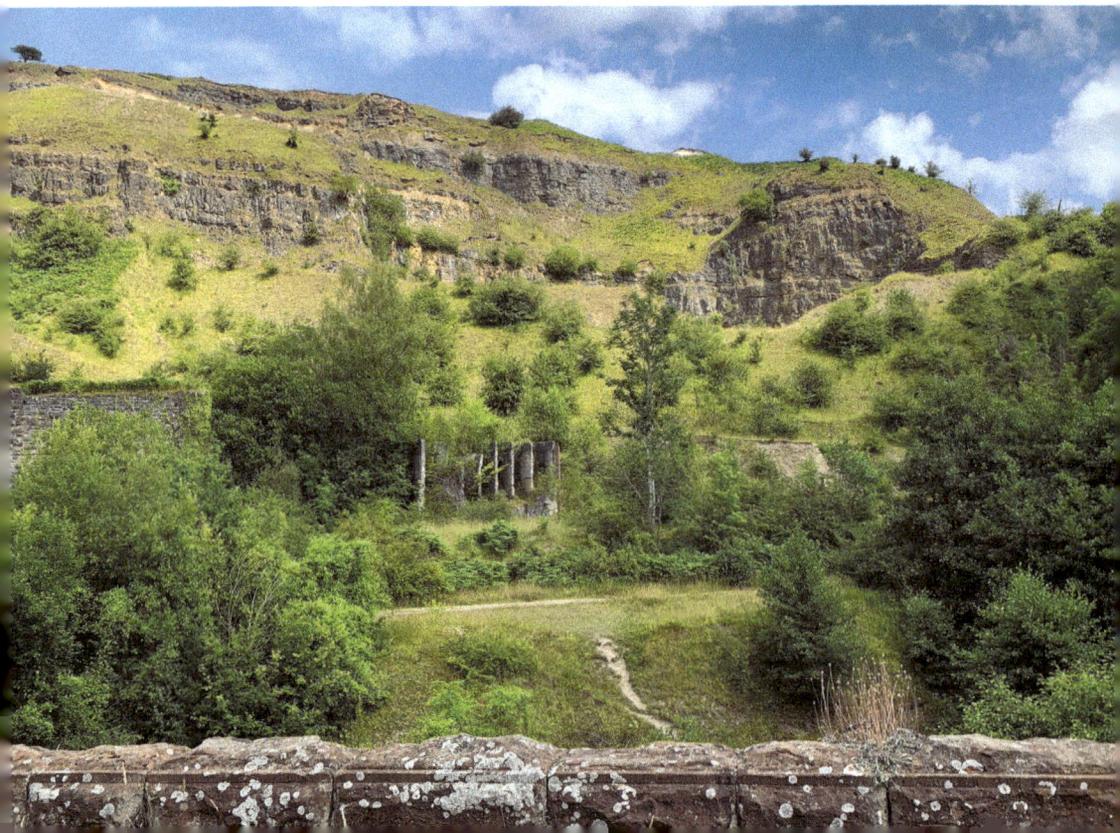

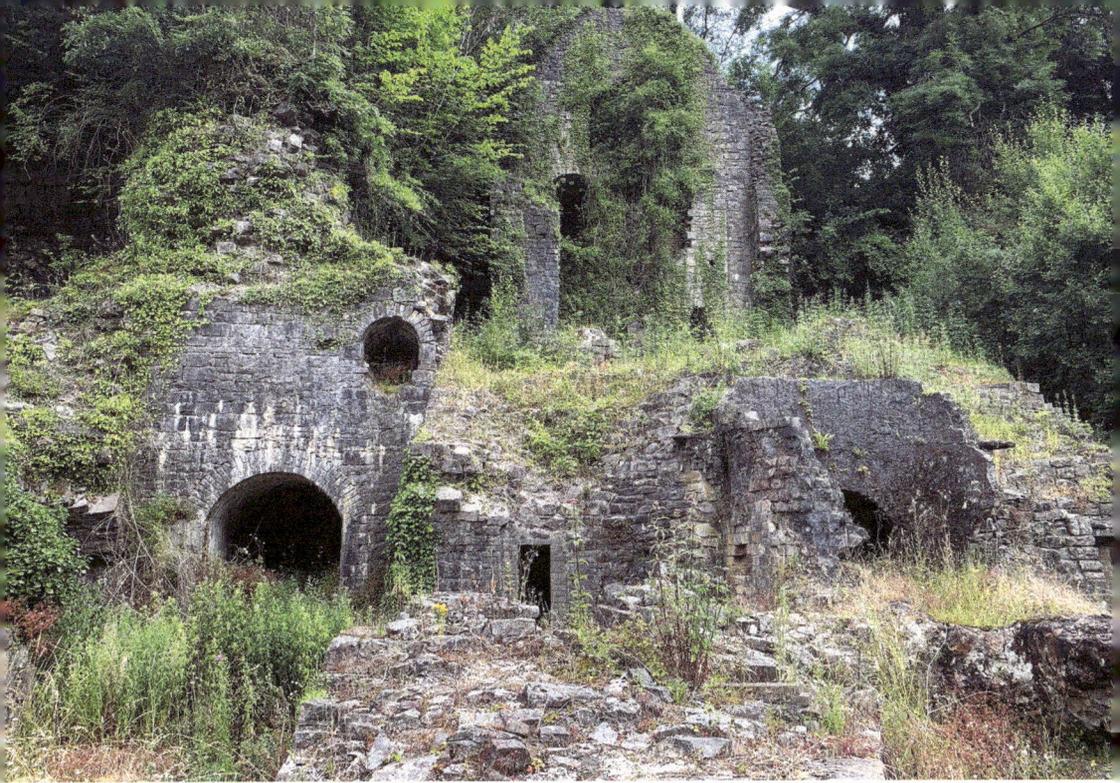

high and lonely place that no imagination, no matter how nuanced and spritely, could conjure? And then there are the ironworks. Staring accusingly out of the landscape like a wronged giant, how many futures did it blight and lives did it claim when its roar filled the valley and cast a shadow that threatened to blot out the sun.

The Gorge is a place of contrasts, of darkness and light, a place that carries its scars like an old soldier, but above all it is a place that once visited lives long in the imagination.

25. Keeper's Pond – A Beauty on the Borderline

Sometimes it's not until you're on the outside looking in that you can truly appreciate a thing. And for any soul who has been captivated by the curious charm of Monmouthshire, then there's nothing quite like walking up the tumble from Blaenavon and that sweet moment when the Abergavenny road levels out, and the weary traveller catches a breathtaking eyeful of the Usk Valley in all its panoramic and technicolour glory.

Anyone with a living heart can't help but feel its quickened beat and their spirit soar with joy as they gaze upon the regal sweep of the Sugar Loaf and the Black

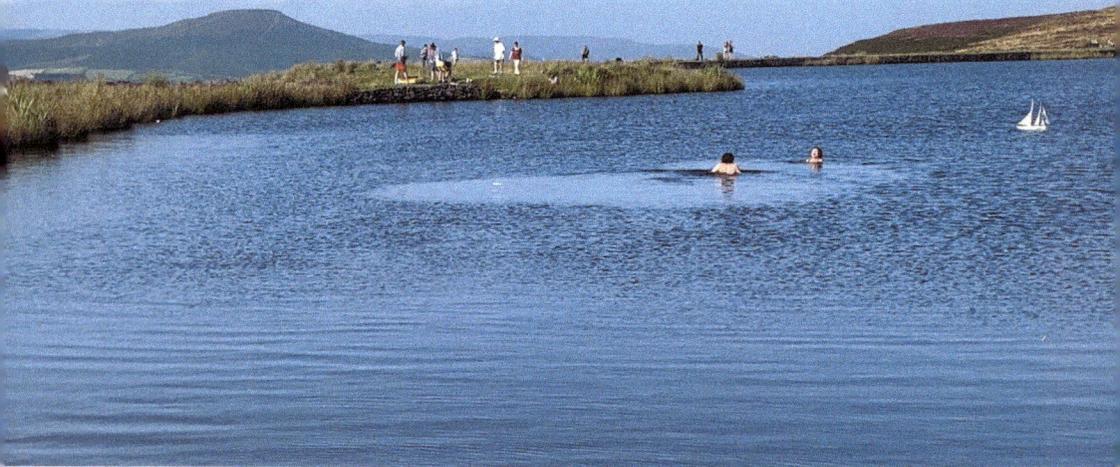

A high place to free swim.

Mountains in all their aloof splendour. Like silent sentries, these ancient and weathered shapes stand stoically guarding the land of milk and honey from the industrial ravages that laid waste to the naked and scarred hills of nearby Blaenavon.

And as you cross from one county to another you'll notice a brooding expanse of water to your right, which lies on the borderline a staggering 475 metres above sea level. It's called the Pen-Ffordd-Goch Pond, but locals know it better as the Keeper's.

Like a geographical nomad it stands on the border between Monmouthshire and Torfaen, and from its vantage point you can see the Usk Valley in the one direction, and in the other the brooding backdrop of the guarded and watchful Coity mountain and the Severn Estuary beyond.

The Keeper's Pond is within the Blaenavon World Heritage Site and was purpose built in the early nineteenth century. Its job was to provide water to the nearby Garnddyrys Forge. When the forge came to the end of its shelf life during the 1860s, the Keeper's brief spell as a mere utility for the masters of the Industrial Revolution

Wild horses love the Keepers too.

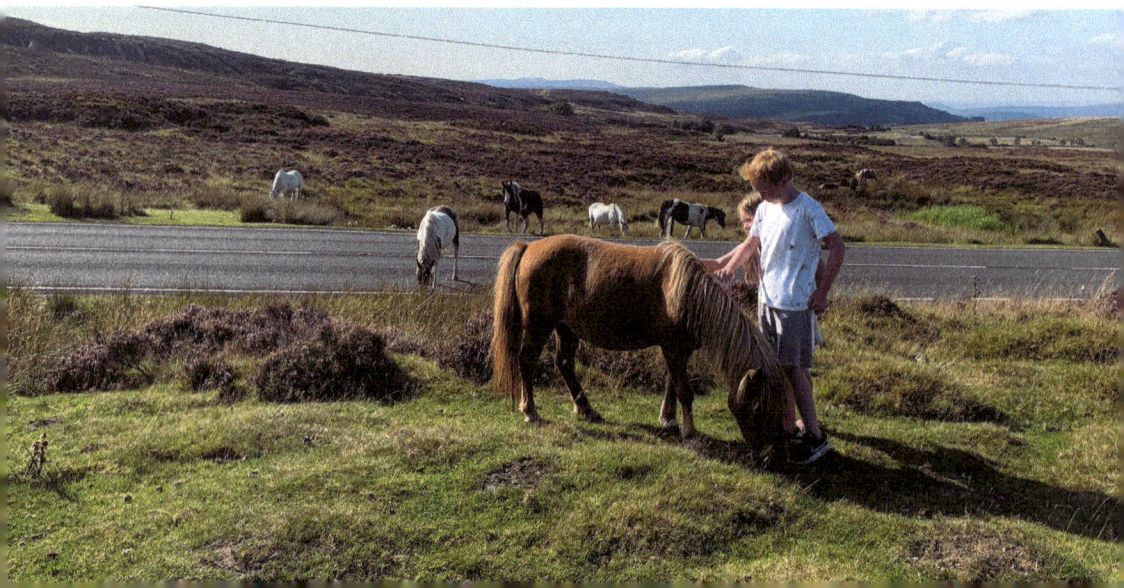

was over. It was reborn as a thing of beauty and a joy forever. An infinite pool of mystery for visitors and natives alike to enjoy from dawn to dusk in the transforming twilight, and for more adventurous and nocturnal-prone souls in the hushed still of night when the moon is sovereign and mystery holds sway.

Regardless of what time you visit, the pond has become a hugely popular picturesque spot for picnics, ramblers, curious horses and for pursuers of that most modern phenomenon – wild swimming. It's the perfect starting point for a wander to the top of Blorenge mountain and to take in all the tramways and tunnels that once transformed this area into an infernal hive of activity.

And if you're wondering how the Keeper's got its distinctive name, it was because the gamekeeper who used to patrol the surrounding grouse moors lived in a little nearby cottage. So now you know.

26. Caerwent Roman Town – Market of the Silures

Before the Normans and Saxons took their turns in conquering Wales, there were the Romans. The first imperial invasion took place in AD 48, and military occupation was almost complete by AD 78.

The hordes from the Eternal City abandoned the region in AD 383 and among many other notable things they left behind was Venta Silurum, also known as Caerwent. Today it is a quiet village bypassed by the A48, but it was once the capital of the Silures.

As a powerful and warlike tribe of Celts, the Silures initially proved more than a match for the Romans, who they crushed in a memorable victory in AD 52. Yet, due to their sheer force of numbers and unrelenting enthusiasm for empire building, the Romans eventually forced the Silures to surrender and set about building Caerwent in their image.

Once renowned as a miniature version of Rome, Caerwent had all the usual trappings of Roman civilization such as temples, baths, houses, shops, a civic hall and an impressive marketplace.

Today a walk around the ruins of what has been described as the first true town in Wales merely hints at its former glory, but nevertheless it still boasts the best-preserved Roman town walls in Britain, and with a bit of imagination you can really get a feel for what such sites as the old temple must have once looked like. It is always intriguing to walk in such abandoned sites and recall the drama, dreams, desires and deaths that must have once unfolded here.

The ambition and empire of the Romans may long have crumbled to dust, but their influence and legacy live on in the arenas of politics, philosophy, sports and in such sites as Caerwent, which generations of this curious roaming breed once called home.

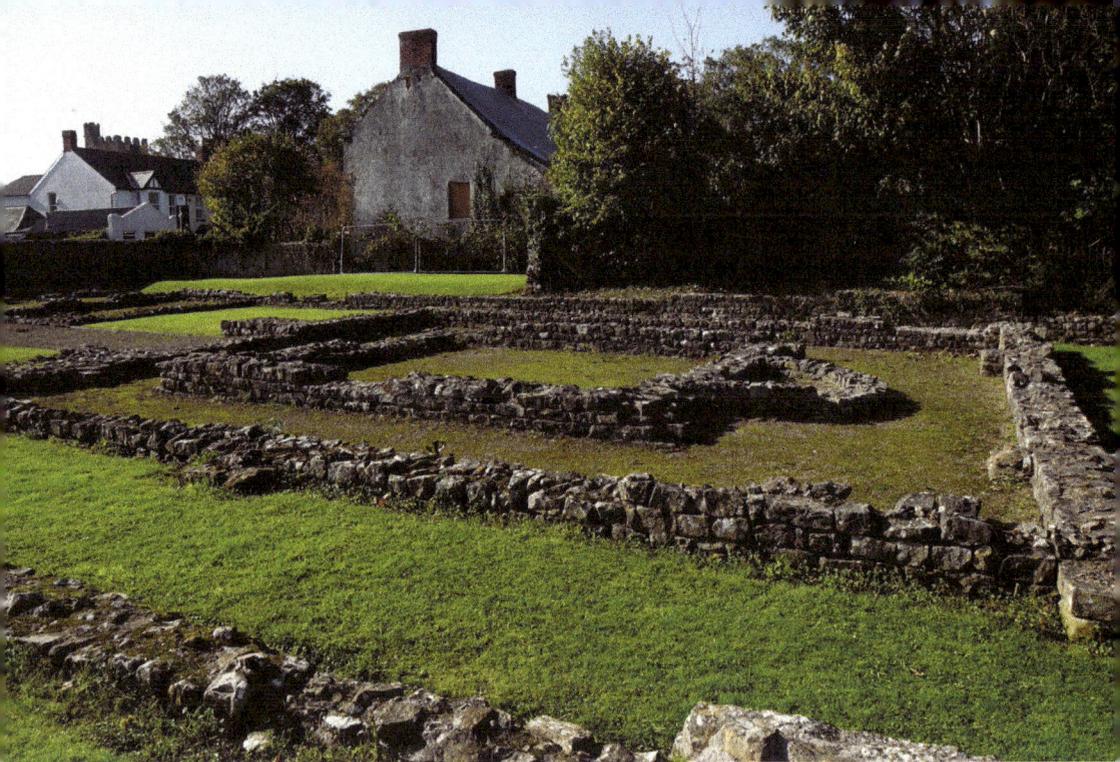

27. Monmouth Shire Hall – Democracy in the Dock

The year was 1840, the month was January, the venue was Monmouth Shire Hall, and the last mass treason trial to take place in Britain had begun. For three weeks during that bleak midwinter, Monmouth was in the national limelight and all eyes – rich, poor, young and old – were transfixed by the proceedings within the town's historic courthouse.

In the dock were a group of remarkable men, but they were not terrorists, they were Chartists and their only crime was to dare defy an oppressive system and a wealthy establishment that would seek to deny others the right to live a decent life, the right to be treated fairly, and the right to vote.

The charge of treason had no place in that farcical court of law. For it was no less than democracy itself that was being put on trial.

John Frost, William Jones and Zephaniah Williams had led the Chartist march on Newport to put an end to the diabolic working and living conditions working people had to endure while a corrupt and privileged parliament gorged on cake and sniggered.

Yet for daring to dream and having the audacity to believe in the six points of the People's Charter, the leading Chartists of the day were put in chains and

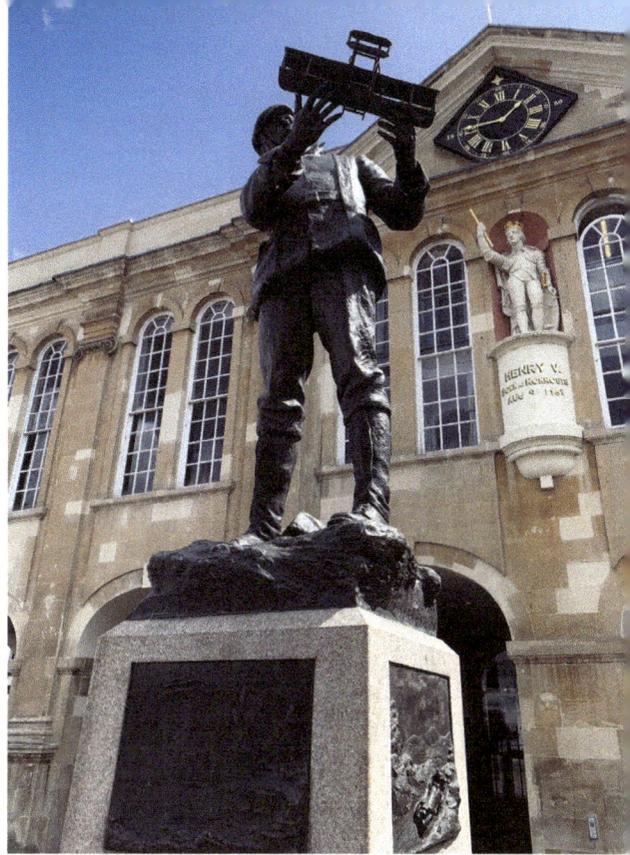

Right: Two of Monmouth's most famous sons – Charles Rolls and Henry V – stand in stony silence outside of the hall.

Below: The court where the Chartists were put on trial.

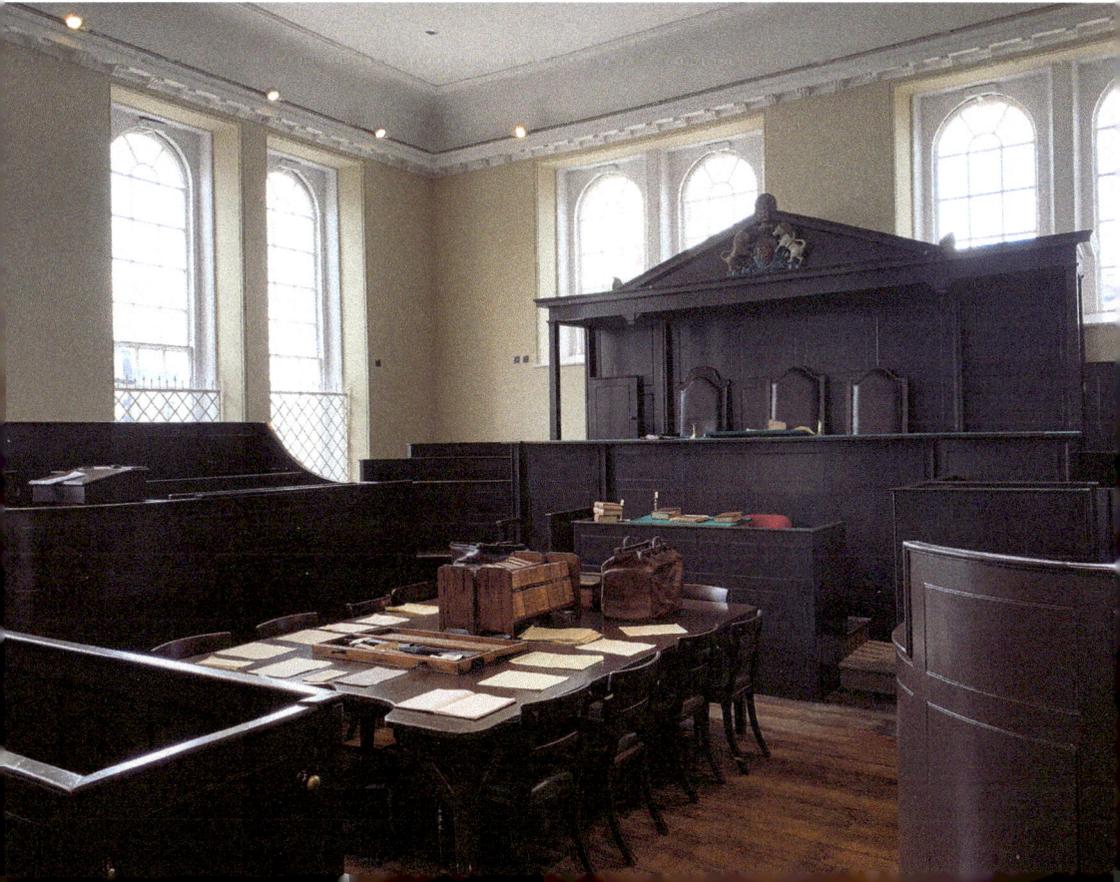

dragged before the court in a show trial designed to demonstrate to the world how determined Britain and the Crown were to preserve the status quo and make sure the plebs never forgot their place again.

On 16 January the pale but composed prisoners listened as the judges put on their black caps and Lord Chief Justice Tindal announced, 'Frost, Williams and Jones, you will be drawn on a hurdle to the place of execution and each of you will be hanged by the neck until you be dead and afterward the head of each of you will be severed from the body and the body of each be divided into four quarters.'

A terrible hush descended upon the courtroom. Those in attendance had expected the verdict to be harsh but this was barbaric.

The system had spoken and the prisoners were taken down, yet the leading Chartists never had to face the full horror of the British establishment's vengeance. They were given a reprieve of sorts and transported to Tasmania instead.

Yet despite the severity of the punishments, the spirit of Chartism didn't die. The proceedings in Monmouth's Shire Hall had planted a seed in the hearts of many. The wind had changed direction and it was only a matter of time before every man and woman in Britain had the right to vote.

The uncompromising and unforgiving courtroom, which played a pivotal role in the birth of modern democracy, can still be visited today and it is well worth doing so.

Walking in its hushed, authoritarian and intimidating atmosphere offers a rare insight and timely reminder of the courage and heart those Chartists of yesteryear showed in the face of a system designed to grind down any defiance and terrorise any disobedience. Fortunately for the rest of us, there were some cogs that refused to buckle.

Below left: The stairs to the holding cells.

Below right: The author pleads with the judge to be lenient.

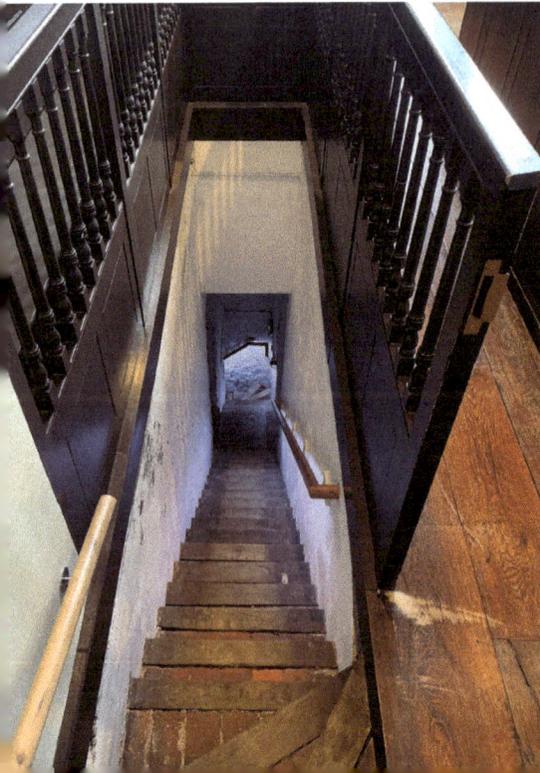

28. The River Wye – A Bandit on the Borderline

Out of all of Monmouthshire's rolling rivers, the Wye is the longest by a long chalk, unless you count the Severn, which admittedly does skirt around Sudbrook for a brief dalliance with this fair land.

Yet it's the Wye that runs through a major part of the county and looks simply stunning in areas where it has landmarks like Chepstow Castle and Tintern Abbey to complement its broad and majestic contours.

The Wye begins its journey at Plylimon in Mid Wales before being swallowed up by the bleak and desolate ugliness of the Severn Estuary. Legend has it that the Wye's source high in the lonely and windswept Cambrian Mountains is the home of a sleeping giant, and his spirit lives in the water that flows through such spots as Hereford, Hay, Ross, Builth Wells, Monmouth and Redbrook.

The Wye is a popular spot with salmon fisherman and poets such as William Wordsworth who once wrote in tribute to this gushing force of nature, 'How oft, in spirit, have I turned to thee, O sylvan Wye! thou wanderer thro' the woods, How often has my spirit turned to thee!'

If you really want to get a feel for this stretch of water then why not put your walking boots on and have a crack at the Wye Valley Walk. Be warned, though, at 136 miles it is quite a trek, but rest assured you can break it up into bite-sized chunks.

Big river keep on rolling.

29. Chepstow Castle – A Clifftop Fortress

Some castles enchant, some castles impose, and some castles impress. In Chepstow, on the banks of the Wye, you'll find a castle that ticks all those boxes and so much more.

Chepstow Castle doesn't just tell a story in stone and structure, it writes a veritable library on the history of castles, their role, and their significance.

The castle is acclaimed as the oldest stone fortification in post-Roman Britain and was originally known as Striguil, which is derived from the Welsh word 'ystraigl', meaning 'river bend'.

For over six centuries the richest and most powerful movers and shakers of the medieval and Tudor era set up home here and left their mark, as they enjoyed a life of luxury and opulence far removed from that of the general population they lorded over.

The story begins in 1067 with William the Conqueror's old buddy Earl William Fitz Osbern, who was keen to turn the vastly important strategic site into one of the first Norman strongholds in Wales. The earl succeeded in fine style. The limestone cliffs it is perched upon like a watching and fearless eagle are a

Regal and proud.

testament to its excellent defensive location and its defining factor as a fortress on the borderline between England and Wales.

The Great Tower was finished in 1090 and was unusual for its time in that it was constructed of stone and not wood. This was thought to be a show of strength by the Normans, who wanted to intimidate the Welsh king Rhys ap Tewdwr.

During his time at the castle, the Earl of Pembroke, William Marshal, exploited the knowledge he had gained during the Crusades and added further fortifications in the 1190s, including the first twin-towered gatehouse in Britain and the oldest surviving castle doors in Europe, whose sheathed iron plates and elaborate lattice framework can still be seen on display within the castle's grounds.

Marshal was undoubtedly the castle's most interesting resident. After Richard the Lionheart offered him the rich heiress Isabel de Clare's hand in marriage for his loyalty and skill on the battlefield, the young knight-errant was transformed into one of the richest men in the kingdom thanks to his wife's sprawling family estates, which included Chepstow Castle.

Marshal would go on to negotiate Magna Carta and ruled as regent of England for the young Henry III, until his death in 1219. When you visit Chepstow Castle and marvel at such landmarks as Marshal's Tower, spare a thought for the man whose identity is wrapped up in these very stones.

In 1270 the Earl of Norfolk, Roger Bigod, set about building more walls and more towers in time for Edward I, who visited the castle on his triumphant tour of Wales in 1284.

The castle's size and the size of its garrison meant that Glyndŵr decided to avoid attacking it during his great rebellion, and in the wake of Henry VIII's Laws in

An eye-catching sight. (Photo by Nilfanion, CC BY-SA 4.0).

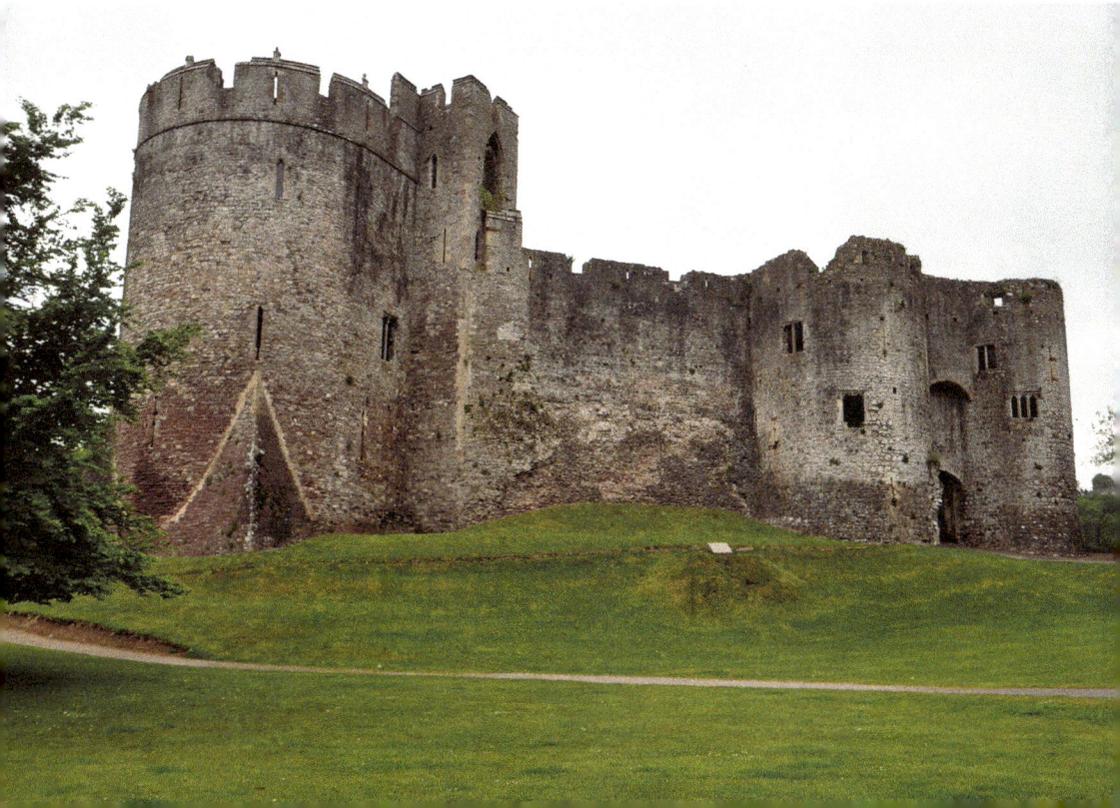

Wales Acts of 1535 and 1542, in which he abolished the Marcher lords' autonomous powers, it becomes more of a great house for various lords and ladies rather than a clifftop fortress.

During the Civil War, the castle became a battleground between Royalist Monmouthshire and Parliamentarian Gloucestershire. It eventually fell to Parliamentarian forces on 25 May 1648.

In the aftermath of the war, the castle was sometimes used as a political prison and Henry Marten, one of the commissioners who signed the death warrant of Charles I, was confined here after the restoration of the monarchy, until his death in 1680.

In the late eighteenth century the castle became a picturesque' feature on the Wye tour, and today its presence continues to overshadow the entire town of Chepstow and capture the eye and imagination in the way only that which is very old and has a tale to tell can.

30. Gunter Mansion – An Attic of Secrets

Not many towns can boast their very own saint, but Abergavenny can, and you can now visit the house where he secretly attended Mass in the heart of this busy market town.

David Lewis, also known as Charles Baker, was born in Abergavenny in 1616, and in 1970 was among forty English and Welsh martyrs executed for their religious beliefs who were canonised by Pope Paul in 1970.

Although David was well liked by both Catholics and Protestants, he was nevertheless a Catholic, and a Jesuit to boot, which in an era where the government actively persecuted people for their religious persuasion was very dangerous.

Father Lewis was ordained in Rome and later attended secret Mass in a secret attic chapel in Cross Street's Gunter House, and was rumored to have led pilgrimages up the 'holy mountain' to the old chapel of St Michael.

He was arrested at Llantarnam in 1678 and appeared before the Monmouth Assizes on 28 March 1679, who condemned him to die a traitor's death in accordance with the Protestant law of the time. He was later offered his freedom by a privy council in London in return for the low-down on the 'Popish Plot' and his willingness to conform to the Protestant Church, but he remained firm in his resolve and was determined to die as a Catholic Priest.

On 27 August 1679, Father Lewis was hanged and disemboweled in Usk's Porthycarne Street. His body was burnt and the remains remain buried outside the west door of Usk's St Mary's Priory Church.

Before he met his grisly end, Father Lewis addressed the crowd in Welsh and said, 'I was condemned for reading Mass, hearing confessions, anointing sick, christening, preaching, and worshipping God. For religion, I die.'

A trip to Gunter Mansion offers an ideal opportunity to walk in the footsteps of David Lewis and stand in the same place where he prayed for the last time before being executed for his beliefs.

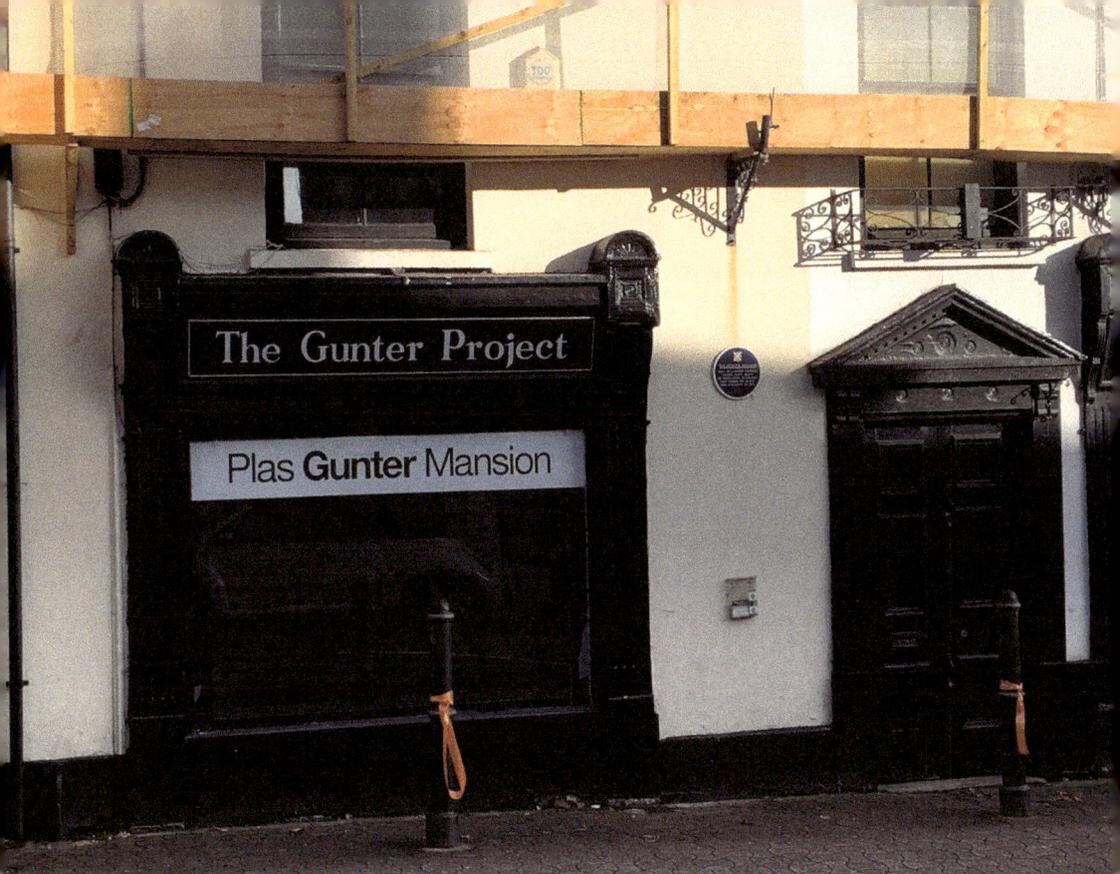

There is currently a permanent exhibition of the history of the mansion and its planned restoration will hopefully allow members of the public to see its most significant rooms, thus making it one of the brightest jewels in Abergavenny's tourist crown.

The mansion has survived a chaotic and pivotal time in British history and it would truly be sobering to walk among walls that have been privy to so many secrets, some of which cost those who kept them their lives.

31. The Kymin – A Doorway to Another Dimension

There is something otherworldly and occult-like about the Kymin. Particularly the Naval Temple and the Round House, which sit silhouetted by the dawn on this hill with its commanding views of Monmouth, the Wye Valley, the Brecon Beacons, and the Malvern Hills.

So intoxicating is the landscape, and so picturesque is the nearby Beaulieu Wood, that over 200 years ago a gang of local gents formed what would become known as

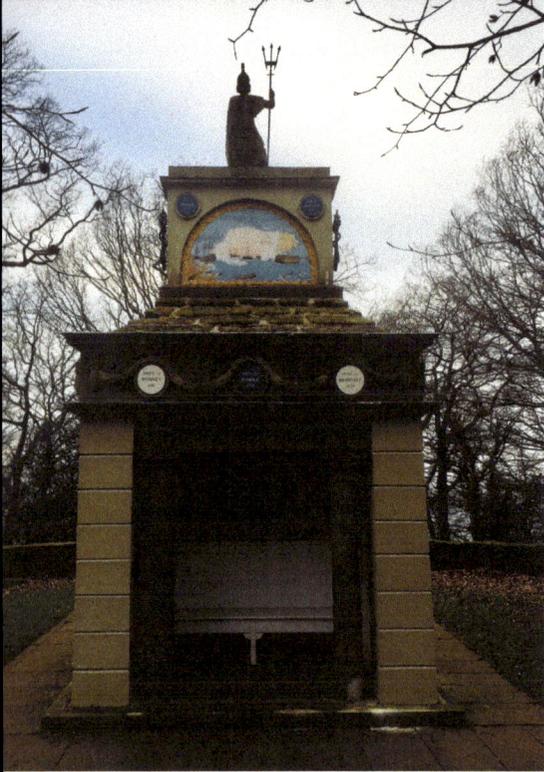

Left: Britannia guards the way.

Below: The Round House keeps its solitary vigil.

the Kymin Club. Their purpose? To picnic, philosophise and develop the poetic eye in contemplation of the beauty which met their gaze wherever it should roam.

Of course, British weather being what it is led to the earnest nature lover building the Round House – so they could enjoy their picnic paradise all year round. They also created a bowling green and other pleasure grounds where they could work off the cake and wine. Both the Round House and the pleasure grounds can still be seen. However, it is the former, built in 1796, with its prime position, outstanding views and resemblance to a little castle belonging to some Victorian magi steeped in occult law, that really fires a lively imagination into thinking about what strange meetings and stranger discussions occurred here. This impression deepens when viewing the most prominent landmark of the Kymin, which of course is the neoclassical Naval Temple.

Built in 1800 to commemorate Britain's superiority at sea and celebrate sixteen of the navy's most famous admirals, the temple appears in the blood-red sunsets of autumn and the pale sunlight of winter to be a doorway to another time and place.

It truely is one of a kind. The building was fuelled by the patriotic pride of the Kymin group and other local citizens who were awestruck by the victories of Admiral Nelson, who was then at the height of his powers in the wake of his famous victory at the Battle of the Nile.

Nelson visited the temple with Lady Hamilton in 1802 and said that the Kymin was one of the most beautiful places he had ever seen. He also described the Naval

Into the mystic.

Temple as an absolute credit to Monmouth because it was, 'The only monument of its kind erected to the British Navy in the whole range of the Kingdom.'

Today the Naval Temple stands as a symbol of a bygone and less politically correct age. Upon its triumphal arch, Britannia sits on a rock proud and watchful. Beneath her stone and weathered throne the standard of Great Britain waves in triumphant splendour over the fallen flags of France, Spain and Holland.

Beneath that there is a place to sit, ponder and breathe the air of an area that has a majesty and might in every sense of the word.

32. Clytha Castle – Love's Great Folly

There have been many architectural wonders built in the name of love: the Taj Mahal in India; the Mystery Castle in Phoenix, Arizona; the Swallow's Nest Castle in the Ukraine; Dobroyd Castle in Todmorden, England; and, of course, Clytha Castle in Monmouthshire.

Perched on Clytha Hill and overlooking the sweeping and landscaped estate of the same name, which was built on the backs of theses who toiled in the coalfields and ironworks of the nearby valley towns, Clytha Castle is one of Wales's most outstanding eighteenth-century follies.

John Davenport designed it, and it was built in 1790 upon the orders of Clytha House's William Jones who wanted it as a memorial to his late wife Elizabeth. The purpose of the folly was to 'relieve a mind afflicted by the loss of a most excellent wife'.

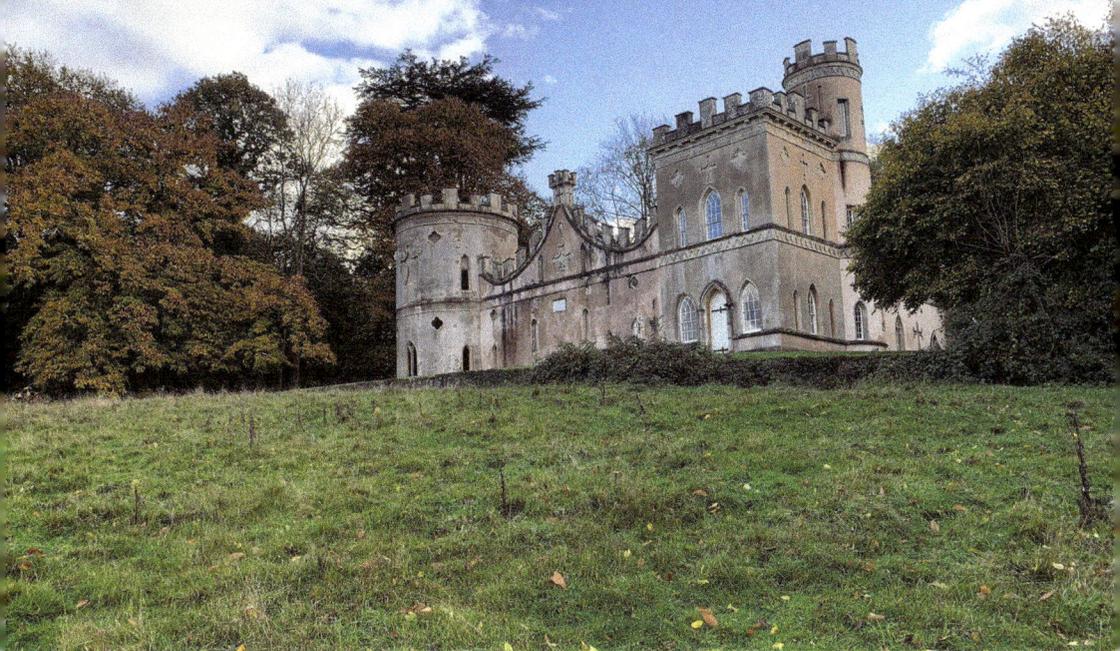

Above: A Gothic masterpiece.

Below: Behind the façade.

A lonesome view.

The Gothic design of the folly perfectly matches its remote setting and surrounding woodland, and with outstanding views of the Skirrid and Sugar Loaf, it must have been a grand place to brood and reflect on mortality in front of an open fire while nursing a fine whiskey.

The Landmark Trust took over care and maintenance of the building in 1974 and it is frequently available for holiday rents.

There are many riverside rambles and routes leading to, from and surrounding the castle, including one that will take you to the remains of an Iron Age fort. The Clytha circular walk in particular is a great way to stretch the legs, take the air and enjoy the sense of timelessness a soul can find in this neck of the woods.

33. The Old Railway Line – A Place to Let Off Steam

Before the motor car began choking the climate and tying the world up with roads, if you wanted to get from A to B there was the old iron horse or, as it was more commonly known, the steam train.

Parts of Monmouthshire once formed an impressive segment of the Merthyr, Tredegar and Abergavenny Railway. In its heyday, this was one of the most impressive and severely graded lines in the British Isles.

Created by the heavyweight industrialist Crawshay Bailey, who was determined to create a route between Abergavenny and Merthyr no matter what natural obstacles stood in his path, the railway overcame steep slopes, deep valleys and an array of spectacular twists and turns to ensure the sound and smell of steam became a popular sighting in such towns as Abergavenny and villages like Govilon, Gilwern and Clydach.

Off the rails.

Its tracks have long since been torn up, the steam has evaporated into thin air, and the haunting cries of the old engines have been silenced by the study and monotonous hum of the motorway. Yet where once there was the hiss of steam and the distinctive clatter of wheels heading down the track, you'll now find a stillness and a solitude, which makes for a wonderful stroll.

The old railway line is now hugely popular with walkers and cyclists and is the ideal place to meander. Along the way, you'll find lots of relics to remind you what an engineering miracle once weaved its serpentine way through this area, and as you stroll over and under bridge, through the abandoned track's densely wooded sides, and admire the outstanding views you'll wonder why on earth we no longer travel in such a pleasant and leisurely style.

34. Caldicot Castle – A Country Manor

Caldicot Castle isn't just a grandiose structure from days of ol; it's situated in an idyllic 55-acre country park, which makes it the perfect place to visit to take your fill of both history and Mother Nature.

Built on an ancient site that has long been valued for its strategic value of being near the Bristol Channel, the Romans used this area to their advantage. Not one to miss an opportunity to build a castle in a place where they could exert maximum control, the Normans were the first to dig in and build a motte with two baileys and a surrounding ditch. The impressive round keep that was built on the motte in 1221 is still there in all its crowning glory. A quick climb of the spiral staircase that weaves its way through the four-storey keep will take you to the top of this formidable architectural beauty with its 9-foot walls and basement that once concealed a vaulted dungeon.

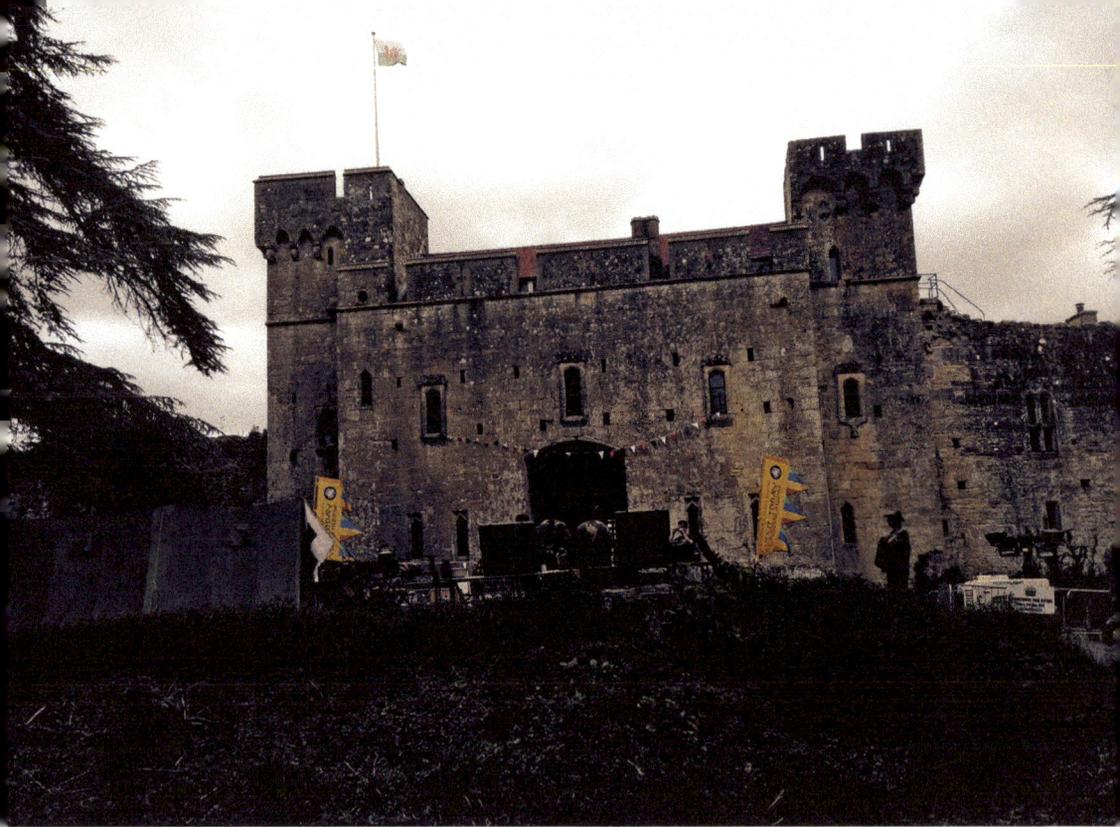

Above: A ramshackle masterpiece.

Left: Standing tall! (Photo by Bob and Anne Powell)

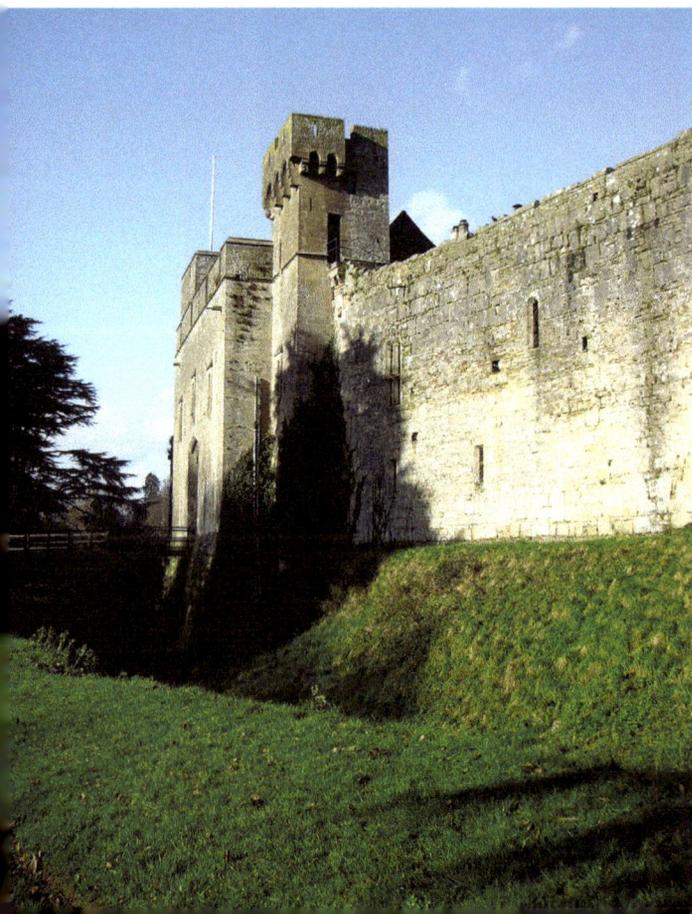

In the bird's nest of the keep, the view is outstanding. The castle, the park, the River Nedern and the surrounding countryside are laid at your feet like an intricate tapestry. It's the perfect place to appreciate this castle, which was originally a fortress and later became a Victorian family home.

The infamous antiquary Mr J. R. Cobb bought up the manor in 1855 and went on a mission to restore it to its former finery. Cobb was a big fan of castles and also came to the aid of the ones at Manorbier and Pembroke. He made Caldicot his family home, and visitors to the castle today can marvel how the medieval and the modern have mingled to create a ramshackle masterpiece.

35. Llanthony Priory: A Haunting Testament

In the Vale of Ewyas and surrounded by gangs of hills you'll find the haunting ruins of medieval man's devotion to God and spirituality – Llanthony Priory.

The skeleton of a great ambition.

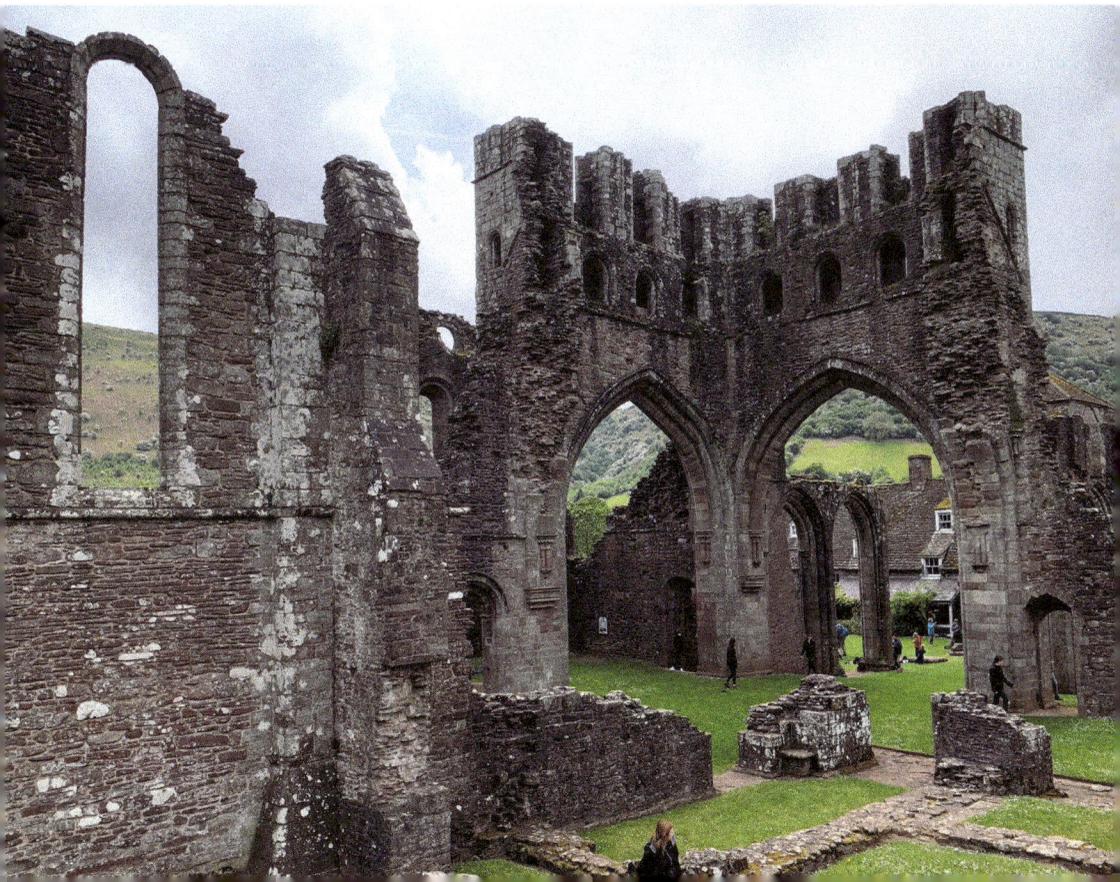

Now in a state of slow decay and but a withered shadow of its former glory, the stone remains still stand as an evocative and beautiful reminder of what once was.

The story of the priory begins in the early twelfth century when a rich nobleman called William de Lacy was out hunting. A sudden and fierce downpour brought a premature end to that day's bloodsport and he was forced to take shelter from the storm in the broken-down remains of the Celtic chapel of St David.

While ruminating on missed opportunities and the transitory nature of time, our hero of the hour was suddenly gripped by an overwhelming religious devotion, and decided then and there to establish a priory on that exact spot.

Being a man of means this was no pipe dream for William, and by 1108 there was a small church and a community of Augustinian monks flourishing on the site.

As was the way back then, the monks were bestowed with much land and an abundance of gifts. A path was made so live fish could be taken from the nearby Llangorse lake, before being wrapped in wet rushes and transported over the mountains to the monastery's fishponds. A similar path (Rhiw Cwrw) was forged to Abbeydore for the sole reason of bringing the thirsty men of the cloth barrels of beer.

The monks, who were mainly English, aggravated the natives somewhat and repeated attacks on the religious community led to them fleeing to the safety of Hereford and Gloucester as their home was destroyed and the land reclaimed.

Fast-forward to the thirteenth century and the prior was re-established and rebuilt in a grandiose fashion. The imposing archways and elegant windows you see today all date from this period.

Yet the priory's existence triggered further turbulence when Prince Owain Glyndŵr attacked in the fifteenth century as part of his bid to recapture Welsh land that had been taken by the English.

It was ultimately Henry VIII who did what the great prince could not. The priory was reduced to ruins and left to crumble under the Dissolution of the Monasteries. After decades of decay, the land was purchased by the poet Walter

A curious blend of the old and new.

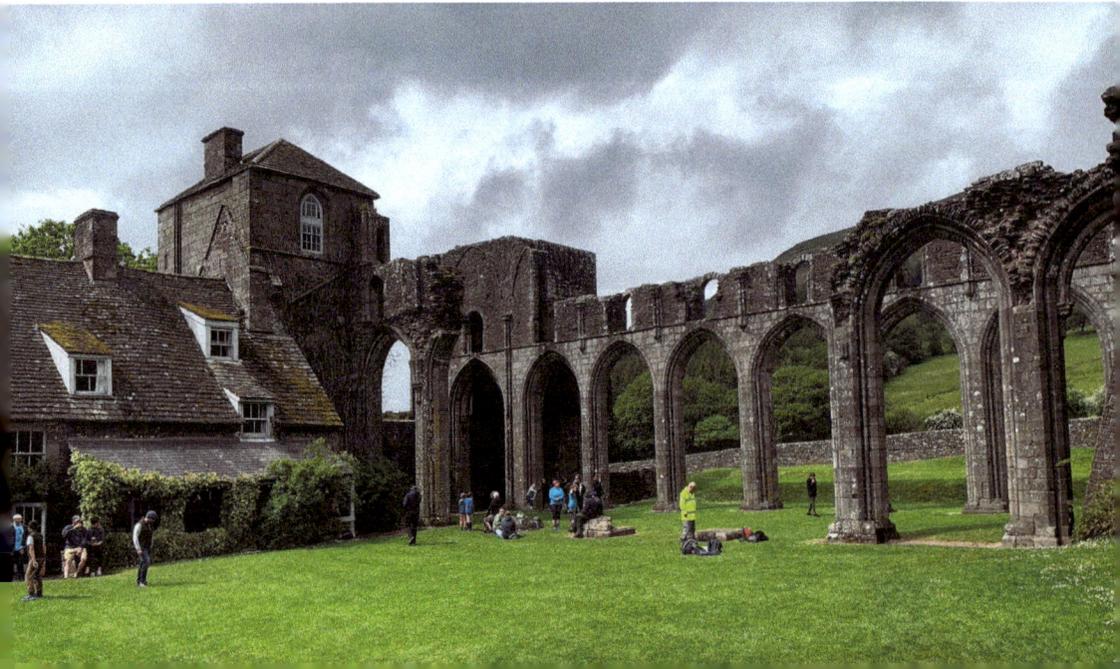

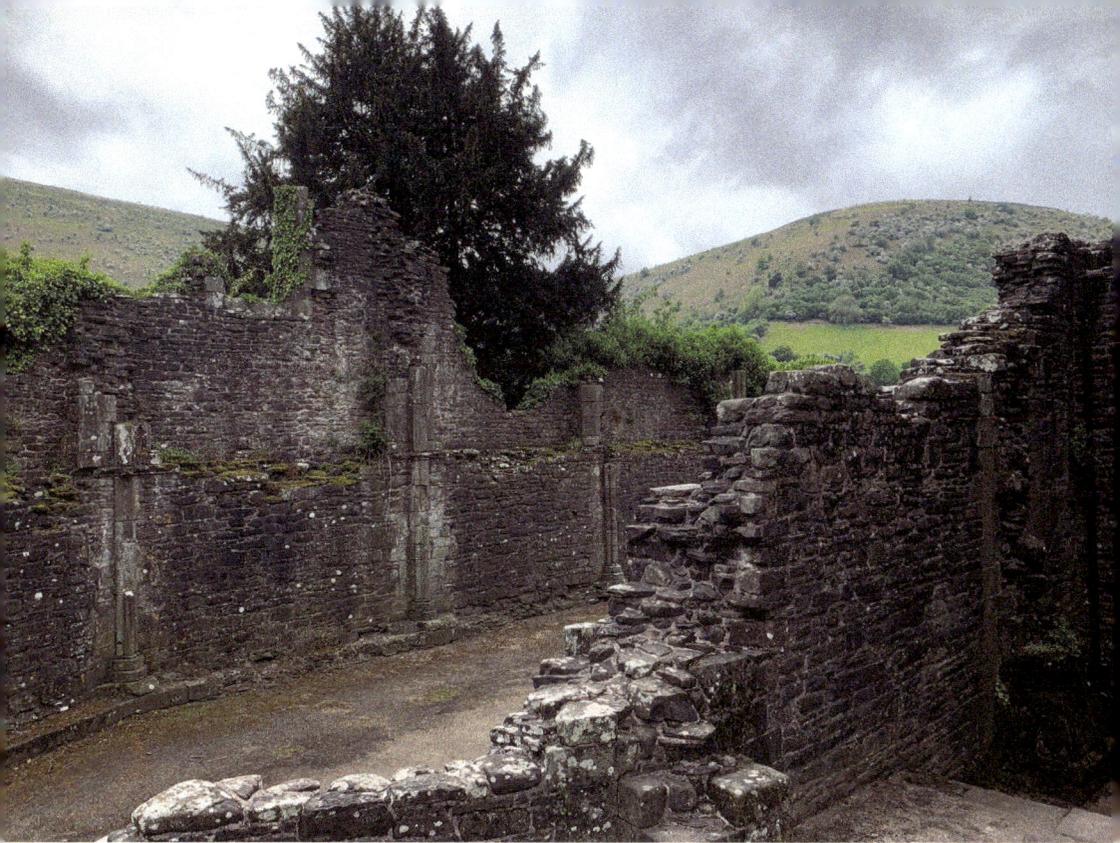

The stones are old, but the hills are older.

Savage Landor in 1807. Savage had delusions of grandeur and wanted to establish a magnificent and memorable estate. He failed in his self-appointed task, as once again local opposition nipped his schemes in the bud and he eventually gave up the ghost, sold the site to tenant farmers and moved to Spain instead. All that remains of Savage's legacy are some of the beech, chestnut and larch trees, which he planted in abundance.

Cadw now owns the site and the Llanthony Priory hotel is nestled among the ruins of a building that was built in a way that they just don't build them anymore.

36. The Deri – A Magical Mountain

Visitors to the Black Mountains often overlook the Deri in favour of the more imposing peaks, such as the Sugar Loaf and the Hay Bluff, which is a shame because as anyone who has made a hike up this beautiful and benign little charmer on the outskirts of Abergavenny knows, it's well worth it.

The Deri is a cheeky little mount with a sunny disposition and gentle flanks which even the laziest of walkers will not find too challenging. It's often described as the 'Magical Mountain' because of the otherworldly woodland leading to its summit, but also because in late autumn it is abundant with a bumper crop of mood-enhancing mushrooms. The Deri is always a rewarding hill to climb and one to lounge idly upon, especially on a warm spring evening when the birds are full of sweet song and the air is heavy with promise and the intoxicating perfume of a warm southern breeze.

In 2016, a few days before the National Eisteddfod, the delightful Deri caught more than just a roving rambler's wandering eye; it captured the attention of the entire town of Abergavenny after deciding to get a 'tattoo' on its fair flank of a smiling face and the Welsh word for 'welcome' – 'Croeso'.

It was not the first time this chirpy and cheeky Monmouthshire mount has been emblazoned with a smiley face. This universal symbol of unbounded joy has often popped up periodically on the Deri from time to time in a mysterious fashion, and it usually likes to make a show for the big occasion.

Local legend has it that in 1971, Black Sabbath rented a cottage on the Deri to write and rehearse their third album, *Master of Reality*. How much the classic Sabbath song 'Sweet Leaf' was influenced by this little Abergavenny hill we may never know.

A snow-capped Deri lies to the left of the Skirrid with the sleepy market town of Abergavenny sandwiched in between. (Photo by Tony Kelly)

37. The River Monnow – A Little River with Big Magic

The Monnow may be only a little river that flows into the Wye at Monmouth, but for much of its length and breadth it forms a boundary between England and Wales. It is only fitting for a passage of water with such a distinct personality that it is surrounded, not just by enchanting country, but the shadows and spells of superstition as well.

Take, for example, the bridge that crosses the Monnow between Kentchurch and Grosmont. Local folklore has it that Jack O' Kent and the Devil worked side by side to build the bridge in one night. Apparently, what they built by the moon would crumble to dust by the dawn if the bridge remained unfinished, so speed was of the essence for Jack and his satanic colleague.

The unlikely pair made a contract that the first living things to pass over the bridge would belong to Lucifer for eternity. Being a mischievous sort, Jack threw a bone across the bridge and a luckless stray hound chanced after it. Needless to say, the Devil was none too happy that after a full night's graft all he had for his pains was the soul of a wandering canine.

Interestingly, Jack O' Kent, who features elsewhere in this book and is said to have many a dalliance with the Devil, was apparently based on a Monmouthshire minister called Revd John Kent. Sion Cent was his Cymric pseudonym and he was said to

Strange currencies!

have lived from 1420 to 1470. Like a lot of learned men in those distant days, the common folk believed him to be a man with magical powers who enjoyed many a transaction with the horned one.

How much truth there is in this we'll never know, but one thing remains hard, fast and undeniable: when the misty moonlight lies softly on the surface of the river, the gentle breeze shakes the ancient trees and a distant owl sounds its haunting lament for the night, anything is possible on the banks of the mysterious Monnow.

38. St Andrew's Church – A Memorial for an Old Soldier

The Church of St Andrew in Tredunnock is something of a curiosity. Behind its white-painted gates, which were created to mark the ascension of Edward VIII in 1902, and within its cool and calm interior, you'll find a sandstone memorial to Julius Julianus. The man commemorated was a Roman soldier who served eighteen years with the 2nd Augustan Legion based at Isca Augusta, which people now know as Caerleon.

A historic house of the holy. (Photo by Christine Johnstone)

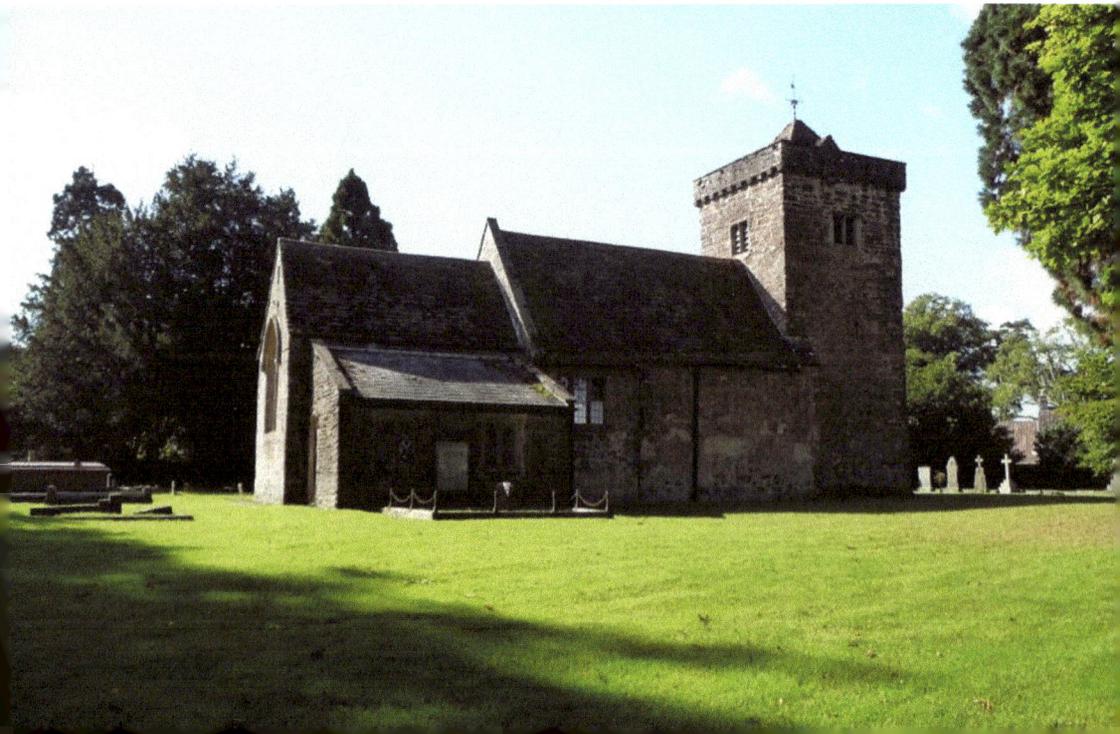

The stone tablet is in Latin but translates thus: 'To the memory of Julius Julianus, soldier of the Second Augustan Legion. He served 18 years and lived 40 years. He is buried here. Set up under the direction of his wife Amanda.'

Julius was thought to be buried far from the seven hills of the Eternal City in the Roman cemetery at Caerleon. How his gravestone ended up in a sleepy church in Monmouthshire remains a mystery.

The porch of the church also contains an early tablet by sculptor Eric Gill. Eleanor Isabella Gill, the only child of the Arctic explorer Sir John Franklin, lies buried in the peaceful churchyard of a medieval church with many a story to tell and secret to reveal.

39. Monmouth Castle – A Forgotten Fragment

Out of all of Monmouthshire's castles, it's probably the one that lies in the town that gives the county its name that's the least impressive, and that's mainly because not much of it is still standing.

Perched high on a hill above the River Monnow and close to the hustle and bustle of the marketplace, Monmouth Castle once served an important role as a bastion for the Marcher lords.

The birthplace of a king! (Photo by Ethan Doyle White, CC BY-SA 4.0)

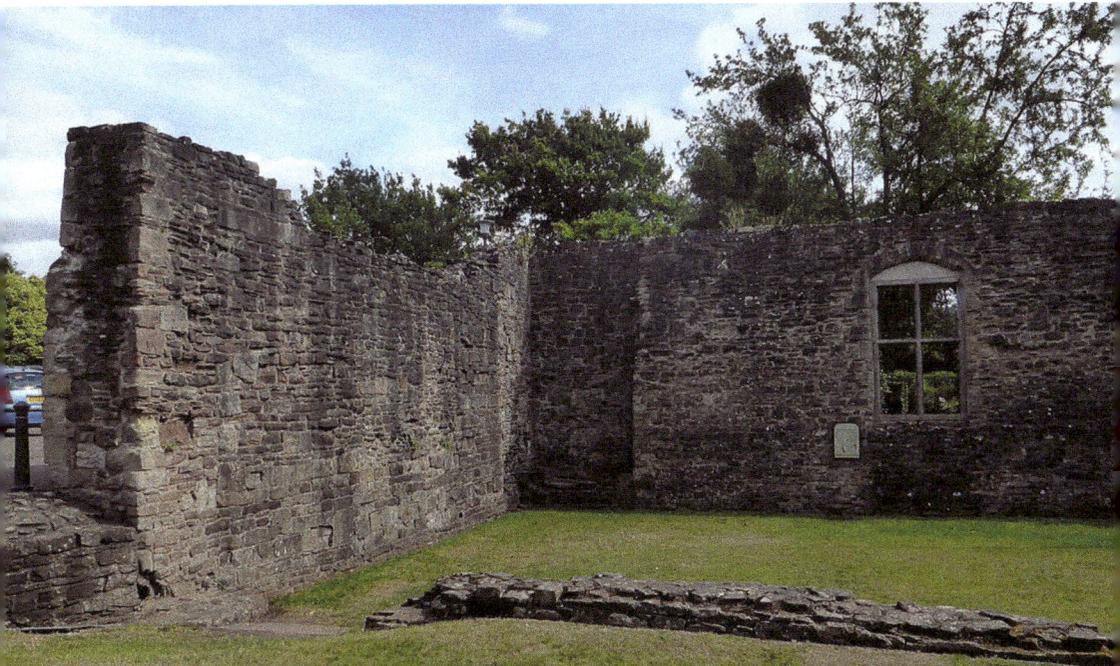

Not content with being the lord of the manor at Chepstow, William FitzOsbern decided he needed a castle in Monmouth as well.

What was once made out of wood had turned to stone by 1150, and over the years various lords ensured that an impressive gatehouse, curtain wall and great round keep all conspired to make this a castle worth talking about.

Another notable thing about Monmouth Castle is that on 16 September 1387, Henry V of Battle of Agincourt fame was born here.

As with so many castles, the Civil War put an end to the Monmouth masterpiece and in 1647 on 30 March townsmen and soldiers began pulling down the great round tower and the end was nigh.

In 1673, Henry Somerset, the 1st Duke of Beaufort, built the Great Castle House on the site, which has been described as 'a house of splendid swagger outside and in'.

Not much of the original castle remains, but what little there is has an intriguing story, not least because it remains one of the few castles in Britain still in military occupation.

In 1875 the Great Castle House became the headquarters of the Royal Monmouthshire Royal Engineers (Militia). And, it has to be said, a visit to this underwhelming castle can definitely be compensated by a trip to the Royal Monmouthshire Royal Engineers museum, which is on the castle site and contains a wealth of information items and materials to anyone interested in military history outside of castles – yet inside them too, if you catch my drift.

40. Abergavenny Castle – The Liar's Den

Wales has the highest concentration of castles in Europe. Estimates suggest Cymru was home to over 600 of these bastions of stone and oppression.

The Normans have been described as 'colonists of genius' and they went all out to crush any Welsh opposition by fair means or foul. There is an infamous tale surrounding Abergavenny Castle that illustrates this to perfection. If you are sitting comfortably, we shall begin.

On Christmas Day in 1175 the lord of the manor, one William de Braose, fondly remembered as the Abergavenny Ogre, kindly invited all the local Welsh chieftains to a festive knees up at the town's castle. Willing to put aside years of bloody conflict, the Celts happily accepted the Norman lord's invite and, led by Sitsyllt ap Dyfnawl, the Welsh lads turned up expecting to share a few gallons of ale and make merry with the boys from France. Except the only thing on the menu that night was carnage – and lots of it.

After politely leaving their swords, axes and spears at the door, Sitsyllt and his crew took their seats at the table in the Great Hall, picked up their goblets of mead and looked forward to the hogs' heads, roast swan and other Norman delicacies on offer, but things turned sour quicker than a lump of stilton cheese in the microwave

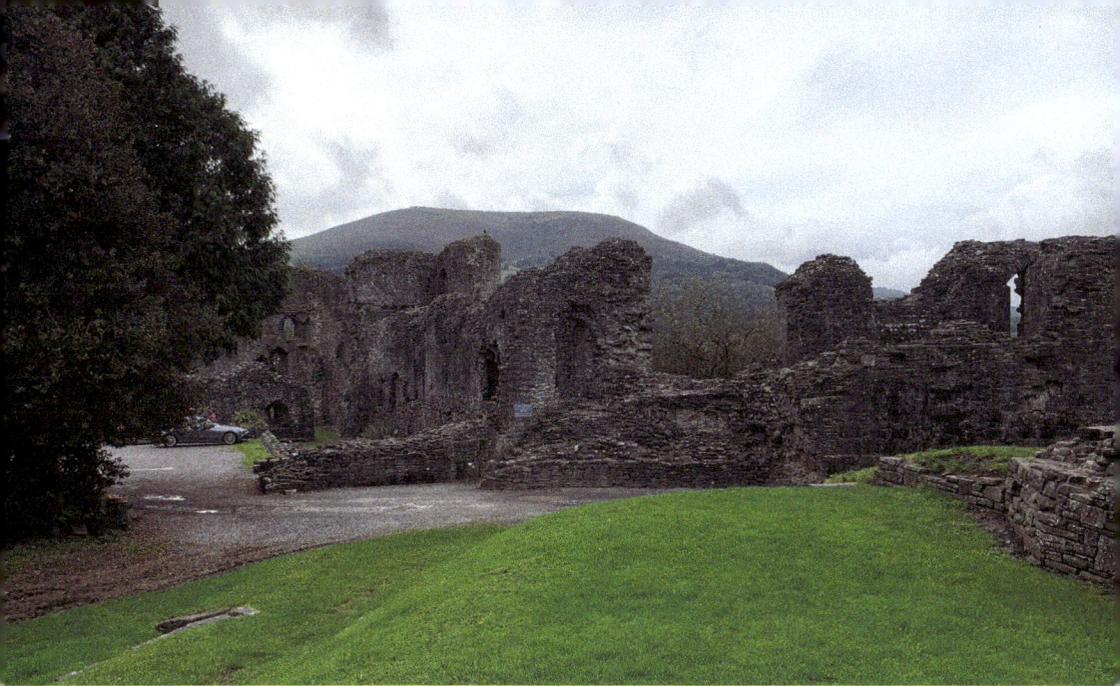

Above: A place of treachery and slaughter.

Below: A sculpture situated in the castle, reminding all of the great bloodshed that once occurred there.

when Lord de Braose announced that he had recently decided from that day on no Welshman should have the right to bear arms.

As you can imagine, this little revelatory nugget sat in the stomach of the gathered assembled about as well as an undercooked chunk of rotten fish, but before they could protest or beat the living daylights out of William for his brass-necked audacity and poor etiquette, it all went to hell in a handcart.

At a curt prearranged nod of the head from William de Braose, the time-honoured bond between visitor and guest wasn't so much broken but ruthlessly torn apart, as a horde of soldiers led by the Sheriff of Hereford, Ranulph Poer, descended upon the unarmed and shell-shocked Welshman and butchered every last one of them in a gleeful savagery. All that is except Prince Iorwerth of Caerleon, who is said to have wrested a sword from a witless Norman and hacked his way through the throng to liberty and life.

Not content with such a massacre, the bloodthirsty butcher de Braose saddled up a posse of his men the very next day and once again went on the rampage. This time to Sitsyllt's home, where they killed his seven-year-old son Cadwaladr in front of his widow.

The hunting lodge, which now houses the Abergavenny Museum.

Such treachery and psychopathic behaviour earned de Braose a defining role in Abergavenny's history. The belligerent brute nearly got his just rewards in 1182 when the sons of the slaughtered Welshmen came of age and stormed the gates of Abergavenny Castle, killing the entire garrison, but to their disappointment, de Braose and his wife Maud were elsewhere.

Wicked William de Braose continued to narrowly escape justice for his diabolical deeds, and he was never dealt retribution by a Welsh hand. Instead, he fell out of favour with King John and after having all his castles seized he fled to Ireland with his family, where his wife and eldest son were captured by the king's men and starved to death at Windsor Castle – such was the niceties of Norman nobility.

As for the Abergavenny Ogrehimself, he fled to France disguised as a leper, where he died on 9 August 1211. An ignoble end to a wretched creature.

Despite a fierce attack in the early fifteenth century by Owain Glyndŵr and being famously described as being, 'Oftner stain'd with the infamy of treachery, than any other castle in Wales,' Abergavenny Castle still stands and remains a fine ruin to visit and reflect on the slaughter and treachery that these crumbling walls have borne witness to.

41. Capel-y-ffin – The Chapel on the Boundary

In 1870 a Church of England clergyman going by the name of Revd Joseph Leycester Lyne purchased a 34-acre farm a couple of miles north of Llanthony called Ty Gwyn.

In March of that year Joseph and his followers began building a monastery named after the nearby village of Capel-y-ffin, whose purpose was to revive the Benedictine monastic way of life. Before the monastery was finished, Joseph, caught in the fierce grip of the Catholic revival, would change his name to Father Ignatius and a local legend was born.

Father Ignatius would earn renown as an Old Testament preacher whose oratory skills were second to none. His firebrand style of speaking and the zeal with which he spread the word would see him earn renown as a household name. He toured both the United States and Canada to deliver his booming sermons.

Father Ignatius was a no-nonsense type of guy. A sort of Al Capone in a monk's habit. He is often regarded as being more at home with preaching the gospel to the drunks and ne'er-do-wells of Monmouthshire than he was in toeing the line for the Church authorities who often viewed him with disapproval.

Writing in *Victorian Studies*, David Hilliard suggested that Father Ignatius was part of an Anglo-Catholic underworld whose members delighted in religious ceremonial and the picturesque neo-Gothic externals of monastic life. These groups did not enforce strict criteria for entry and they were likely especially attractive to homosexually inclined young men who felt drawn to the male environment of a monastic community and the dramatic side of religion.

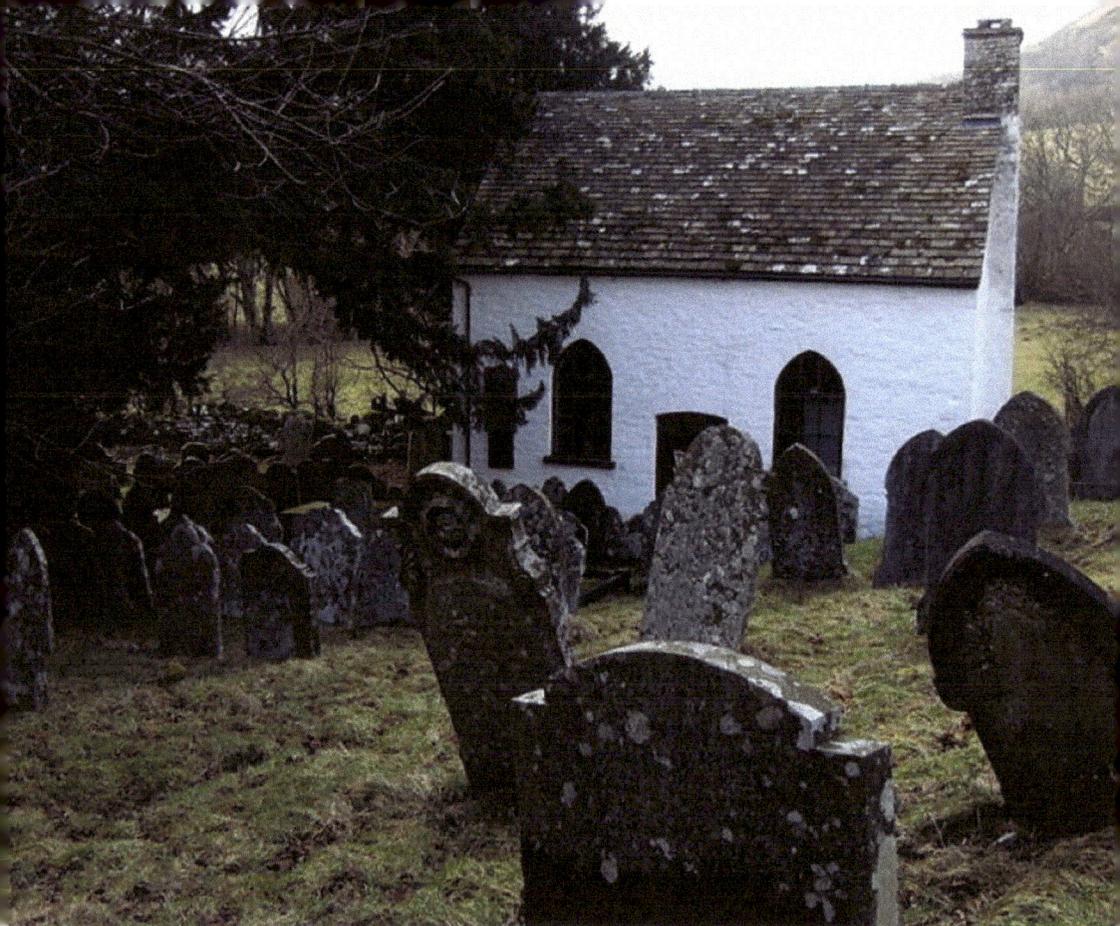

During his thirty-eight-year tenure at Llanthony, over 300 men of all ages came to stay and study with Ignatius, who was said to have possessed a deep spirituality and whose face shone with a heavenly light whenever he prayed.

He was also said by his contemporary, Anglican diarist Francis Kilvert, to have often been surrounded by ghosts 'who will never answer though he often speaks to them'.

Visions of the Virgin Mary gliding across the grounds of the monastery were said to have been seen by various witnesses in August and September 1880, and the flickering appearances of Our Lady of Sorrows on the site have since been commemorated with a statue that stands on the forecourt outside the Mmonastery.

Father Ignatius died in Surrey in October 1908 at the age of seventy-one. His mortal remains were carried back to the home he loved in a hearse drawn by a team of white horses. He was laid to rest beneath the floor of the abbey church he had given so much of his life to.

In 1924 Capel-y-ffin was sold to artist stonemason and writer Eric Gill, who was the chief of another sort of religious community looking for a private rural retreat for his somewhat unconventional domestic arrangements.

In the churchyard of the Church of St Mary the Virgin, which lies on the site, you can still find the base of an old stone cross and two small headstones carved by Gill. When Gill's community eventually departed the monastery became a school, and then a guest house, but neither venture lasted long.

Haunting and historic.

Today it appears as if the entire site is perpetually holding its breath and waiting for something significant and revelatory to happen. Nevertheless, this strange little corner of Monmouthshire is well worth a visit, not just for the surrounding views, but to appreciate how strange this little dwelling, high in the proud and savage Black Mountains, actually is.

42. St Faith's Church – An Ancient Resting Place

The dead are not just names carved in stone. Inside every grave their lies a story, and you can learn a lot about a place by visiting a local cemetery.

The length and breadth of Monmouthshire is scattered with old churches and their graveyards, but there aren't many as atmospheric and otherworldly as St Faith's in Llanfoist. If you're one of those souls who delight in taking a measure of peace, solitude and melancholy reflection in the quiet and final resting places of the living, then a trip to the little church dedicated to St Faith, which is nestled beneath the wooded slopes of the Blorenge, will help you get things into perspective.

Thought to have been founded in the sixth century by St Ffwyst (hence the name of the surrounding village of Llanfoist), this ancient site has a strange charm. The current church has been through many restorations since the thirteenth century. Its most significant was paid for out of the purse of iron master Crawshay Bailey Jr, who wished to honour his father who is buried in the graveyard's soil and whose polished red granite memorial towers over all others.

Despite the enchanting stained-glass windows and engaging wall memorials within the church, it's the graveyard with its splendid example of a medieval churchyard cross and the countless fading memorials to movers and shakes in the local area which captures the wandering eye.

Although rain has washed away many of the inscriptions written upon the weathered monuments, which bear their lonely testament to another time and an another place, a soul alone in this place is overwhelmed by the impression that the past is reaching on up out of the graves to tell its tales and release its secrets.

The old graveyard used to be home to some spectacular yew trees, but the last one thought to be a thousand years old was felled in January 2012 by high winds.

In one quiet corner lies the unmarked grave of the man may believe invented the Severn Bridge. Samuel Baldwyn Rogers was an inventor during the Industrial Revolution and he devised plans for that famous architectural landmark over 100 years before it was built. Like many, his contribution to history was lost to time and the man hailed a genius was buried in a pauper's grave.

The secrets of the graveyard.

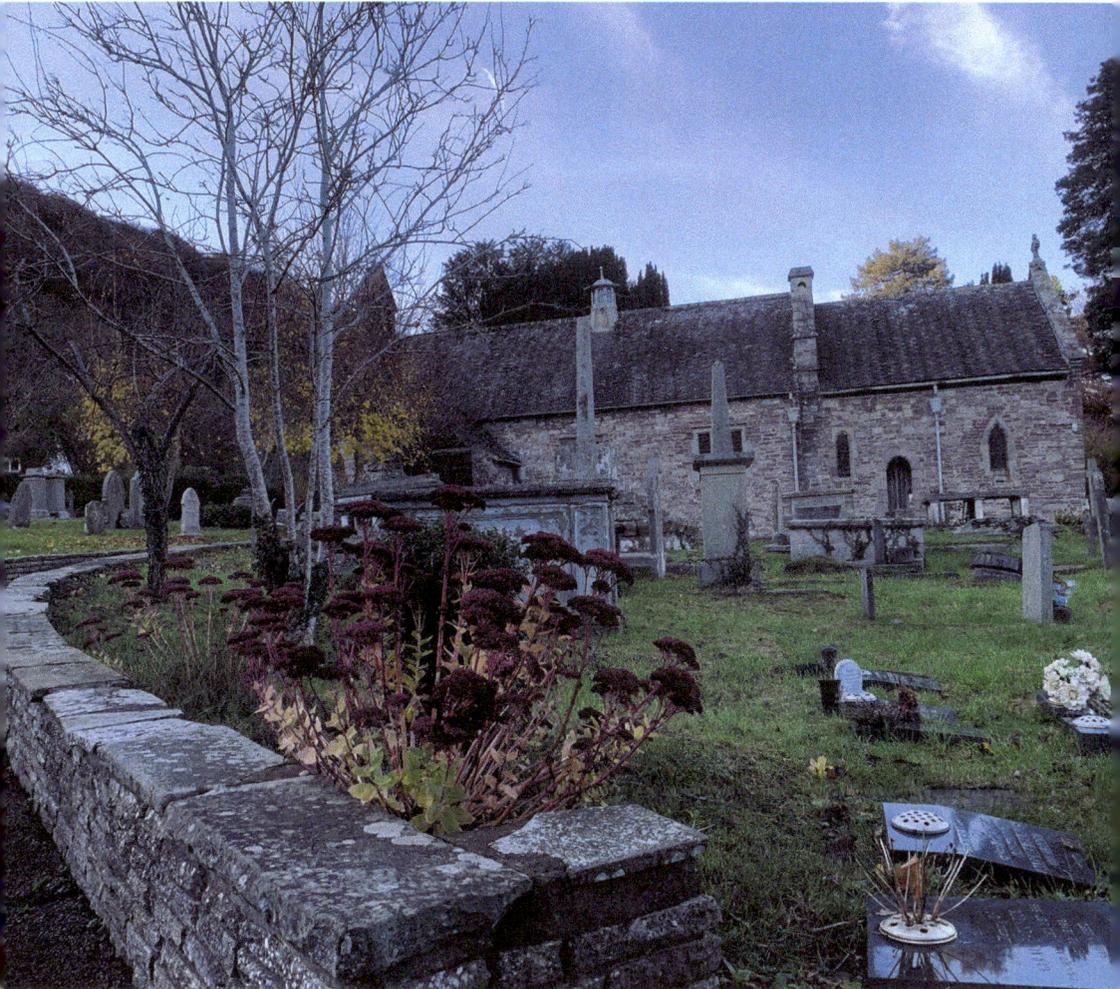

A place to restore faith.

Another celebrated personage thought to be buried in St Faith's is someone by the name of Ivor. In a song celebrating the laying of flowers on the graves at Llanfoist the fourteenth century, Welsh poet Dafydd ap Gwilym wrote:

When the flowers all their splendour show
And the smooth branches from the silence grow
I bring the rose from the closes far
In fields and forests brilliant as a star
The pliant clover with glittering gems in mass
The joy and pride of the pasture grass
At the Lord's great hour in their lovely bloom?
I lay them loyally on Ivor's tomb.

43. The Nelson Museum – Admiring the Admiral

Monmouthshire is a long way from Norfolk and the last place you might expect to find a museum dedicated to that county's most famous son – Lord Horatio Nelson.

On 19 August 1802, at the height of the old sea dog's affair with Lady Hamilton, a liaison that scandalised Victorian society, Britain's greatest naval hero, his lover and her husband Sir William sailed down the River Wye and had a splendid two days in the fair town of Monmouth.

The much-admired Admiral was a firm favourite in the area and his visit was welcomed by cannonades firing, brass bands playing, cheering crowds, and fanatical fellows all keen to catch a glimpse of the iconic Brit.

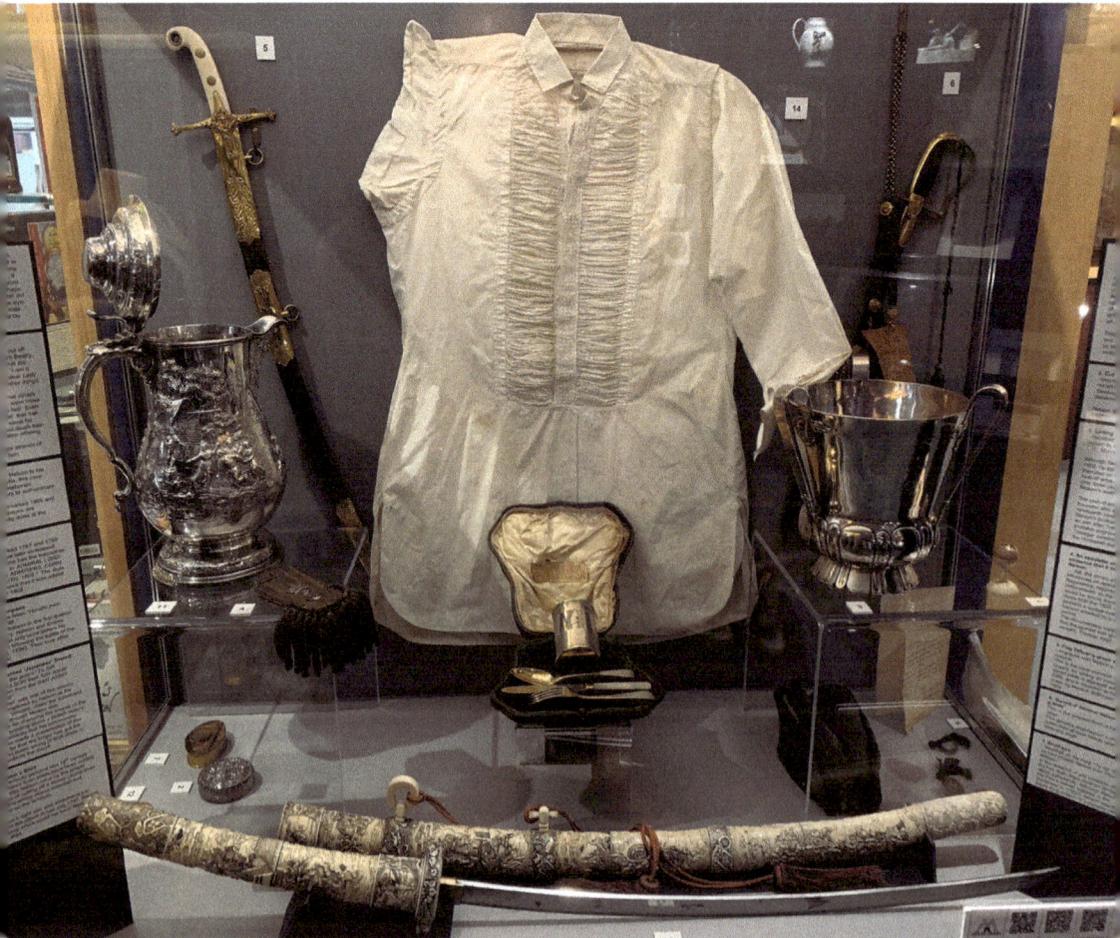

Relics from the sea dog's life.

The tale of Nelson's visit made a big impression on Lady Georgina Llangattock. Upon her death in 1923, Lady Llangattock who also happened to be the mother of Charles Rolls of Rolls-Royce fame left her entire collection of Nelson memorabilia to the town.

As Lady Llangattock was somewhat smitten with Nelson she had amassed quite the collection. A gymnasium in Glendower Street she had gifted to the town was reopened as a shrine to all things Nelson in 1924 and is now known as the Nelson Rooms. In 1969 the museum was rehoused at the Market Hall where you can find it to this day.

The collection features such rarities as letters penned by Nelson, a lock of his hair and the table the famous sailor dined upon during his visit to the Kymin Round House. As well as featuring swords and other artefacts from the Nelson era, the collection is also home to many a fake, such as a glass eye purported as belonging to Nelson when in fact he was only blind in one eye and not missing an eyeball.

The forgeries, however, give a real indication of just how famous Nelson was during his lifetime and the years that followed when memorabilia and souvenirs relating to the great Brit were highly sought after and proved hugely lucrative.

The museum is well worth a visit if the hero Horatio is your cup of tea, because among all the flotsam and jetsam you'll get a real sense of the famous Brit and his voyage through history.

44. The Skirrid Inn – A Great Place to Hang

Strutting the length and breadth of Monmouthshire can be extremely thirsty work, and if you fancy wetting your whistle while on your merry march around the county there's probably nowhere more fitting to have a swift pint of something uplifting than in Wales's oldest pub or as it's more commonly known – The Skirrid Inn.

Standing in the shadow of its namesake, the Skirrid Inn in Llanfihangel Crucorney has been quenching the thirst of eager punters for many a moon. It is over 900 years old and it boasts an old-world authenticity and history in every dark nook, cranny, and rope mark from the numerous public executions that used to take place here.

Back in the days when justice came in the form of a rope, the inn was used as both a courtroom and place of execution. The notorious 'Bloody' Judge Jefferies would preside over proceedings and condemn prisoners to the hangman's noose for such petty crimes as sheep rustling.

A curious soul can still observe the rope marks on the oak beam above the pub's staircase where more than 180 poor felons danced the hangman's jig before they shuffled off this mortal coil.

Local legend has it that some of the hanging judge's victims are still rumored to stalk the Skirrid Inn in search of retribution for their unjust punishment. As for 'Bloody' Judge Jefferies, it's said he too still roams the inn's upper floors looking to assuage his terrible appetite by condemning even more souls to swing until their hearts are stilled and their eyes are unseeing.

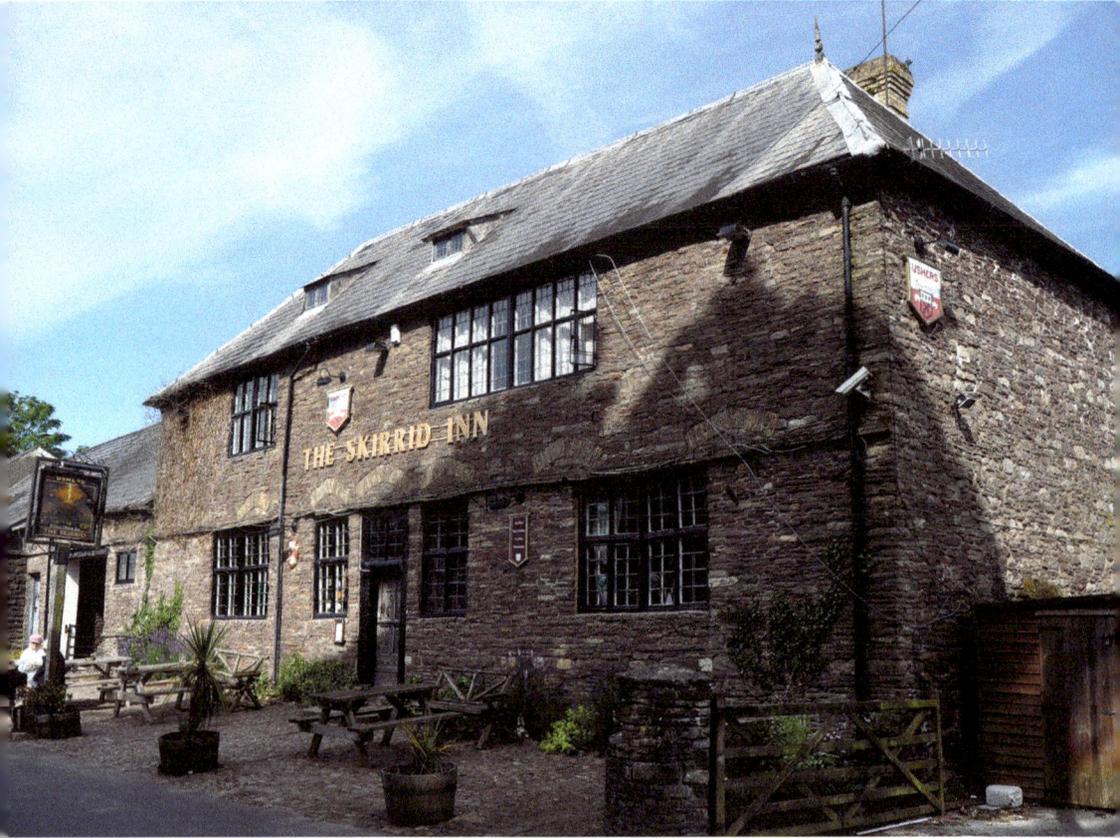

Monmouthshire's oldest watering hole. (Photo by Andy Dolman)

On a brighter note, although it's said to be something of a goldmine of paranormal activity, not all of the spirits who ply their trade at the Skirrid are malevolent.

Fanny Price, for example, is said to be a friendly sort. Old Fanny used to serve pints at the Skirrid back in the eighteenth century, but she sadly died of consumption aged thirty-five. She is said to be still lurking with in the confines of the Skirrid Inn alongside Father Henry Vaughn and a strange perfumed apparition called the White Lady.

As well as being soaked in superstition the Skirrid is shrouded with layers of colourful historic fact. During the Welsh revolt against the rule of Henry IV of England, Owain Glyndŵr was set to rally his troops outside of the inn before leading them on a raid of nearby settlements who were sympathetic to the English.

Wounded and dying soldiers fighting under Glyndŵr's flag were also said to have found sanctuary at the Skirrid.

If you visit the inn you'll be in grand company. The Great Bard William Shakespeare apparently once supped a tankard of something refreshing here and a whole host of kings from all over England and Wales were said to use the ancient mounting stone in the forecourt as they dismounted their steeds in search of a little liquid refreshment.

So what are you waiting for? Saddle up and enjoy!

45. Usk Rural Life Museum – Pitchforks and the Past

By and large Monmouthshire is a rural county, and if you want a real taste of how they used to live and work in this little corner of Britain, then grab yourself a pitchfork and straw hat and take a detour to Usk Rural Life Museum.

There's something reassuring about museums that document how times have changed; namely that times have indeed changed, and we're no longer forced to butcher beloved pet pigs, wear poorly tailored clothes, live in cramped and squalid accommodation, and work from dawn to dusk just to survive.

Life was hard back in the good old days when sanitation, electricity, Amazon and Netflix were not around to get in the way of us getting our hands dirty and scratching out a bare living off the land.

With over 5,000 exhibits curated by local enthusiasts over the last fifty years, this museum houses an engaging collection of everything from vintage tractors to everyday household items. It even has a penny-farthing.

If you want tractors we got 'em!

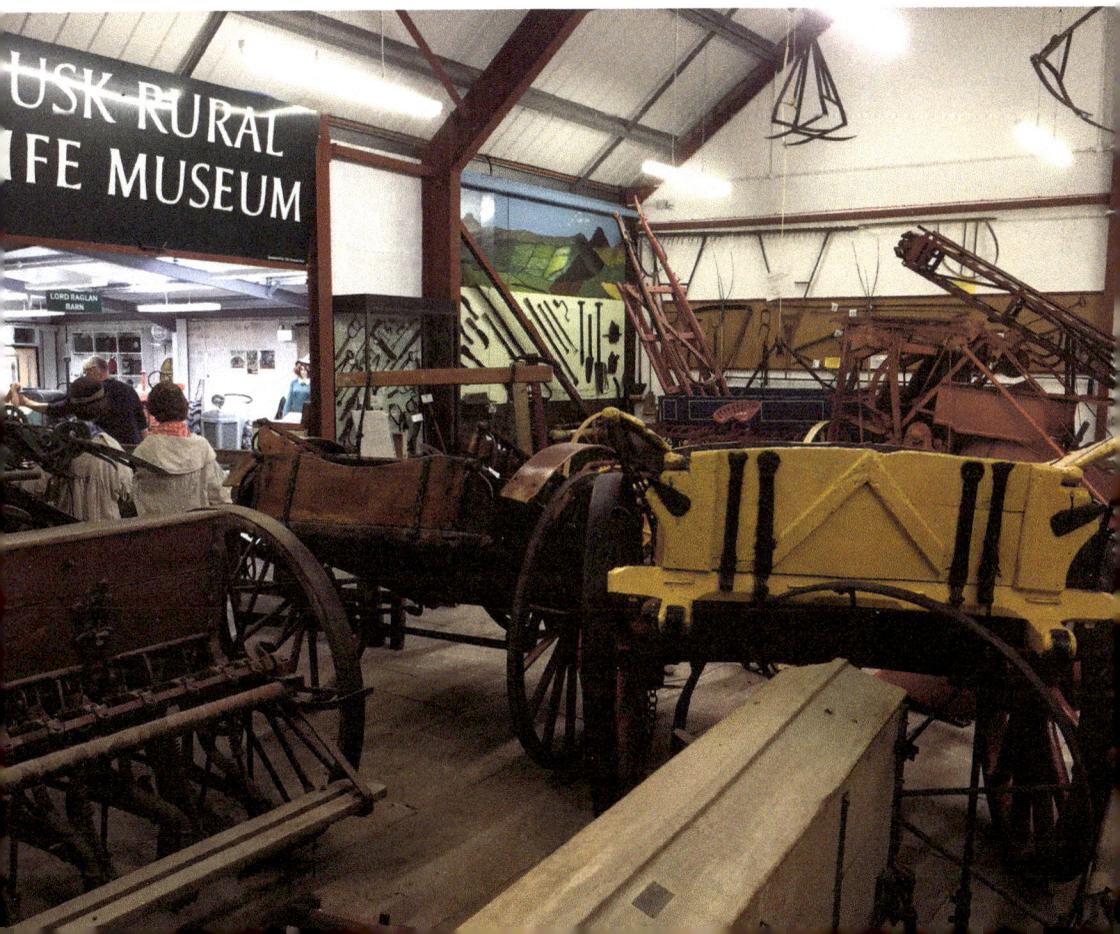

The museum's collection covers a 100-year span from 1850 to 1950 and is housed in a sixteenth-century malt barn and its adjacent buildings. Among its special collections you'll find a replica of a Victorian cottage, a stable, a forge, carts, a cobbler and a whole lot more besides.

They say the past is a different country and they do things differently there, to find out just how differently take a trip to a place which celebrates difference in style.

46. Usk Castle – Off the Beaten Track

Despite its abundance of charms and rare delights, Usk Castle is perhaps one of Monmouthshire's most overlooked gems. It's not as widely promoted as a lot of the county's castles and, although it is close to the picturesque town of Usk, you won't stumble across it by chance. It's billed as a secret castle waiting to be discovered, but once discovered it's never forgotten.

Enchanted and slanted.

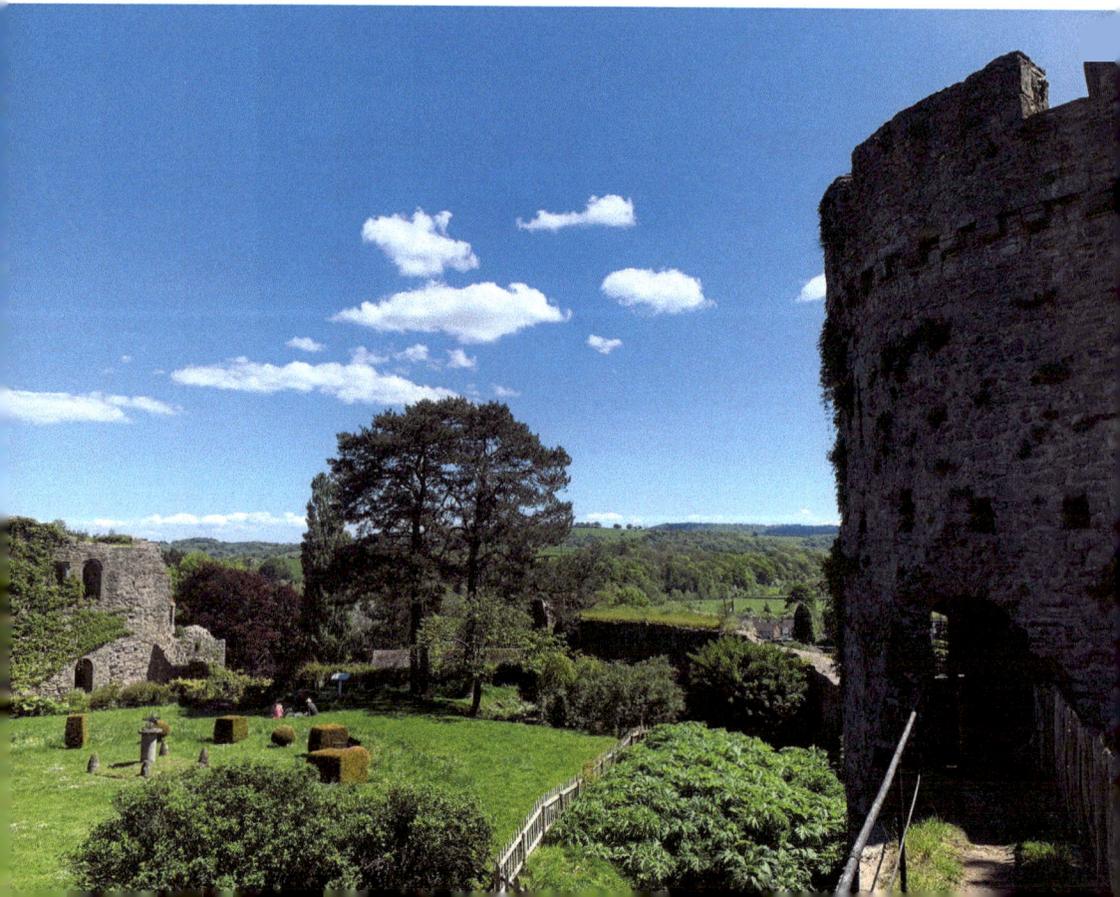

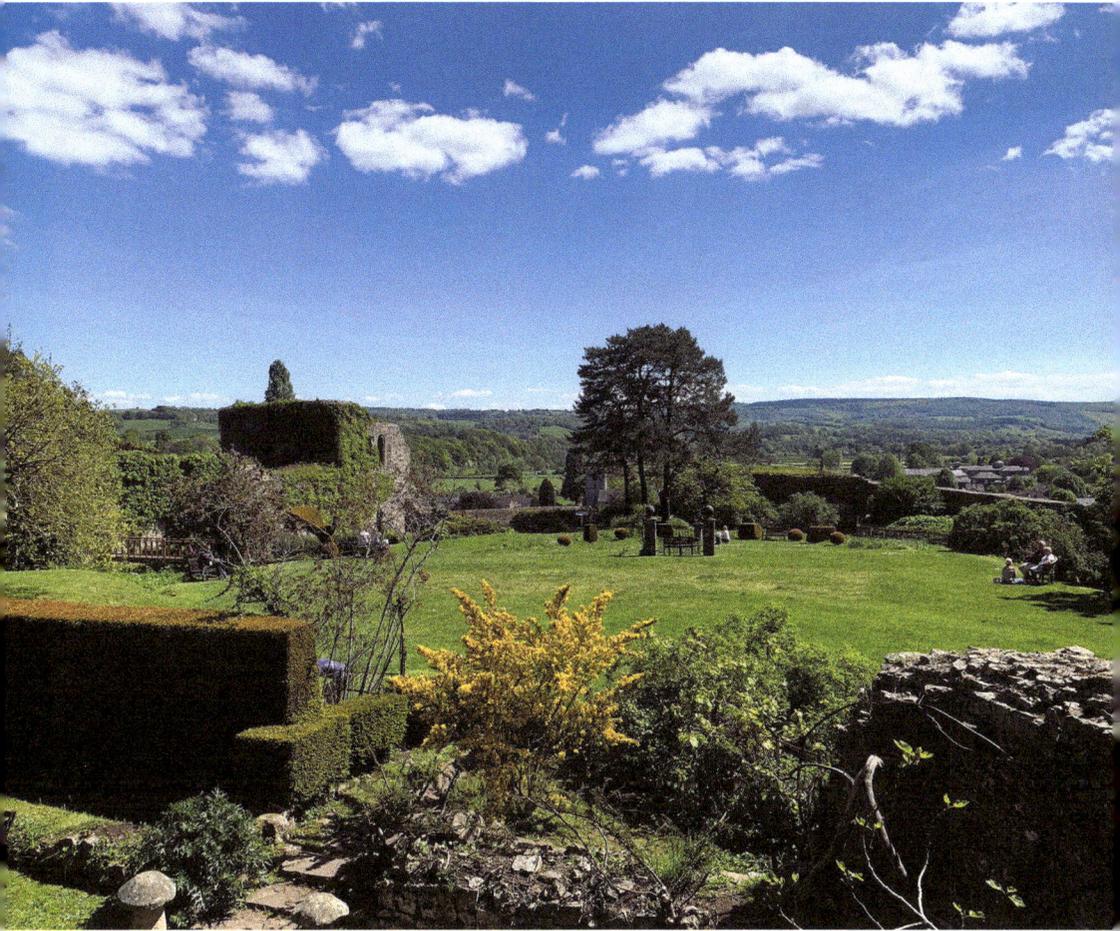

A spellbinding view.

Upon walking up the gentle hill and steps leading through its fairy-tale gates the first impression of Usk Castle is that it is a masterpiece of elegant decay. Everywhere you look it's hard to know where the ruins end and the hands of nature begin. It's not so much like walking through the remains of a structure that has been reclaimed by vegetation but walking in a landscaped garden with a castle feature.

Legend claims that Richard, Duke of York, set up residence in the castle during the 1400s and his two sons Edward IV and Richard III were born in its walls. The area's most famous son, the Welsh historian Adam of Usk, took his first breath here. Rumor also has it that in the Treasure Tower a dog called Coker once lived, and this might just be the first reference to a Cocker Spaniel in recorded history.

With breathtaking views over Usk and an abundance of little corners to sit and take in the scenic surroundings, Usk Castle is something of an aesthetic wonder. Although its history of blood and conquest tells a different tale.

In 1170 the man who gave Usk town its first charter, Richard 'Strongbow' de Clare, supervised the building of the great keep on a site that probably once

A grand entrance.

housed a wooden motte-and-bailey castle and was the former residence of William the Conqueror's standard-bearer at the Battle of Hastings.

The Garrison Tower has been described as a military masterpiece, and was built in 1209 by William, Earl of Pembroke. It was constructed during a time when England's King John and Wales's Llewellyn the Great weren't exactly seeing eye to eye.

The castle was subject to many notable sieges during the medieval period. It was briefly in the hands of Hywel, a Welsh prince of Caerleon, but Henry II and his troops recaptured it and killed the prince. In 1405 Owain Glyndŵr laid siege to its walls during the Battle of Usk. Glyndŵr suffered a terrible defeat at the hands of the future Henry V and lost over 1,500 men.

That same year another Welsh prince, Gruffydd Owain, attempted to attack, but he too suffered heavy losses when his forces were intercepted by English troops led by Lord Grey.

On a glorious day when the skies are blue and the sun is full and lazy, it's hard to reconcile the carnage and screams that must have once echoed around this castle's walls. Today it's more popular as a spot for people to get married than it is for them to hack each other to pieces, such is time's transformative and healing power.

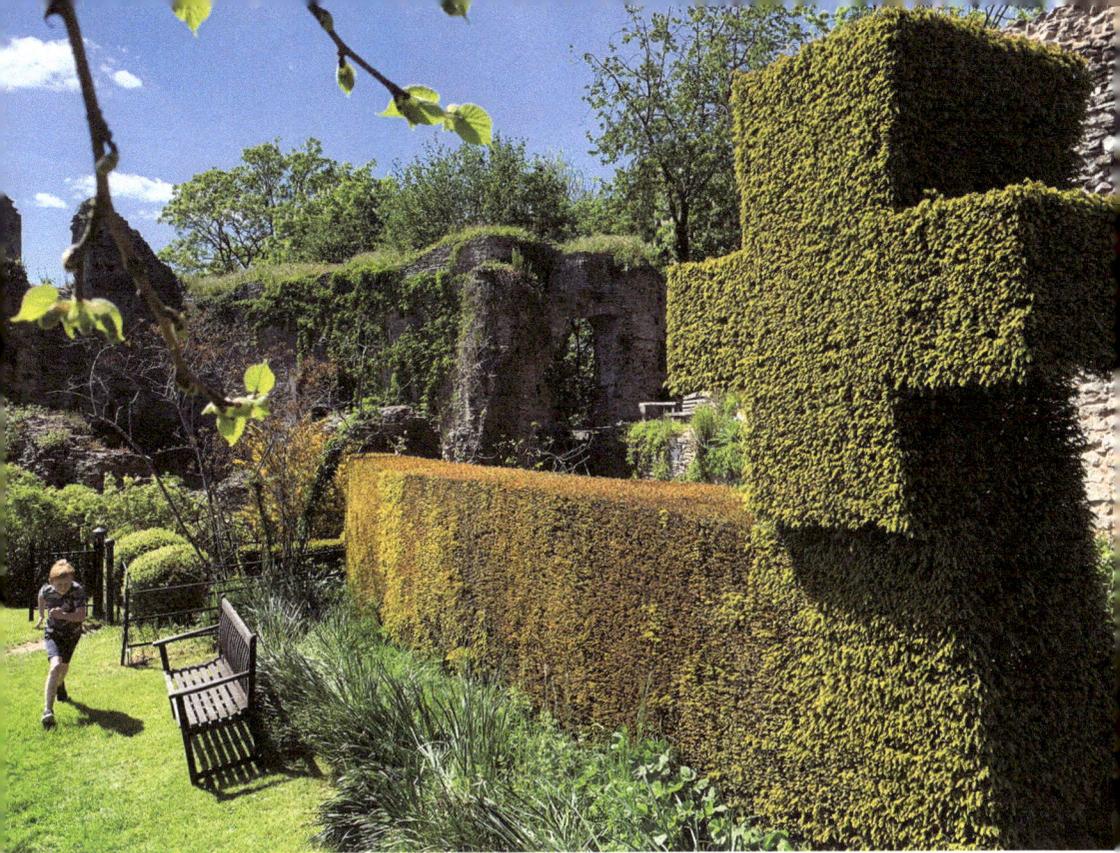

Above and below: A place to take the weight off.

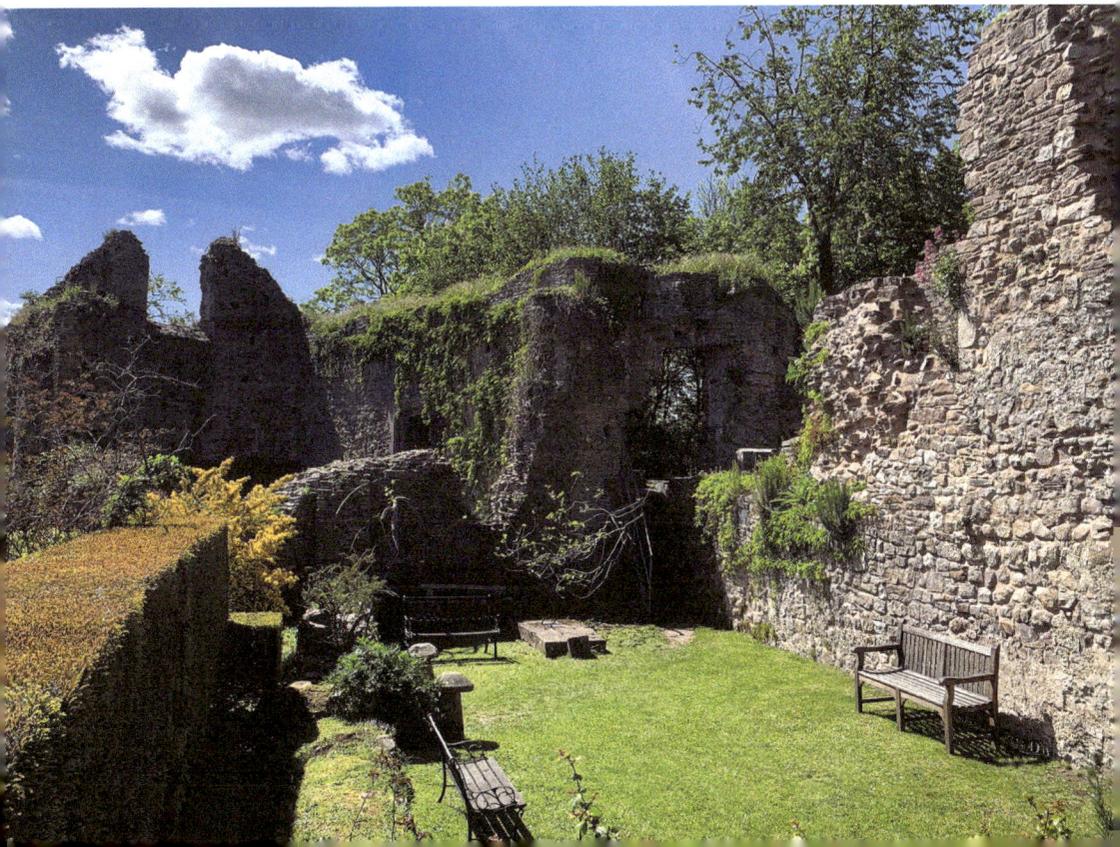

47. The Circle of Legends –
In the Footsteps of Giants

Just upstream from Tintern Abbey is the Old Station where you'll find six historical and mystical characters from Monmouthshire's past carved in oak and chestnut.

The life-sized sculptures are there as a starting point that will lead you on six separate trails into the surrounding Monmouthshire countryside. You might be surprised to find King Arthur among the six. He is often associated with Cornwall or Somerset, but many believe he was from Monmouthshire. Some historians speculate he was the legendary King of the Silures, Arthurius ap Meurig ap Tewdrig.

Geoffery of Monmouth is one of the more factual figures in the circle. Born in 1100, he wrote the *History of the Kings of Britain*, which helped to establish the legend of King Arthur.

The other legendary figures in the circle include King Tewdrig, who ruled the kingdom of Gwent before choosing the life of a hermit at Tintern. His country had need of his sword again during the Saxon invasion and he successfully repelled the invading hordes, but was also mortally wounded in the process. He was taken to Mathern where he died in a place that has since been named Tewdrig's Well.

Will the circle be unbroken? (Photo by Gareth James, CC BY-SA 2.0)

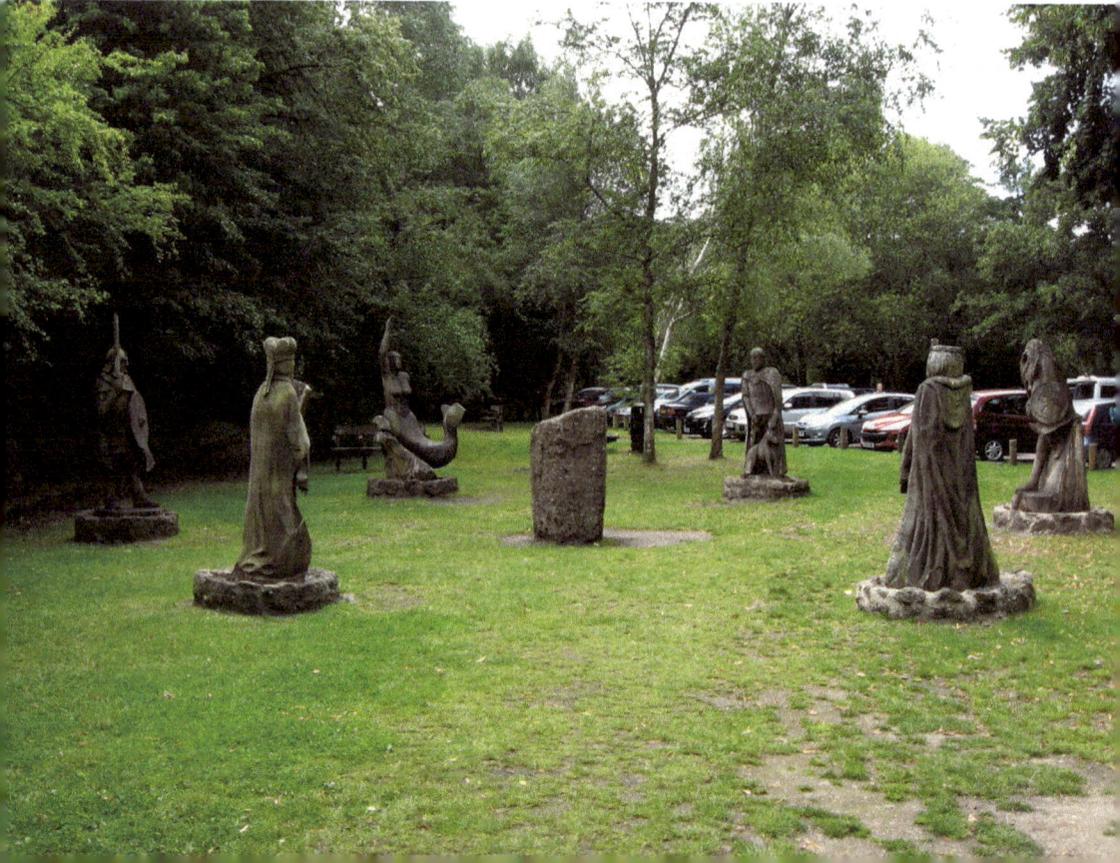

And then we have the bare-breasted goddess of the River Severn – Sabrina. Known among the Welsh as Hafren, legend has it that she was once the illegitimate child of a married king of England and a Welsh lady named Elfridis. On the jealous queen's orders, both mother and child were thrown into the Severn. In the toss and turn of those cruel tides, she was transformed into a goddess of healing.

King Offa, best known for his formidable dyke, takes his place within the circle as the former King of Mercia (AD 757–796). His kingdom suffered so terribly from Welsh incursions he decided the only thing to do was to build a massive earthwork from sea to sea.

Last but not least we have Henry III's queen and Edward I's mother, Eleanor of Provence. The lady from France had a huge architecture influence on Grosmont Castle where a chimney was named after her.

Each legend has a walk in their name through an area of Monmouthshire where they have many links, and each walk offers an intriguing glimpse of how land and legend are often one and the same.

48. St Mary's Church – The Welsh Westminster

Described as the Welsh version of Westminster Abbey, the Priory Church of St Mary in Abergavenny is an Aladdin's cave of religious and medieval treasures.

Inside its doors, you'll find ten alabaster chest tombs, which are described as the most magnificent of Wales. One of the fifteenth- and sixteenth-century tombs houses the remains of Richard Herbert, who grew up in the splendid confines of nearby Raglan Castle alongside the future Henry VII. It was this link that spared the church from the Dissolution of the Monasteries, which was ushered in during the reign of the portly monarch.

Perhaps the most remarkable of St Mary's sacred objects is the fifteenth-century wooden sculpture called the *Tree of Jesse*. The Jesse tree was carved from a single piece of oak and depicts the lineage of Christ. It is thought to be the only one in existence in the world. When on display at the Tate Britain in London in the early 2000s, it was hailed as 'one of the finest medieval sculptures in existence.'

Originally founded in 1087 as the church of a Benedictine priory, archaeological studies have since raised the possibility St Mary's was once a site of Romano-British and possibly Celtic worship.

Today the parish of St Mary's runs from the ancient Llanellen Bridge to the peaks of the Sugar Loaf.

The church has a somewhat brooding and unquantifiable presence, which is often best appreciated from the sprawling and refreshing gardens of rest to its left. It's bulky symmetry and slightly guarded air is unusual in a place of worship, but nevertheless it has a certain something that puts it in a league of its own when it comes to the houses of the holy.

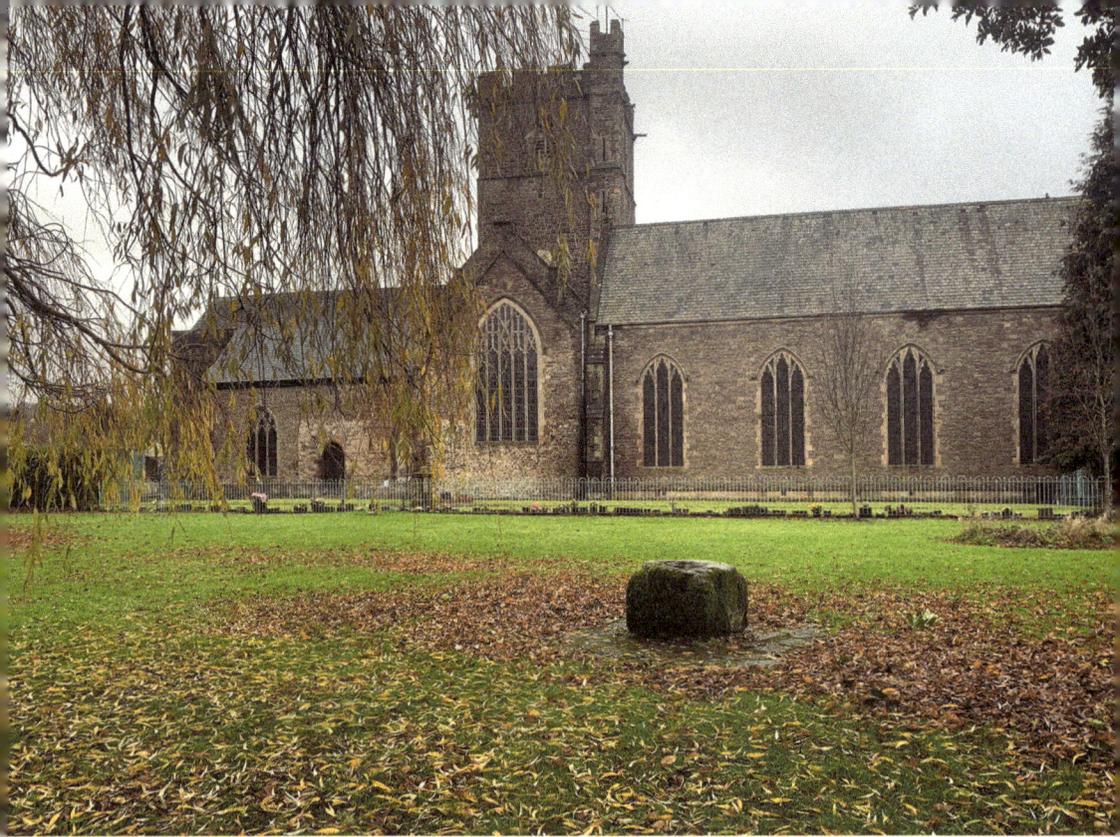

Above: All hail St Mary.

Left: His name is Jesse!
(Photo by Michael Woodward)

49. Skirrid Fawr – Shattered and Great

Standing on the outskirts of Abergavenny, in splendid isolation from the other six hills that surround that guarded and gated market town, stands the Skirrid Fawr. This symmetrical oddity stands aloof and alone, and its scarred and broken appearance gives it the impression of a perpetual outsider. Although lacking the stature of the nearby Blorenge and the Sugar Loaf, the Skirrid has an undeniable presence that invites the curious passer-by in to question just how this curious and distinctive mound of earth situated on the eastern end of the Black Mountain range is often called the Holy Mountain or Sacred Hill.

Myth and mystery surround the Skirrid, and its very name was forged in the furnace of folklore and fable. Adopted from the Welsh phrase 'Ysgyryd Fawr', Skirrid Fawr translates as 'shattered great'. The Skirrid got this striking name because of its distinctive shape, which appears as if some giant or beast from an age before history had slashed and gouged out a part of the hill and left a desolate hollow and gnawing absence in its wake.

When the sun is full, the sky is blue and all is well in our fair age of reason and enlightenment, it's difficult to imagine the Skirrid got its 'split personality' from anything other than a land-slip that occurred during the Ice Age. Yet when the moon is full, the shadows creep and the primal memories of darker days hold sway, it is easy to believe that the Skirrid was split in two due to the terrible wrath of the Devil himself.

The story goes that Satan flew into a furious rage after failing to recruit the Archangel Michael into the ranks of the fallen. In a vile temper, the horned one stamped like a toddler having a tantrum upon the Skirrid and created the mount's distinctive shape.

To the ends of the earth.

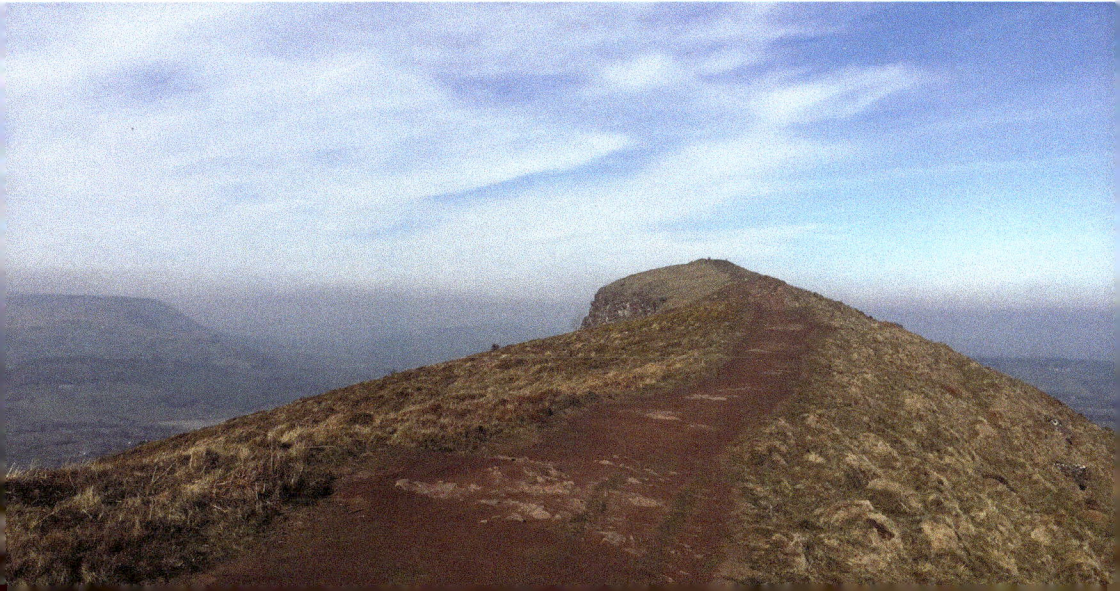

Another tale suggests that the Devil was having a heated debate with local legend Jack O' Kent about which was bigger, the Sugar Loaf or the Malvern Hills. Disgusted that Jack was right, old Nick collected a huge apron of soil, which he intended to dump over the Malvern hills and make them bigger in stature than the Sugar Loaf. His plan backfired. The apron split and the soil crashed all of over the Skirrid and formed the tump at the northern end.

Another theory was that Noah's Ark passed this way during the great flood when Abergavenny and its seven hills laid beneath the water, and the hill of that great ship ploughed through the once intact Skirrid.

A legend popular with locals suggests the dramatic landslide was caused by an earthquake or a bolt of lightning that hit the hill at the exact moment Christ was crucified.

Whatever the truth, the earth from the Skirrid has been considered holy and fertile for time out of mind. In days gone by it was often scattered on coffins and has been used in the foundations of churches.

Take a trip to the top of the Skirrid today and you'll still find the remains of the chapel of St Michael's, an Iron Age hill fort, and a curious stone that is known as the Devil's Table. So called because at the tail end of the nineteenth century a man who lived on the Skirrid apparently gave out advice and magical gifts to anyone who placed money on the table.

Whether you believe the old superstitions is up to the individual, but today people still make pilgrimages to the Skirrid in as great numbers as they did in times gone by. And the instinct that calls us to the high and lonely places of this isolated island or ours remains the same: the need to connect with something natural, timeless and magnificent.

A mountain with character.

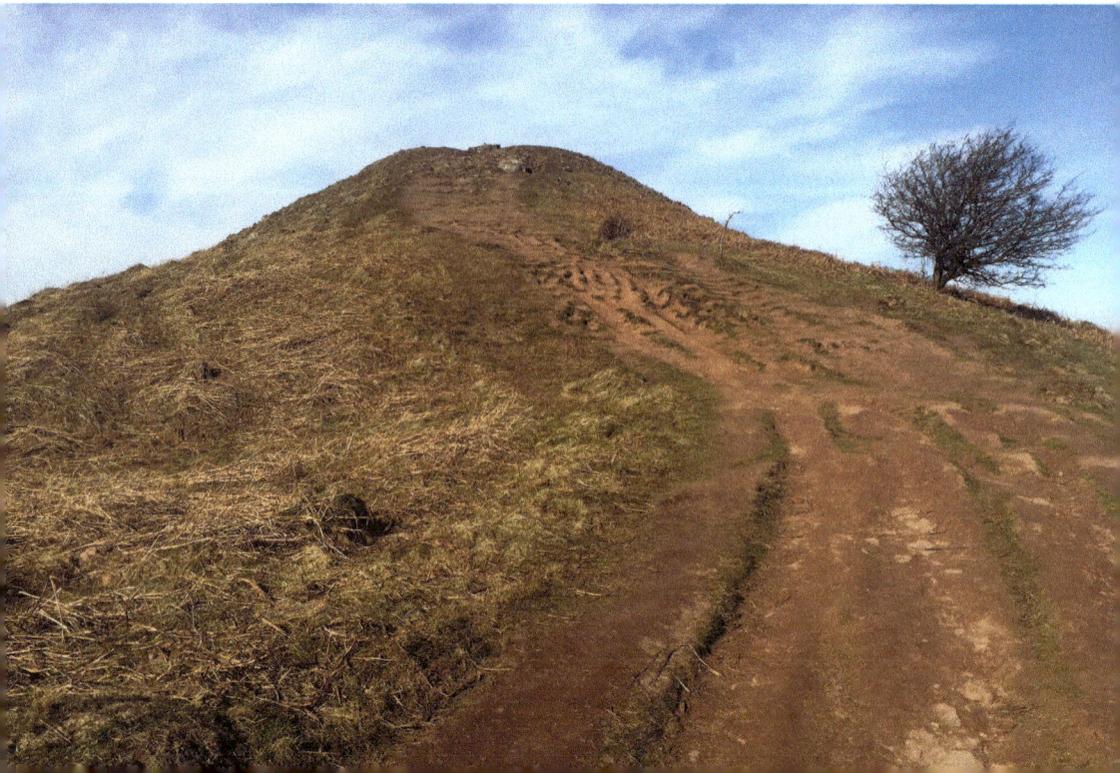

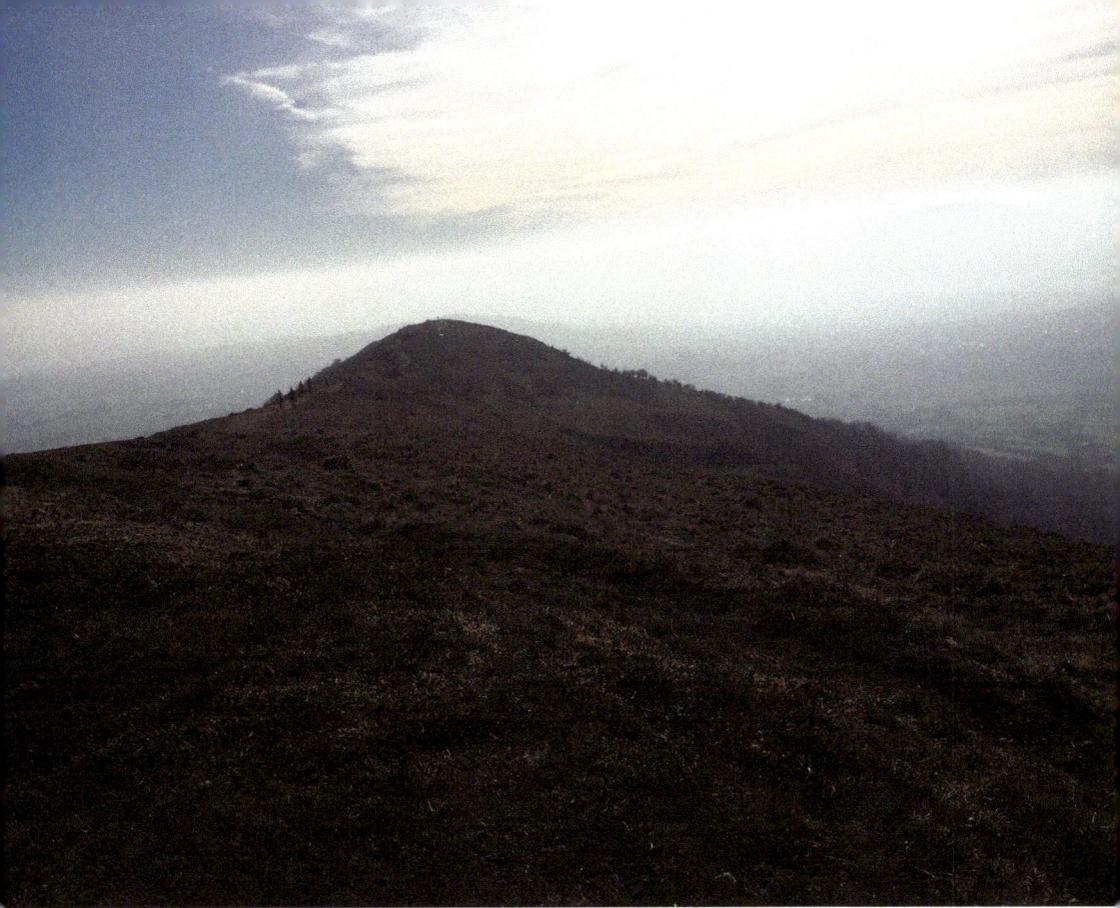

A striking silhouette.

When walking upon the brow of the Skirrid and immersed in the invisible forces and elusive energies found on all mountaintops, it often feels and appears as if one is walking on the back of a sleeping dragon. Its head is hung low, its body is crouched in slumber, its hidden eyes watch warily and its contours in repose suggest a state of guarded distrust against the modern world and all its trappings.

50. Black Rock Picnic Site – A Cup of Tea on the Edge

The Severn Estuary is a strange place. The Severn Bridges are even stranger. They hang suspended between two lands, and their ugly symmetry and unsightly cables appear as if constructed by an alien civilization who cares little about anything but utility.

In short, they are a no-man's land, which span a great expanse of water that does not want to be crossed. Interestingly, before the bridge was built, the author of *Robinson Crusoe*, Daniel Defoe, once refused to cross the Severn's rough swift

tide by boat. In 1966, Bob Dylan had no such qualms and crossed on the ferry. Film director Martin Scorsese went on to use the iconic image for the cover of his Dylan documentary and album of the same name, *No Direction Home*. Four months later the bridge opened and the ferry closed down. In 1996 another bridge was built to cope with increased demand, and like anything hideous, both bridges are best viewed from a distance.

Black Rock Picnic site in Portskewett is a picturesque spot sandwiched between these two metallic monstrosities. It exists on the far-flung reaches of Monmouthshire, and in keeping with anything on the edge it offers panoramic views and gives a unique perspective.

Behind one lies Monmouthshire, understated and restful, and ahead looms the brooding waters of the Severn and the two bridges, which will take you far away from the mountains, the rivers, the castles and the curious high roads and low roads of that ancient county into something different and something else.

The Black Rock Picnic site is indeed a fine place to have a cup of tea and admire the views before getting back in the car, slamming on Dylan's 'No Direction Home', and returning to the welcoming arms of Monmouthshire.

The end of the line. (Photo by Robin Drayton)